& Post-Impressionist Masterpieces: The Courtauld Collection

for the International Exhibitions Foundation, Washington, D.C. and the Courtauld Institute Galleries, London

Designed by Derek Birdsall RDI

·Typeset in Monophoto Van Dijck by Jolly & Barber Ltd, Rugby, and
printed in Italy by Amilcare Pizzi, s.p.a, Milan

Library of Congress Catalog Card Number 86-51199
ISBN 0-300-03828-3
ISBN 0-300-03891-7 (pb)

Contents

Participating Museums

The Cleveland Museum of Art, Cleveland, Ohio: 14 January – 8 March 1987

The Metropolitan Museum of Art, New York, New York: 4 April – 21 June 1987

The Kimbell Art Museum, Fort Worth, Texas: 11 July – 27 September 1987

The Art Institute of Chicago, Chicago, Illinois: 17 October 1987 – 3 January 1988

The Nelson-Atkins Museum of Art, Kansas City, Missouri: 30 January – 3 April 1988

This exhibition is organized and circulated by the International Exhibitions Foundation, Washington, D.C.

A generous grant from the IBM Corporation has made the American tour possible.
The exhibition is also supported by an indemnity from the Federal Council on the Arts and the Humanities.
Additional assistance has been received from the Woodner Foundation and British Airways.

Cover: Gauguin, detail from *Te Rerioa* (no. 41)

Annemarie H. Pope Foreword

It is a great honor and pleasure for the International Exhibitions Foundation to present this magnificent exhibition, *Impressionist and Post-Impressionist Masterpieces: The Courtauld Collection*, to American museum audiences. Drawn from the holdings of the celebrated Courtauld Institute of Art in London, the forty-eight paintings shown here include superb works by the foremost artists of late nineteenth-century France. This is the first major loan exhibition from the Courtauld ever to travel to the United States.

This exhibition has been planned to coincide with the Courtauld Institute's efforts to raise funds for the conversion of historic Somerset House into new gallery space, libraries, and classrooms for the University of London's graduate program in art history. We are therefore especially pleased to bring the distinguished collection of Impressionist and Post-Impressionist works acquired by the Institute's initial benefactor, Samuel Courtauld, to the attention of the American public. It is our hope that the Courtauld Appeal, under the chairmanship of Mr H. Morton Neal, will succeed in the enormous task of moving all its components under one roof.

Our profound thanks are due to Professor Peter Lasko, former Director of the Courtauld Institute, who initiated this project, and Professor Michael Kauffmann, present Director, who has continued to further it. We would also like to recognize Dr Dennis Farr, Director of the Courtauld Institute Galleries, for his commitment to and co-ordination of the exhibition, and for his scholarly contribution to the catalogue. He has been supported by numerous colleagues, notably William Bradford, Curator of the Galleries. We are grateful to the Trustees of the Home House Society, and to the anonymous lender of five paintings formerly in Samuel Courtauld's collection, for the confidence they have placed in us while the exhibition tours the United States. We thank Sir Michael Levey and his colleagues at the National Gallery, London, for their kind co-operation.

Their Excellencies Emmanuel de Margerie, the Ambassador of France, and Sir Antony Acland, the Ambassador of Great Britain, have graciously agreed to serve as Honorary Patrons of the exhibition during its tour. We are most grateful to them for their interest and support.

We would also like particularly to acknowledge IBM Corporation in the United States and Great Britain for its generous sponsorship of the national tour of this exhibition. It should be noted that IBM's involvement as a corporate donor includes a major grant toward the renovation of Somerset House.

Additional support for the exhibition has been received in the form of an indemnity from the Federal Council on the Arts and Humanities. This assistance has been crucial in enabling us to organize and circulate the exhibition, and we are extremely grateful to the Council for its invaluable help. British Airways has also generously assisted with transportation for the exhibition, and we would like to thank as well The Woodner Foundation for its support of yet another of our exhibitions.

Essays in the catalogue have been written by Dr Farr, Dr John House, and Robert Bruce-Gardner, Gerry Hedley, and Caroline Villers of the Courtauld Institute's Technology Department. It has been co-published with the Yale University Press which has assumed responsibility for editing and co-ordinating production. Derek Birdsall is to be commended for the striking design of the catalogue. We would like to express our deep admiration and gratitude to all contributors to the catalogue.

We are happy to thank the Andrew W. Mellon Foundation again for its generous support of our catalogue program.

Lastly, I would like to add my personal thanks to the staff of the International Exhibitions Foundation. Notable are former staff member Taffy Swandby, who assisted in the early stages; Gregory Allgire Smith, our Executive Vice President, who patiently took over negotiations on the exhibition and catalogue; Lynn Kahler Berg, our very capable Registrar; Linda Bell, our Exhibitions Coordinator; and Tam Curry, our Editor. Colette Czapski, S. Stanley Dawson, Bridget Goodbody, Ingeborg A. Schweiger, Diane Stewart, and Sarah Tanguy all lent their considerable talents to the development of this highly important exhibition.

Annemarie H. Pope
President
International Exhibitions Foundation

Samuel Courtauld as a Collector and Founder of the Courtauld Institute

The historical significance of the Courtauld Collection is examined by John House in his essay, *Impressionism and its Contexts*, but the character of its creator, Samuel Courtauld, and the stages of his conversion to the work of the artists whom we now recognise as the great masters of Impressionism and Post-Impressionism, are not always precisely definable.[1] Courtauld's autobiographical essays and other private papers, from which Anthony Blunt quoted in 1954, can no longer be found, although letters written by Courtauld to Christabel, Dowager Lady Aberconway, between June 1929 and September 1947, have survived and are accessible.[2] These shed light on his complex personality, his literary and musical tastes, his love of hunting and fast cars, with a vividness that eludes the formal obituary notices and tributes to him published after his death on 1 December 1947.[3] Even such basic documentation as account books, dealers' invoices and receipts, are apparently no longer extant, and the historian of the collection must rely on facts garnered about some of Courtauld's paintings in 1935, a year after he made the second of his gifts to the Courtauld Institute of Art. These were compiled by Margaret Whinney and published in *A Catalogue of the Pictures and Other Works of Art at Home House, 20 Portman Square, London* of that year. Other paintings and drawings which came to the Institute in 1938 and 1948, were first catalogued by Douglas Cooper (assisted by Philip Troutman) in the catalogue raisonné of the whole collection published in 1954.[4]

This is not to say that the general outlines of the way the collection developed are ill-defined, but we still do not know for certain in which year some paintings were bought, nor, within a particular year, can we always be sure of the sequence of acquisition. Clearly, a collector must respond to opportunities as they occur, but we do not know, for example, whether Courtauld ever coveted a particular picture long before it appeared on the market. Such evidence we have suggests this was not the way he collected. There remains the more fundamental point as to why he began collecting Impressionist paintings at the time he did. Again, the evidence of his own memoirs, or those extracts from them which have been published, helps, but these also raise other questions the answers to which we can only begin to guess at. A distinguished economic historian has called Courtauld a 'consolidator', rather than an innovator in the textile industry from whence he derived his considerable personal fortune, but also notes that he had an excellent technical knowledge. Certainly, Courtauld was not an innovative collector, since American, French, and German collectors

preceded him in the field; and even within a British context, Sir Hugh Lane and Gwendoline Davies had started their collections of Impressionist painting long before Courtauld. Miss Davies had begun in 1912 to collect modern French paintings on an appreciable scale, and not only artists of the 1860s to 1890s, but also those of the next generation. Where Courtauld surpassed his British predecessors was in scale and sheer quality. If he was slow to start (he was forty-six in 1922 when he began seriously to collect), he more than made up for this by speed and decisiveness. Within eight to ten years he built up not only his own collection; in 1923 he gave £50,000 to the Tate Gallery as a trust fund (the Courtauld Fund) for the purchase of Impressionist and Post-Impressionist paintings. He had quickly realised how poorly represented these were in the national collection and that it would soon no longer be possible to acquire first-class works at comparatively reasonable prices. By this most generous act, Courtauld totally changed the national collection. He brought to his collecting that combination of flair, energy, and sense of public duty that had marked his successful career as a leading industrialist. He did not seek to acquire social status by virtue of his collecting. Indeed, he refused a peerage in the 1937 Coronation Honours List, preferring to keep his independence and integrity.[6]

Although Samuel Courtauld came from a cultivated, typically Victorian family of prosperous silk-merchants who had also become landowners, there was no strong family tradition of art collecting as such, for Samuel's father, Sydney Courtauld (1840–99) was interested in engineering and music, and his mother, Sarah Lucy Sharpe (1843–1906), devoted herself to art and literature.[7] Samuel, born 7 May 1876 at Bocking Place, Essex, was the second of four sons. He was descended on his father's side from a Huguenot family of distinguished silversmiths and silk-weavers, while his mother's family included the poet-banker and collector, Samuel Rogers, and an eminent archaeologist and classical scholar, Samuel Sharpe. The first immigrant, Augustin Courtauld, left his home on the Ile d'Oléron off the west coast of France after the Revocation of the Edict of Nantes in 1685 and settled in London in about 1690. There, as a Protestant, he could remain free from religious persecution. The Courtaulds switched from silversmithing to silk-weaving in the nineteenth century and for almost one hundred years their factory at Pebmarsh, Essex, flourished as a small-scale family business. This was transformed just before and during World War I by the development of the synthetic fibre rayon silk, made from

cellulose. When Samuel Courtauld joined the board of Courtaulds Ltd. in 1915, it had become an international company worth £12,000,000.[8]

The Courtaulds were Unitarians, and although accepted into the land-owning classes by the later nineteenth century, their religious beliefs and puritanical way of life set them apart from their neighbours. The young Samuel was sent to a preparatory school Bingfield, near Southport, much favoured by such Nonconformist/Unitarian families as Holt, Nettlefold, Kitson, Greg, Beveridge, Kendrick and Chamberlain (the young Neville Chamberlain was a contemporary of Samuel Courtauld).[9] From here he went to Rugby School, and afterwards, instead of proceeding to university, was sent to Krefeld and Paris to study weaving and prepare himself for the family business. He became Mill Manager at Halstead, Essex in 1901, the year of his marriage to Elizabeth ('Lil') Theresa Frances Kelsey, who was to share his interest in art and music.[10] By 1908, Courtauld was promoted to General Manager of all the firm's textile mills, joining the board in 1915, and becoming Chairman in 1921, a position he was to hold until his retirement in June 1946.

Courtauld's early exposure to art followed a fairly conventional pattern. Occasional visits to the National Gallery as an eighteen-year-old youth 'damped my spirits', he recalled much later in life, because of 'the rarified atmosphere of education and sanctity' which he felt there (many years later, in 1936, he was to become Chairman of the National Gallery Board of Trustees). He enjoyed the rich colours of Turner's *Fighting Temeraire* and *Ulysses deriding Polyphemus* in the National Gallery, but much more enjoyed his visits to the Royal Academy as 'a genuine pleasure, if not a very deep one. There was little of schoolroom austerity and piety to be seen on those walls. . . .'[11] His first visits abroad deepened his understanding of the old masters, especially those he saw in the Louvre, and of contemporary artists' work, he 'noted with approval' some ballet paintings by Degas. This taste for Degas was shared by an older generation of English artists, notably Sickert, and collectors, although Courtauld was probably unaware of this.

After his marriage, Elizabeth and he visited Italy and here he was profoundly affected by the great Renaissance masterpieces to be seen in Florence and Rome:

> The old masters had come alive to me, and British academic art died. In the former I now perceived a wonderful mastery allied with strong emotion and with life itself; I felt strong and exciting currents still flowing beneath the surface of the paint. In the latter I felt nothing but artificiality and convention, and could detect no progress in technique.

This strong emotional reaction to the revelations that art could offer to those receptive to them is a key to Courtauld's own voyage of discovery. Many years later, he produced an anthology of verses written by himself about some of the old master paintings which had particularly impressed him. This privately printed anthology, *Pictures into Verse*, by 'S.C.', was an attempt

> to record the personal and purely subjective impressions and fancies which have taken form in my own mind when I have set my imagination free before these cherished treasures, allowing them to perform what Charles Morgan, through the mouth of Sparkenbroke, claims to be the true function of art: '. . . it re-enables a man to imagine for himself. It unfreezes the river.'[12]

The verses, which were never intended to be read beyond a small circle of

1. Although the text incorporates some material first published by me in the catalogue to *The Great Impressionists* exhibition published in Tokyo and Canberra 1984, further research has provided interesting new information about Samuel Courtauld.

2. Anthony Blunt, 'Samuel Courtauld as Collector and Benefactor' in Douglas Cooper, *The Courtauld Collection: A Catalogue and Introduction* (University of London, The Athlone Press, 1954). Extracts from a few of the letters written by Samuel Courtauld to Lady Aberconway were first published by Professor Donald C. Coleman, *Courtaulds: An Economic and Social History*, Oxford (vols. I and II 1969; vol. III 1980); there are four unbound volumes of his letters in the British Library (referred to as B.L. henceforth throughout these notes) Additional MSS. 52432–35. Coleman did not identify the recipient, simply referring to her as 'an intimate friend'.

3. An obituary appeared in *The Times*, 3 December 1947, where only a passing reference to the Courtauld Institute was made, a deficiency remedied by tributes from Sir Robert Witt and Professor Anthony Blunt published in *The Times*, 6 December 1947. Another tribute, referring to his literary interests, appeared on 9 December, signed 'C.M.', i.e. Christabel McLaren, Lady Aberconway; and on his personal traits from 'R. &. J.H-W.' on 12 December. One of these signatories was presumably Sir John Hanbury-Williams, who had succeeded Courtauld as Chairman of the company in 1946.

4. Apart from Douglas Cooper's catalogue, referred to in n. 2 above, there was a privately-printed catalogue by Paul Jamot and Percy Moore Turner, *Collection de tableaux français, faite à Londres, 20 Portman Square, par Samuel et Elizabeth Courtauld* (1934) of which only fifty copies were published.

5. Coleman, *Courtaulds*, II, p. 221.

6. Letter to Lady Aberconway, dated 21 April 1937 (B.L. Add. MSS. 52432). Written from the British Legation, Budapest.

7. Blunt, in Cooper, *The Courtauld Collection*, pp. 1–2; Coleman, *Courtaulds*, II, pp. 210–11. Samuel's sister, S. Renée Courtauld, has left a short but vivid account of their childhood. (Typescript [November 1951] deposited at Trinity College Library, Cambridge: Butler and Courtauld Papers, D.29. I am indebted to the Hon. Sir Richard Butler for permission to consult them.)

8. Coleman, *Courtaulds*, p. 210.

9. Ibid.

10. They were married in an Anglican parish church, St. Marylebone, London, on 20 June 1901, as Courtauld recalls in a letter to Lady Aberconway, dated 30 December 1931 (B.L. Add. MSS. 52432) shortly after Mrs Courtauld's death on Christmas Day 1931.

11. Blunt, in Cooper, *The Courtauld Collection*, p. 2.

12. *Pictures into Verse* (n.d.), Foreword, p. 5. Courtauld refers to an 'anthology' he is composing in a letter to Lady Aberconway, dated 8 August 1939 (B.L. Add. MSS. 52433), and seeks her opinion. It was presumably the manuscript of *Pictures into Verse*. I am grateful to Dr Anne McLaren for allowing me to see a copy of this book.

family and friends, are romantic in spirit and couched in elaborate Swinburnian language. Only two Impressionist works from his own collection, both by Renoir, *Le Printemps (Chatou)* and *La Loge* are included in this anthology. In a footnote to the poems which accompany these two paintings, Courtauld diffidently explains the attraction Renoir's work had for him:

Both pictures reveal the power which Renoir possessed at one period of conveying quietly but very firmly the solid structure beneath a tender and evanescent surface. No other impressionist did this, yet none ever rendered the subtle charm of surfaces, the colour of atmosphere, or the beauties of texture, with so sensitive and rich a brush as he.[13]

It seems that Courtauld only gradually realised that the emotion and vitality of the old masters was to be found again in the modern French School. He became aware of the work of Manet and Monet, as well as Degas, but still could not appreciate Cézanne and Seurat. Neither did Roger Fry's two Post-Impressionist exhibitions in London of 1910 and 1912, nor the various shows at the Salon des Indépendants in Paris elicit a sympathetic reaction from him, rather the reverse, for he derided the Fauves and their precursors attracted some of the same odium. The next stage of his conversion came, he tells us, in 1917, when he saw Sir Hugh Lane's collection on exhibition at the Tate Gallery, which was 'my second real "eye-opener"' . . . I remember especially Renoir's *Parapluies*, Manet's *Musique des Tuileries* and Degas's *Plage à Trouville*. . . . I knew nothing yet of Cézanne, but I was initiated in a curious way.' He then recounts the infectious enthusiasm of a young portrait painter (probably Glyn Philpot, R.A.) who led him to Cézanne's *Provençal Landscape*, which had been lent by Gwendoline Davies to an exhibition of French art at the Burlington Fine Arts Club in May 1922. He made Courtauld 'at that moment' feel 'the magic . . . and I have felt it in Cézanne's work ever since.'[14] That exhibition contained seventy-one works by all the major French artists of the last hundred years: from Corot, Daumier and Delacroix through Courbet, Manet and Degas to Renoir, Cézanne, Gauguin and Seurat. The loans came principally from English and French private owners, with some contributions from London dealers such as Oliver Brown of the Leicester Galleries and Percy Moore Turner of the Independent Gallery, whose Renoir, *Le Printemps (Chatou)*, Courtauld was to buy five years later.

From May 1922 Courtauld began his career as a collector in earnest and over the next ten years or so he acquired some superb masterpieces. In 1921 he had bought two Thomas Gainsborough portraits which had once belonged to his mother's family. One of these, *Portrait of Mrs Gainsborough c.*1779, not only represents a leading eighteenth-century master but is a tender work with a delicate handling of paint that accords well with Renoir's *La Loge* (no.14), which Courtauld was to buy in 1925. Already, surely, some idea of what he looked for in a painting was beginning to emerge. Apart from the Gainsboroughs, he started modestly by buying a Toulouse-Lautrec drawing *Woman in Bed*, a late Renoir oil *Woman tying her Shoe* (no.16), and a recent landscape of St. Paul, 1921, by Jean Marchand (1883–1941), a painter then much admired by London art critics. The last two works came from Percy Moore Turner, who was to be a helpful guide and adviser.

It has been emphasised by those who knew him that Courtauld always made the final decision about buying a picture himself, and he would frequently look through a dealer's stock room. He often preferred to have paintings hanging for some weeks in his handsome Robert Adam house

(built 1773–5) in Portman Square to make sure, before completing a purchase, that his choice was the right one. He greatly valued his wife's taste and judgement and the collection is very much the joint creation of Samuel and Elizabeth Courtauld.

P.M. Turner, who had run picture galleries in Paris from 1906 to 1914 before setting up in London in 1921, was a friend of Roger Fry, and the shape of the Courtaulds' collection, with its strong emphasis on Cézanne (twelve oils, if one includes the paintings acquired for the Tate Gallery through the Courtauld Fund), Seurat (twelve oils, including the monumental *Une Baignade, Asnières* bought for the Tate in 1924 and now in the National Gallery), Degas (eight oils and pastels and two bronzes) and Manet (five oils, plus important graphic works by him), seems to show at the very least that the Courtaulds shared with Fry a remarkable similarity of taste. Although Samuel Courtauld's tastes were much less austere than Fry's there are other interesting resemblances between the two men.

Fry was born into a Quaker family; his father, Sir Edward Fry, had been a judge and at first opposed his son's wish to become a painter, after Roger had graduated from King's College, Cambridge, with a first-class honours degree in the natural sciences. Ten years older than Courtauld, Fry shared with him a Nonconformist religious background, and after establishing a high reputation as an old master expert he underwent a conversion to modern art when he discovered Cézanne in 1906.[15] In 1916 he began to recognise the importance of Seurat but did not write a full-scale essay on him until 1926.[16] Fry and his friend the economist Maynard Keynes also obtained Courtauld's financial support for an artists' co-operative exhibition society, the London Artists' Association, formed in 1925. There can be no doubt that Courtauld was aware of Fry's critical opinions, for he owned copies of Fry's *Vision and Design* (1920) and *Transformations* (1926). After learning of Fry's death early in September 1934, he wrote to Lady Aberconway:

. . . I had quite a shock when I read of Roger Fry's death. He was so much alive, & I don't think his work was nearly finished, for his opinions never ceased developing & I think he might have produced a great volume of illuminating & far-reaching criticism in his old age. He was unique in the world of art & his views on art seemed to me more & more to illuminate life & thought in general.[17]

The warm tone of this letter also suggests that the two men were personally acquainted. Courtauld was certainly friendly with Fry's early collaborator, Clive Bell, for he notes in a letter that Bell dined with him in Rome in March 1932 and they met up again in Italy early in April.[18] Nevertheless, it should be said that Courtauld was, like Fry, a most independent-minded man who would not care whether the 'experts' agreed with him once he had made up his mind about a picture.

During 1923 Courtauld quickened his pace of acquisition, laid the foundation of his collection and defined its scope. He bought Daumier's *Don Quixote* (no. 4); two small Degas bronzes of dancers and the pastel of *Seated Woman adjusting her Hair* (no. 9); Manet's *Bords de la Seine à Argenteuil* (no. 2); two Monets, the *Antibes* landscape (no. 13) and the *Vase of Flowers* (no. 12); two Cézannes, *The Etang des Soeurs* (no. 21) and the *Still Life with Plaster Cast* (no. 28), the first truly major work to enter the collection; Gauguin's *Haymaking* (no. 39) and a splendid early Seurat drawing *Standing Female Nude*, once doubted but now regarded as authentic.

In three successive years, 1924, 1925 and 1926, Courtauld bought three superb Cézannes: *The Tall Trees at the Jas de Bouffan* (no. 23), *The Montagne Sainte-Victoire* (no. 24) and *The Lac d'Annecy* (no. 29); sometime in 1926 he

acquired the first of his three Gauguins, *Nevermore* (no. 40); earlier, in 1924, he had bought two Manets, one through the Courtauld Fund, *La Serveuse de Bocks* (now in the National Gallery, London), the other for himself, the beautiful *Les Paveurs, rue de Berne* (on loan from the Courtauld heirs to the Fitzwilliam Museum, Cambridge). The crowning glory of the Courtauld Collection, Manet's famous last great masterpiece, *A Bar at the Folies-Bergère* (no. 3), was bought in 1926 along with that strangely haunting and faintly comic image of Madeleine Knobloch in *Young Woman Powdering Herself* by Seurat (no. 36), one of three works by this artist acquired that same year.

This bare recital of names and titles gives some idea of the vigour with which Courtauld pursued his purpose. It is no accident that many of the paintings in his collection have become acknowledged by historians as key works in the careers of the artists who painted them, but Courtauld followed no set programme, he was guided by a natural taste of quite remarkable consistency. There were limitations to it, the only Picasso oil in the collection is the early oil *Child with Dove* of 1901, and the Picasso drawings are both from his Neo-Classical phase of the early 1920s. There are no Fauve or Cubist paintings and the two Matisse drawings do not belong to the most adventurous period of the artist's career. Yet how appropriate it is that Courtauld should own Renoir's *Portrait of Ambroise Vollard* of 1908 (no. 15), which he bought direct from Vollard in 1927, and thus preserve in company with his Impressionist paintings a portrait of the dealer who did so much to promote them. Mr and Mrs Courtauld continued to acquire important paintings such as the two Degas oils: *Woman at a Window* (no. 7) and *Two Dancers on the Stage* (no. 8), both bought in 1927, as was the Van Gogh *Peach Blossom in the Crau* (no. 38). The following year they purchased the Van Gogh *Self-Portrait* and the Toulouse-Lautrec *Tête-à-Tête Supper* (no. 44) as well as the Manet replica of *Le Déjeuner sur l'herbe* (no. 1). Then came another painting by Gauguin, more small oil sketches by Seurat, a Bonnard (no. 46) and a Vuillard (no. 47), all of the highest quality.

Apart from an exquisite early Camille Pissarro, *Lordship Lane Station* (no. 5), a Boudin, a Cézanne and a Monet all acquired in 1936, and a Seurat in 1937, Courtauld bought very little after 1930, except for work by a few young English artists who exhibited at the London Artists' Association; some old masters, a number of which were bequeathed to his family, were mainly bought during the last ten years of his life. However, in 1947, he did buy one Impressionist work, the Sisley *Boats on the Seine* (no. 18).

Urged by his friends, Viscount Lee of Fareham and Sir Robert Witt, Courtauld had been considering endowing an institute for the study of art history at London University. By 1927, Lord Lee, who had served as a military attaché at the British Embassy in Washington, D.C., and whose wife was an American, was convinced of the need for an English equivalent of the Fogg Art Museum at Harvard University. He found Courtauld receptive to his ideas which coincided with an as yet unformulated scheme in Courtauld's own mind. Negotiations with the University were begun in 1928 and by 1931 the Courtauld Institute of Art was in being, although suitable permanent accommodation had still to be found. The death of Courtauld's wife at the end of 1931 prompted him to offer to the University the remaining fifty years of the lease of 20 Portman Square; he moved out on 15 September 1932, and the new Institute opened its doors to the first students in October that year, but still in temporary premises in the Adelphi. In December 1932, Courtauld established the Home House Society, in memory of his wife, and seven Trustees were appointed.[19] The Trust Deed states the twofold purpose of the gift:

13. Ibid., p. 62, n. 11. Courtauld expresses the opinion that Renoir before 1880 had 'reached his highest summit'.

14. Blunt, in Cooper, *The Courtauld Collection*, pp. 3–4.

15. Cooper, *The Courtauld Collection*, pp. 48–9; see also Frances Spalding, *Roger Fry: Art and Life* (London, 1980). Although Fry's perceptive book, *Cézanne. A Study of His Development*, did not appear until 1927, he had championed him since 1906.

16. Denys Sutton, *Letters of Roger Fry*, vol. II (1972), pp. 399–400: Fry to Vanessa Bell, letter dated 3 July 1916: 'You know that de Bergen and I had both been trying to get at Seurat, buying reproductions and studying him, and now I've gradually come to think he was the great man we'd overlooked – well all the conversations in Paris ended in discussing Seurat. . . .' In an essay, 'Retrospect', published in *Vision and Design* (1920; J. A. Bullen ed., 1981), p. 202, Fry wrote: 'But my most serious lapse was the failure to discover the genius of Seurat, whose supreme merits as a designer I had every reason to acclaim.' Fry bought Seurat's *La Luzerne, Saint-Denis*, c. 1884–5 (now in the National Gallery of Scotland), in about 1926, probably from the Seurat exhibition held at the Lefèvre Gallery, London, in May 1926.

17. Copies of these two books, with Courtauld's distinctive bookplate, are in the Courtauld Institute Library. Letter to Lady Aberconway, dated 13 September 1934 (B.L. Add. MSS. 52432); although on 12 North Audley Street headed paper, it is clear from internal evidence that Courtauld was writing from the country. He also says he would write [a letter of condolence] to Helen Anrep, who had become Fry's close companion. There are fairly frequent references to weekends spent with Maynard and Lydia Keynes in Courtauld's letters to Lady Aberconway during the 1930s.

18. Letters to Lady Aberconway, dated 29 March and 6 April 1932 (B.L. Add. MSS. 52432).

19. Letter to Lady Aberconway, dated 29 August 1932 (B.L. Add. MSS. 52432): 'I shall shortly leave this house – to come back & find it *still* empty is too painful. . . .' On 30 August, he told her he was moving into 12 North Audley Street on 15 September. The Trust Deed is dated 16 December 1932. The title 'Home House Society' is a reference to the Dowager Countess of Home (pronounced 'Hume') who commissioned Robert Adam to build 20 Portman Square, 1773–5, and the building is also known as Home House.

a) to be dedicated to some object calculated to increase the enlightenment of mankind and for the said purpose to constitute and endow an institution for the promotion of education in art and archaeology the diffusion of knowledge of all matters connected with the study of the practice and enlightened criticism of art and archaeology and

b) to promote for the benefit of the nation the preservation and exhibition of a building of beauty and historic interest.

Reference is also made to the arrangements entered into by Courtauld and other benefactors with London University to provide 'systematic education of students in the history of art and archaeology and for the training of teachers and experts in art and archaeology by founding an unincorporated institution (not yet completed) . . . to be called . . . the Courtauld Institute of Art'. Among the objects of the Society are listed 'the perpetual preservation and exhibition to the public of 20 Portman Square and the works of art therein and from time to time acquired by the Society'. This refers to the collection of Impressionist and old master paintings and furniture given by Courtauld and in 1932 he had provided a further £70,000 to the Institute for the housing of the collection.[20] This money was subsequently used to meet the cost of the new Courtauld Institute Galleries, opened at Woburn Square in 1958.

Courtauld clearly envisaged the teaching of the history of art as part of a wider humanistic study, where perceptions and enjoyment of works of art would be heightened by a broader and deeper knowledge of the civilisations from which they sprang. He also had in mind a more immediately practical purpose, that of spreading a knowledge of the fine arts to as wide a public as possible:

Today we need teachers and leaders for the great host of laymen whose interest in art might be awakened, or further stimulated. It is obvious that we must train enough scholars and experts to teach these more popular teachers of tomorrow, for though the purpose of him who aspires to enrich the lives of the laity cannot be to turn them into specialists, yet he himself must have been taught something more than the mere rudiments of art history; especially must he be able to judge whether such 'facts' as he has to make use of are really entitled to that name.[21]

It is interesting to reflect that the embryonic University of London, in the shape of University College, had twice invited Sir Charles Eastlake to accept a chair of art, first in 1833 and again in 1836.[22] Eastlake refused, but had he accepted the University would have had a chair of art history well before those created at the Universities of Berlin (1844) and Vienna (1852).

The strong sense of public duty which impelled Courtauld to make magnificent benefactions undoubtedly sprang from his religious upbringing. As a chairman of a multinational company, he was seen by his fellow board members as 'an aloof, remote, rather shy but autocratic figure. He had presence, intelligence, and a patent integrity'.[23] Although he admired American technical achievements, he was not enamoured of some aspects of American commercial life. As might be expected, he disliked excessive advertising and what we now call 'consumerism'. His public image hid inner self-doubts about his adequacy and his faith, and he became more introspective in the 1930s, a process aggravated by his wife's death.[24] His thoughts on art and literature now seem to us very Victorian in their earnestness, but there can be no doubting his deeply felt response to painting. When, typically in furtherance of a scheme beneficial to the National

Gallery (a new French room), he parted with some of his favourite paintings in 1937, he wrote to Lady Aberconway:

. . . I didn't break the sad news to you that 'La Loge' went away from here [12 North Audley Street] on Tuesday. I thought it would make you sad, and at moments I felt like weeping myself. However, it fulfils a scheme which I have been working for from the beginning, so I must not repine now. The Van Gogh portrait & the Cézanne pot of primulas have gone too, & from the Institute, the big Gauguin, the Toulouse 'Jeanne Avril', the Van Gogh landscape, & the Gardener & the Lac d'Annecy of Cézanne. It should make a room unequalled anywhere, though not so easy to hang. . . .[25]

On a more general level, he wrote to her in March 1941:

Beauty to me of course is spiritual as well as physical and the most complete beauty must be both. I feel too that bodily beauty is closely and subtly linked with beauty of spirit. This feeling about beauty, and the need for it, are essential parts of me: unless women have beauty they are antipathetic to me in life as well as art: it is an ingrained prejudice. . . . What interests me most in writing – in any other art – is to try to get into touch with the mind of the artist, for this revelation of his own mind is the most interesting thing of his art. . . .[26]

This links up with Courtauld's *Pictures into Verse*, already referred to, but it does also suggest that he felt such revelations could only come after long contemplation of the work of art, aided by knowledge of the artist's life and historical context. One senses, too, that for Courtauld this process of communion was almost more an instinctive process than a coldly intellectual analysis.

Courtauld's munificence stimulated other benefactors to enrich the collections of the Courtauld Institute by gifts and bequests. In 1934, after his death and in accordance with his wishes, Roger Fry's family gave many of his paintings, Omega Workshops designs and West African sculpture to us. One of his two Bonnards, *A Young Lady in an Interior* (no. 45) is included in the exhibition. Courtauld's two friends, Lord Lee and Sir Robert Witt, who had worked with him to found the Institute, bequeathed their collections in 1947 and 1952 respectively. Lee's early Italian pictures and magnificent *cassoni*, were later to be handsomely complemented by Mark Gambier-Parry's bequest (in 1966) of his grandfather Thomas Gambier Parry's important pioneering collection of Trecento and Quattrocento pictures. Witt's old master prints and drawings collection, some 4,000 strong, as well as his photographic archive (now the Witt Library), was also to be complemented by Mr and Mrs W.W. Spooner's gifts and bequest of eighteenth- and early nineteenth-century English watercolours in 1967. A fine group of thirteen J.M.W. Turner watercolours, spanning the whole of his career, came to us in memory of Sir Stephen Courtauld (1883–1967, younger brother of Samuel) from his family.

Perhaps the most magnificent bequest, rivalling Samuel Courtauld's collection in quality, came to us from Count Antoine Seilern in July 1978. This was first put on public display at the Galleries, as the Princes Gate Collection, in July 1981. Count Seilern never wanted his name attached to his collection, yet it is of astonishing range and variety and reflects his personal taste in no uncertain manner. Its strengths lie in the early Flemish and Italian schools, in the thirty-two Rubens paintings and studies and the group of Tiepolo oil studies. He also admired Cézanne, Degas, Kokoschka, Manet, Pissarro, and Renoir, but these works, under the

terms of his will can only be lent once every five years, and since they were shown in Japan and Australia as recently as 1984, cannot be included here. His choice collection of some 300 drawings also ranges widely, from Mantegna and Hugo van der Goes to Delacroix and Picasso, with particular emphasis on Bruegel, Rembrandt, Rubens, and Tiepolo.

Gifts and bequests continue to come to the Courtauld. Recently, Lillian Browse, the former London art dealer, gave a group of works and signified her intention to bequeath the greater part of the remainder of her collection of late nineteenth- and early twentieth-century French and British paintings and sculpture, including fine examples of Degas, Sir William Nicholson, and Sickert, as well as contemporary artists. The late Alastair Hunter, a former Dean of St. George's Hospital Medical School, London University, bequeathed in 1983 a small but carefully chosen group of modern British paintings, including the early abstract *Painting*, 1937, by Ben Nicholson, and works by Sutherland, Hitchens, Keith Vaughan, John Hoyland, and a Picasso etching from the Minotaur suite. In the same year, Anthony Blunt, a former Director of the Courtauld, bequeathed his collection of architectural drawings, mainly French and Italian of the seventeenth century, a field in which he had himself made many distinguished scholarly contributions.

All these collections were formed by men and women of great discernment and knowledge; each of them bears the personal imprint of their collector. Seilern, in particular, combined connoisseurship with scholarship, backed by financial resources which, though considerable, were by no means unlimited. The collections thus form a unique and precious adjunct to the teaching activities of the Courtauld, as well as providing enjoyment to the general public. It had always been the intention of our founder and his friends that the Courtauld Institute and its collections should be housed under one roof. Part of Courtauld's collection hung in the principal rooms at Portman Square until 1958, when the new Courtauld Institute Galleries were opened at their present site in Woburn Square, within the main Bloomsbury campus of the University and above the Warburg Institute. Plans to build a new Courtauld Institute on a site adjoining the Galleries came to nothing, partly because of financial difficulties. The accommodation for the Institute is now quite inadequate to house the four specialist libraries and academic staff and students. The space at the Galleries allows us to exhibit barely 40 per cent of our collections, and study facilities are most inadequate. However, a solution to the problems has been found.

By 1978 the Fine Rooms at Somerset House, which form part of the North Block and overlook The Strand, had become available. The Fine Rooms, built by Sir William Chambers between 1776 and 1780, as part of a grand government office-development on the site of an old royal palace, housed the Royal Society, the Society of Antiquaries, and the Royal Academy of Arts who also, from 1780 until they moved to Burlington House, Piccadilly, in the mid-nineteenth century, held their annual summer exhibitions in the Great Room at Somerset House. We plan to move both the Courtauld Institute and the Galleries to the North Block of Somerset House by mid-1989.

Dennis Farr,
Director
Courtauld Institute Galleries

20. Coleman, *Courtaulds*, p. 212.

21. Blunt, in Cooper, *The Courtauld Collection*, pp. 6–7, quotes from Courtauld's unpublished essays written during the last years of his life.

22. David Robertson, *Sir Charles Eastlake and the Victorian Art World* (Princeton University Press, 1978), pp. 48, 49 n. 24. The original reference to the invitations appears in Eastlake's *Memoirs*, edited by his wife.

23. Coleman, *Courtaulds*, p. 215; information derived from his interviews with former associates of Samuel Courtauld.

24. Ibid., pp. 213–14, 218.

25. Letter dated 8 April 1937 (B.L. Add. MSS. 52433).

26. Letter dated 3 March 1941 (B.L. Add. MSS. 52434), quoted by Coleman in *Courtaulds*, p. 215.

As a group of paintings, the Courtauld Collection is the product of a particular historical situation, but this moment in the history of art collecting in the twentieth century is quite distinct from the contexts in which the paintings themselves were made, in the later nineteenth century. The collection includes paintings of different types which would never have been exhibited together at the time of their making, and no single collector in the nineteenth century would have assembled paintings by all of the artists represented in it.

It is this twentieth-century history that meets present day viewers in exhibitions like the present one, and in the Impressionist and Post-Impressionist galleries of great art museums. In a sense, of course, this is inevitable, since we are viewing them in the twentieth century, and with twentieth-century viewpoints and preconceptions. But this issue is more acute as far as Impressionism and Post-Impressionism are concerned than it is with any other movement from the art of the past, because they have, in the twentieth century, been so thoroughly dragged apart from their original contexts, and presented as cornerstones of a seemingly organic cultural tradition – often simply described as 'modern art'. This tradition is itself a twentieth-century construction.

There are, then, two quite distinct histories of Impressionism and Post-Impressionism to be written, firstly one which analyses the place that these works of art – their production, exhibition and sale (or non-sale) – occupied in the art practice of the later nineteenth century in France, and secondly a history which describes the emergence of this retrospective 'modern' tradition in the twentieth century, and unravels its bases and the interests it serves. These two histories cannot be absorbed into a single unproblematic history, as has been done in some of the most celebrated accounts of the period;[1] for the values of a particular present position cannot be applied uncritically to the elucidation of the past.

In this essay I want to outline some of the frameworks which seem to me to be central in the first of these histories: to consider the ways in which Impressionist and Post-Impressionist painting needs to be related to broader issues in the history of nineteenth-century painting. A number of recent studies have begun to tackle the art of the period from some of these viewpoints, and I will indicate the most important of these in footnotes. At the end, I will briefly indicate some of the key points in the second history, of Impressionism's emerging fame, and will consider the moment at which the two histories converged, around the turn of the century.

Fundamental to changes in French painting in the later nineteenth century were changing patterns of exhibition and sale. Increasingly professional and specialised art dealers were emerging, who sought to cater to the needs and tastes of an increasingly buoyant market for modern paintings among private collectors – not only French collectors, but an international phalanx of buyers who looked to the Parisian art market as the purveyor of artistic fashions. At the same time, the traditional dominance of the officially organised Salon came to be challenged, as artists found alternative means of exhibiting their pictures which better suited the smaller, more informal works which many buyers sought.

In discussions of Impressionism, much attention has been paid to the eight group exhibitions organised between 1874 and 1886, at the first of which the painters were christened the 'Impressionists'. But these exhibitions were only one symptom of the larger problem posed by the organisation of the Salon – a vast and multifarious exhibition, in which several thousand works were hung cheek by jowl in large and very tall spaces. Small pictures were at a disadvantage in these conditions; a few – but only the work of well known artists – were hung low on the walls, beneath the large pictures; otherwise they were scattered high and wide wherever they could be fitted. The (admittedly fictional) story of the painter Claude Lantier in Zola's novel *L'Oeuvre* (1886), searching through the Salon halls for his small painting of his dead child vividly dramatises this situation. Thus an unknown painter could best attract attention with a large and insistent painting. Yet there was a growing feeling that the rhetoric of grand painting, and the repertoire of subjects from past history and ancient mythology which the Academy favoured, were inappropriate to the modern world; moreover, such huge paintings could only be bought by the State or by a museum – few private residences could accommodate them. Smaller paintings, of traditionally less significant status, such as landscapes, everyday genre scenes and still life, stood little chance of making their author's reputation. It was such pictures which demanded smaller and more intimate exhibition spaces in order to gain notice. One such space was directed by Louis Martinet in the early 1860s; Manet showed many of his smaller paintings there, and in 1861 François Bonvin, specialist in genre scenes and still lives, wrote to Martinet: 'Yet another good mark for your idea of holding a permanent exhibition! That picture I brought you a week ago has just brought me to the notice of the ministry. Placed in the big exhibition, this canvas would not, perhaps, have

been noticed. *La peinture intime*, large or small, needs a setting like yours.'[2]

The smaller spaces of the Impressionist group exhibitions likewise allowed such smaller works to be seen; at the first exhibition in 1874, the works were divided according to size, with all the smaller ones below the larger. However, such installations were a far cry from the spacious hanging we are accustomed to from modern museums and exhibitions; although no images showing the installation of the group exhibitions have come to light, it is clear that pictures were still hung comparatively close to each other, and generally in at least two rows. Moreover, the works at the first show were hung on dull red material, which would have given an effect quite the opposite to that of the light-toned walls which until recently have dominated twentieth-century installations of Impressionist paintings. Such dark, warm walls were the norm in the later nineteenth century, and the painters would thus have anticipated a light-toned or brightly coloured canvas standing out as the most vivid thing in its surroundings, whereas light walls tend to dull and deaden their effect.[3]

Concentration on the group exhibitions has tended to obscure the fact that, into the 1880s at least, the Salon remained by far the most significant outlet for modern art in Paris. Historians have sometimes been puzzled by Edouard Manet's refusal to join with his friends in the group exhibitions, yet his decision made absolute sense for two reasons: both because he could reach a far larger public through the Salon, and because he continued to put his greatest efforts into a small number of ambitious pictures each year, works large enough in scale to be noticed at the Salon. The Courtauld Collection includes one of the last and most remarkable of these, *A Bar at the Folies-Bergère* (no. 3), shown at the 1882 Salon; this is the only Salon painting in the collection, and was thus designed to be seen in circumstances quite different from all the other paintings which now hang around it. When the critic Théodore Duret urged Camille Pissarro in 1874 not to join in the group exhibition, he was offering sound practical advice, which the comparative financial failure of the group exhibitions proved to be valid; he wrote:

> Among the 40,000 people who, I suppose, visit the Salon, you'll be seen by fifty dealers, patrons, critics who would never otherwise look you up and discover you. Even if you only achieve that, it would be enough. But you'll gain more, because you are now in a special position in a group that is being discussed and that is beginning to be accepted, although with reservations. . . I urge you to exhibit; you must succeed in making a noise, in defying and attracting criticism, coming face to face with the big public. You won't achieve all that except at the Salon.[4]

Recent research has shown that the group exhibitions were received far more positively by contemporary critics than has generally been acknowledged.[5] Many applauded the attempt to create an alternative forum to the Salon, and even the more critical accounts mostly showed a real understanding of what the painters were seeking. The satirical tone of some reviews, such as Louis Leroy's celebrated account of the 1874 show in which he christened the painters as Impressionists, does not reveal a total hostility to their efforts; such humour was often used to heighten the vivid, polemical tone of the best of nineteenth-century art criticism, and to draw out the distinctive and novel qualities of the works under discussion. In order to see how these conventions of art criticism operated, the discussions of the group shows need to be analysed in relation to the patterns of contemporary writing about the Salon exhibitions.

The eight group exhibitions were presented as a single, numbered

1. Most notably, in John Rewald's *The History of Impressionism* (1st ed., New York, 1946) and *Post-Impressionism* (New York, 1956); on these, *cf.* John House, 'Impressionism and History: The Rewald Legacy', *Art History*, September 1986.

2. Letter from Bonvin to Martinet, 22 April 1861, in E. Moreau-Nélaton, *Bonvin raconté par lui-même* (Paris, 1927), p. 58.

3. On the 1874 installation and the other group exhibitions, see *The New Painting: Impressionism 1874–1886*, exhibition catalogue, The Fine Arts Museums of San Francisco, 1986.

4. Letter from Duret to Pissarro, 15 February 1874, in Rewald, *Impressionism* (1973 edn.), p. 310. The attendance figure mentioned, 40,000, is far below actual attendances recorded at the Salon.

5. See *The New Painting* (cited in n. 3); for reprints of the principal critical articles on the 1874 show, see *Centenaire de l'impressionnisme*, exhibition catalogue, Grand Palais, Paris, 1974 (English version, Metropolitan Museum of Art, New York, 1974).

sequence, yet they were very varied, both in who took part, and in the ways they were organised. The artists generally regarded as the core of the group – Monet, Renoir, Pissarro, Sisley, Degas, Morisot and Cézanne – only appeared together twice, in 1874 and 1877; and the sixth and eighth shows, in 1881 and 1886, were particularly remote from the first; the seventh, in 1882, brought many of the original group together again, but in another way it was crucially different from the rest, since it was virtually a dealer show – mounted and substantially selected by Paul Durand-Ruel.[6]

In another important respect, too, the exhibitions did not present a homogeneous image. From the start they showed paintings of varied status – occasional large pictures of a scale which suited the Salon, and mainly smaller pictures; but these smaller pictures included works of two quite distinct types: rapid and seemingly informal sketches, and more elaborated paintings, of the sort which by then were the stock-in-trade of art dealers such as Durand-Ruel. Both of these types were unsuitable for the Salon, but they had distinct histories, and the fact that they were brought together on the walls of the group exhibitions is of considerable importance for understanding the genesis of Impressionism.

Pictures painted for dealers were already a well established commodity. In many artists' work in the 1850s and 1860s there is a clear distinction between Salon paintings and smaller pictures intended to be sold through the trade to private collectors. This can be seen particularly clearly in the case of Millet, whose *Angelus* (later to become the icon of French peasant painting) was originally painted in 1857–9 for direct sale to a collector, not for immediate exhibition; it is smaller and less highly finished than his contemporary Salon pictures.[7] Among the associates of Monet in the 1860s, both Jongkind and Boudin were making their living from such pictures, mostly sold through dealers such as *père* Martin, and the canvases which Monet, Pissarro and Sisley sold to Durand-Ruel in the early 1870s fall into the same category. Renoir's *La Loge* (no. 14), the only painting in the Courtauld Collection that was shown in the first group exhibition in 1874, is typical of these dealer pictures; Renoir sold it to Martin in 1875 for the comparatively high price of 425 francs.[8] Such pictures continued to appear in all the group shows. Indeed it is probably no coincidence that the painters took the final decision to embark on their own shows at the moment that Durand-Ruel was forced by financial constraints to stop buying their work; they needed another outlet for such pictures once Durand-Ruel's extensive purchases of 1872–3 ceased.

All the early shows also included more informal sketches. Often these were subtitled *étude* (study) or *esquisse* (sketch), in order to indicate their status, and the label *impression*, added by Monet to the title of his *Impression, Sunrise* at the 1874 exhibition, carried many of the same implications; the word *impression* was already in wide circulation among artists to refer to rapid notations of atmospheric effects. Though this title led to the christening of the group, the picture itself was not typical of those shown in the exhibitions; however, the subsequent reputation and public image of Impressionist painting has viewed this canvas as the archetypal product of the group.

Such sketches also belonged to a tradition with a long history. At least since the eighteenth century certain particularly 'artistic' collectors had favoured paintings of this type, as can be seen from the sale catalogue of Varanchan de St. Geniès of 1777: 'This collection would appear to be that of a rich artist with good taste rather than of a collector. . . Though finished paintings are more generally popular, a certain class of collector rejoices particularly in a single sketch; he looks for the soul and the thoughts of the man of genius whom he can see and recognise.' In 1876, Duranty, a close associate of the group, described the Impressionists' de-

cision to show sketches in their exhibitions in very much these terms; of the collections made by the principal early patrons of the group, those of Victor Chocquet and, particularly, their fellow painter Gustave Caillebotte fall into the category of 'artistic' collections of men who appreciated the immediacy and expressiveness of the sketch.[9]

All too often, though, such notions of immediacy and expressiveness, of sketches revealing 'the soul and the thoughts of the man of genius', have been taken at face value. But of course brushstrokes on canvas involve a complete imaginative transposition, and it is only on the basis of agreed conventions of representation that they can be seen as recreating an individual's experience of the world – let alone his or her 'soul and thoughts'. No representation in paint is 'natural'; all alike demand historical analysis, to reveal the conventions that underlie them. This is most crucial with types of art such as Impressionism, which have come to be seen as direct, unmediated images of reality. At times the Impressionist painters themselves fostered this idea; Monet declared that he would like to paint 'like the bird sings'; but such aspirations too have to be examined historically, as a rejection of the dominant artifice of Neo-Classical Salon painting, in favour of a type of art whose technique evoked immediate experience. Moreover, their first viewers did not find their art 'natural'; it is only more recently that Impressionist visions of nature have come to be accepted as the norm for 'natural' vision in the west.

The unquestioning acceptance of their vision as natural has had a further implication, by disguising the polemical intent with which it was originally conceived. In its early years, the Impressionists' manner of painting, along with Manet's, was widely regarded as politically radical or subversive, since it challenged traditional hierarchies of representation. Their brushwork, according all objects in the scene approximately equal significance, challenged the centrality of the human figure in the world, and the groupings they chose often presented a complex interplay of elements which prevented any clear-cut reading of the relationships depicted. The uncertainties enshrined in the physical make-up of Manet's *A Bar at the Folies-Bergère* (no. 3) are an important example of this.[10] The historian must examine the original contexts in which the pictures were seen, and their viewers' expectations, in order to understand the reasons for the initial shock they caused, rather than accepting their 'naturalness' uncritically.

It is here that a historical study of Impressionist painting technique becomes essential, both in relating the Impressionists' development of a sketch-like technique to a longer tradition that put a premium on such a sense of immediacy, and in studying in detail the ways in which their technique emerged, in relation to the accepted modes of representation at the time. It was in relation to the niceties of academic finish that their technique signalled their originality and their independence.[11] But at the same time the boldness of some of their paintings must be seen alongside the more tempered, carefully resolved treatment of the pictures they sought to put into the market through dealers; all their works alike need to be considered in relation to their potential public outlets. Even Cézanne, whose private means largely freed him from the need to sell his work, needs to be considered in these terms; for it was his financial independence which allowed him to wrestle so unremittingly with the problem of transforming his experiences of nature into a resolved pictorial form, and also to develop a reputation as a mysterious genius whose works were known only to the chosen few. It was only at the very end of his life, and far more after his death, that this studiedly private art found a wider public, and became for the twentieth century an archetype of solitary creative individualism.

Impressionist and Post-Impressionist art as a whole has become a paradigm of such individualism, but again this notion must be examined critically. The eighteenth-century promotion of paintings which expressed 'the soul and thoughts of the man of genius' must be related to changing notions of human (male) individualism at the time – notions which the Impressionist generation inherited; and our present-day glorification of these individuals – enshrined in collections like Courtauld's and in the galleries of great museums – demands analysis in relation to the very high premium put on individual human agency in modern western culture. These are matters for historical investigation, not unquestioning acceptance.

In recent years, much attention has been paid for the first time to the subjects the Impressionists depicted, and in particular to their fascination in the 1860s and 1870s with the changing landscapes of the environs of Paris.[12] This has served to emphasise their active engagement with the specifics of their surroundings, and has quashed the myth that they just painted the scene nearest to hand. But at the same time it has proved difficult to pin down any real consistency in the visions they presented. Monet's depictions of Argenteuil are an example of this, for they show the place in many different guises, even in a single year. A small country town and agricultural centre about eight miles north west of central Paris, it was being transformed by encroaching industrialisation, and had also become a centre for recreational sailing.[13] Sometimes Monet emphasised one aspect of the place, sometimes another; sometimes modernity dominates, while in other pictures, such as no. 11, there is scarcely a hint of the changes in the place. Likewise his friends showed varied facets of the place when they painted there, such as Manet in no. 2. Certainly this diversity echoes the historical situation in the area around Paris, but the pictures cannot be seen simply as passive reflections of social reality. As paintings, they belonged in a specific context, on the walls of exhibitions or in the stock of dealers in Paris, and their original audiences would have received and classified them in relation to contemporary categories of landscape painting, not by reference to the 'facts of life' at Argenteuil itself, about which many who saw them would have known little. Thus they were primarily contributions to metropolitan debates about city, suburb and country, rather than historical documents about the places depicted. The information culled by the social historian must be complemented by analysis of the function of the pictures as representations – as images which themselves generated beliefs and opinions, and orchestrated discussion.

These issues come clearly into view in discussion of Gauguin's paintings. For many years it has been clear that his images of Tahiti were not accurate images of South Sea island life, but rather visions created firmly within traditional notions of, and fantasies about, the primitive and the exotic.[14] Nevermore and Te Rerioa (nos. 40–1) both relate closely to the imagery of Orientalist painters of the mid-nineteenth century, translating into an Oceanic milieu the imagery of sensuous reverie and of awakening sensuality which had been the stock-in-trade of western images of the middle-eastern harem. Gauguin's trip to Tahiti, and the richness of his synthesis of a wide range of cultural traditions, reinvigorated this tradition, but its underlying dynamic remained largely unchanged, in its deployment of the image of non-western races to fuel debates about modern western society. To the western painter, as to the western viewer of his paintings, these images of indolence and sensuality presuppose the availability of these peoples – whether through economic or military domination – to satisfy western dreams of the 'other'.[15]

In his paintings of Brittany, too, Gauguin stressed the otherness of its inhabitants, presenting their life and labour as if they were hieratic ritual

6. Durand-Ruel also staged the 1876 show, but had little commercial involvement in it, in contrast to the situation in 1882; see *The New Painting* (cited in n. 3).

7. See *Jean-François Millet*, exhibition catalogue by R.L. Herbert, Grand Palais, Paris, 1975–6, no. 66; the *Angelus* can be contrasted with the virtually contemporary *Woman Pasturing her Cow*, shown at the 1859 Salon (*Millet* exhibition, no. 67).

8. For Jongkind's letters to Martin, see V. Hefting, *Jongkind d'après sa correspondance* (Utrecht, 1969); for Durand-Ruel's reminiscences, see L. Venturi, *Les Archives de l'impressionnisme* (Paris, 1939), vol. II; for the early history of *La Loge*, see *Renoir*, exhibition catalogue, Arts Council of Great Britain and Museum of Fine Arts, Boston, 1985–6, no. 26. The current monetary equivalents of nineteenth-century money are notoriously hard to estimate realistically. In relation to average salaries, one French franc of the 1870s is very roughly equivalent to $1.50 – $2 at 1986 values (or £1 – £1.25).

9. The Varanchan sale catalogue, quoted in J. Wilhelm, 'The Sketch in Eighteenth Century French Painting', *Apollo*, September 1962, p. 520. Duranty's essay *La Nouvelle Peinture*, reprinted and translated in *The New Painting* (cited in n. 3), this passage p. 483 (translated on p. 46); much of Caillebotte's collection entered the Musée du Luxembourg, and is now in the Musée d'Orsay, Paris (see n. 21).

10. On the political associations of Impressionist painting, see the essays by Stephen Eisenman and Hollis Clayson in *The New Painting* (cited in n. 3); for discussion of Manet in this context, see T.J. Clark, *The Painting of Modern Life* (London, 1985) and John House, 'Manet's Naïveté', in *The Hidden Face of Manet*, exhibition catalogue published in *Burlington Magazine*, April 1986, pp. 14–17.

11. For a valuable discussion of the 'technique of originality' see Richard Shiff, *Cézanne and the End of Impressionism* (Chicago, 1984); on the relationships of Impressionist technique to academic practice, see Albert Boime. *The Academy and French Painting in the Nineteenth Century* (London, 1971), though the links are somewhat oversimplified here, and John House, *Monet: Nature into Art* (London and New Haven, 1986), pp. 157–66.

12. e.g. R.L. Herbert. 'Industry and the Changing Landscape from Daubigny to Monet', in J.M. Merriman (ed.), *French Cities in the Nineteenth Century* (London, 1982); Paul Tucker, *Monet at Argenteuil* (London and New Haven, 1982); *A Day in the Country*, exhibition catalogue, Los Angeles County Museum of Art, 1984; and T.J. Clark, *The Painting of Modern Life* (London, 1985).

13. See Tucker (cited in n. 12).

14. See Bengt Danielsson, *Gauguin in the South Seas* (London, 1965).

15. For discussion of these stereotypes of the Orient, see Edward Said, *Orientalism* (New York, 1978) and Linda Nochlin, 'The Imaginary Orient', *Art in America*, May 1983.

rather than real physical toil (e.g. no. 39). By the time that Gauguin painted there, Brittany was expanding economically,[16] but it was in Paris that his images of the place had their currency; there, the place retained its image as a repository of traditional beliefs and folklore – of the values which urbanisation was putting under threat. Gauguin's evocations of Breton simplicity were the antithesis of the complexities and uncertainties of dominant city culture.

Gauguin was not the first to reject the landscapes of modernity of the Paris region. By the early 1880s most of the original Impressionist group had also turned away from such subjects, seemingly disillusioned with the possibility of producing an imagery of modern landscape; Monet's focus on the dazzle of Mediterranean light at Antibes (no. 13) is one example of this withdrawal. This change cannot be discussed by reference to the group alone; emphatically modern landscape was by 1880 playing a more prominent part in the Salon exhibitions, in the work of painters like Antoine Guillemet and Luigi Loir, who were producing the large-scale *tableaux* of the modern scene which the Impressionists' friend and erstwhile supporter Emile Zola had long been advocating. The Impressionists themselves moved in various directions – Pissarro to a more idealised, unspecific vision of peasant life, Renoir to a greater sense of tradition and classicism (e.g. no. 16, a very late work), Sisley and especially Monet to a preoccupation with effects of weather and atmosphere. Common to all of their positions was a search for some sort of unity, whether found in the subject depicted or in the atmospheric effect which cloaked it, in contrast to the diverse elements characteristic of many of their landscapes in the 1870s (e.g. nos. 5 and 18). Even when Pissarro did paint urban subjects at Rouen in 1883 (no. 6), the whole scene is absorbed in a unifying light effect.

There is no simple, clear-cut explanation for this change. It is certainly relevant that their dissatisfaction with modern imagery coincided with a degree of disillusionment with the results of their group exhibitions, and a fresh attempt to find a steady market through art dealers; from 1880 onwards, Durand-Ruel was able to buy again, and bought extensively from Monet, Renoir, Pissarro and Sisley. His intervention certainly encouraged them to finish their canvases more fully,[17] and may have affected their choice of subjects. Many of Monet's pictures of the 1880s, in particular, show subjects that were becoming celebrated through tourism – Antibes, for instance, was already an expanding resort.

However, such an explanation is not adequate in itself. The Impressionists' change of direction was only part of a wholesale reassessment during the 1880s of the position of avant-garde painting in France, and this needs to be explored from various angles. One crucial change in the decade was the proliferation of alternative exhibition outlets; some of them were through dealers, such as Georges Petit's *Expositions internationales*, but the most important was the foundation of an annual jury-free exhibition, organised by the Société des Indépendants, at which all submitted works were shown. It was here that Seurat and his fellow Neo-Impressionists, and also Vincent van Gogh, found an outlet for their work. Its importance was that it provided a forum for art of any sort whatsoever; before its institution, a self-taught amateur such as Henri Rousseau (e.g. no. 42) would have had no chance at all of reaching an audience. Broadly speaking, the aims of the Indépendants were anti-authoritarian, and closely in line with the tenets of contemporary anarchist politics, which played a major part on the political left in France in the 1880s and 1890s; in these years, the Anarchists were not a marginal group, and their ideas provided a focus for many of the most crucial issues facing the artistic avant-gardes, about the role of art in modern society. Camille Pissarro was committed to a form of non-violent humanitarian anarchism, and many of Seurat's closest associates were anarchist sympathisers, though Seurat's own political position remains ambiguous.

In one sense Seurat and his colleagues occupied the same position in the later 1880s as the Impressionist group had in the 1870s. Their technique, of treating the whole picture surface with equally weighted dots of colour, was often viewed as politically radical, since its homogeneity challenged the traditional focus on the human subject, and they espoused the imagery of modern Paris and its suburbs as the Impressionists had fifteen years before (see Seurat nos. 34 and 36). However, particularly in Seurat's later work, such as *Young Woman Powdering Herself* (no. 36), there is a clear shift against the ostensible naturalism of Impressionist pictures such as Renoir's *La Loge* (no. 14), in favour of a degree of schematisation which decisively sets the work of art apart from perceived reality. This change is in line with the tenets of the emerging Symbolist movement, with its rejection of naturalism in favour of types of art which sought to express the essence, or underlying idea, of the chosen subject.

In general histories of the art of the 1880s, this change has been described in terms of the replacement of Impressionism by 'Post-Impressionism' as the vanguard movement in Paris. But this formulation raises great problems. The term Impressionism itself had no clear unitary meaning at the time. As Henri Houssaye wrote in 1882: 'Impressionism receives every form of sarcasm when it takes the names Manet, Monet, Renoir, Caillebotte, Degas – every honour when it is called Bastien-Lepage, Duez, Gervex . . . or Dagnan-Bouveret.' In 1888, Van Gogh was able to say that he still considered himself an Impressionist 'because it professes nothing and binds you to nothing', though elsewhere he said that his own increasing preoccupation with expressive colour might not find favour with the Impressionists.[18] Indeed, the term Impressionist, loosely used, remained the most widely used broad category for modern French painting into the early years of the twentieth century. 'Post-Impressionist', by contrast, had no contemporary sanction, being the creation of a rather unconvinced Roger Fry, seeking a title for the exhibition he mounted in London in 1910; its apparent homogeneity has always raised difficulties, given the diversity of the art it encompasses (Gauguin, Van Gogh, Seurat, and at times Cézanne, despite his presence in the early Impressionist exhibitions). Certainly, the history of the use of the term 'Impressionist' has much to tell us about artistic debates in the 1880s, alongside the titles proposed at the time for alternative avant-garde groupings (Symbolist, Synthetist, Neo-Impressionist and so on), but these terms must be seen as focuses for discussion, in relation to which different groups negotiated their own positions, rather than as summing up any 'real' characteristics of the art under discussion.

The issues which I have so far raised seem important to the writing of a history of Impressionism. The resulting history would not be a clear-cut sequential narrative of the development of a movement, but would focus on the varied relationships between the production of art and its exhibition, critical reception and sale; such a history will only be possible if notions of linear development in modern art, of one vanguard superseding another, are abandoned, in favour of a more wide-ranging analysis of the ways in which groupings of young artists negotiated their positions within the dominant frameworks of the Parisian art world at the time. The historical significance of the Impressionists' group exhibitions, and of the works they showed there, can only be understood through a thorough analysis of the position of the Salon and of other institutions at the time.[19]

Much important work has recently been done in these areas, but the overall task is still impeded by the seminal role accorded to Impressionism and Post-Impressionism as cornerstones of the modern tradition. Two

major recent exhibitions have proposed significant reassessments of the period, but both have failed to present the necessary wider perspective because of strong institutional pressures that they should be 'impressionist' exhibitions, without the addition of the needed comparative material.[20] The Courtauld Collection of course belongs to this same framework, since the collection itself is the product of this modern tradition, in its most exclusive form. It is here that we have to move from the first type of history of Impressionism to the second – to the emergence of the modern tradition in the twentieth century.

Only the briefest indication of this can be given here. There seem to be two distinct strands to the story, which only came together after the Second World War. The first of these was the gradual assimilation of Impressionism into the official French notion of the French artistic tradition; the second was the evolving modernist aesthetic, with its prime emphasis on essentially pictorial qualities as the defining characteristic of true modern(ist) painting.

Impressionist painting first found an accepting market in the United States, in the decade after the big exhibition mounted by Durand-Ruel in New York in 1886; it was largely through American buyers that prices for Impressionist paintings – initially primarily Monet and Renoir – boomed in Paris. But during the 1890s French collectors and the French authorities began to take them more seriously. The French government bought an important recent painting from Renoir in 1892, but between 1894 and 1896 the acceptance of Caillebotte's bequest of his collection to the State still produced great controversy, before a large part of it entered the State modern art museum, the Musée du Luxembourg, in 1897.[21] Impressionist paintings were included in the French section of the 1900 Paris Exposition Universelle, but only after argument, and only in the retrospective section, not in the display of the art of the last ten years.

In the gradual emergence of Impressionist painting, the director of the Musée du Luxembourg, Léonce Bénédite, seems to have played a major part, both through his writings and through exhibitions he mounted. One little-known show that he put on at the Musée du Luxembourg may have been a significant step in this process of assimilation; this was the *Temporary Exhibition of Masterpieces by Contemporary Masters* from private collections, under the aegis of the Society of Friends of the Luxembourg in spring 1904, in which even Manet's controversial *Nana* was shown, together with works by Monet, Renoir, Pissarro, Degas and Sisley, and leading academic masters of the period. It was shortly after this that the first book appeared which presented the development of modern art as a series of successive movements in which Impressionism played a decisive part; it even discussed the soon-to-be-christened Post-Impressionists in a section titled 'Pantheist and Living Art'. This was André Fontainas's *Histoire de la peinture française au XIXme siècle* of 1906. In the same years, too, major retrospectives of Van Gogh, Gauguin, Seurat and Cézanne, mounted by the Société des Indépendants and the recently formed Salon d'Automne, brought their art before a wider public. The writings of the much-translated German critic Julius Meier-Graefe also had a major influence on these changing views.

The comparatively late acceptance of Impressionism by French collectors produced an intriguing anomaly in the French national collections, in comparison with the major American museums. The American collectors, from the late 1880s onwards, bought mainly very recent pictures; thus the residue of collections such as those of H.O. Havemeyer and Mrs Potter Palmer has left American museums particularly rich in later Impressionist pictures, of the 1880s and 1890s. French collectors, though beginning to buy around a decade later, focused primarily on earlier paintings – paint-

16. See Fred Orton and Griselda Pollock, 'Les Données bretonnantes: la Prairie de la Représentation', *Art History*, September 1980.

17. See for instance letter from Monet to Durand-Ruel, 3 November 1884, in Daniel Wildenstein, *Monet, biographie et catalogue raisonné*, II (Lausanne and Paris, 1979), letter no. 527. The implications of the relations between the Impressionist painters and their dealers need to be explored more fully.

18. Houssaye, quoted Rewald, *Impressionism* (1973 edn.), p. 476; letters from Vincent van Gogh to Theo van Gogh, c.17 September and 11 August 1888, in *The Complete Letters of Vincent van Gogh* (London, 1958), letter nos. 539 and 520.

19. From this point of view, the two most serious and far-reaching histories of French nineteenth-century painting were published in 1889 and 1931: C.H. Stranahan, *A History of French Painting* (London, 1889) and J.E. Blanche, *Les Arts plastiques, la troisième république, 1870 à nos jours* (Paris, 1931). The only book to discuss the Impressionists in the context of the contemporary art market remains H.C. and C.A. White, *Canvases and Careers: Institutional Change in the French Painting World* (New York, 1965).

20. *A Day in the Country* (cited in n. 12) and *The New Painting* (cited in n. 3); the arguments of both – the first about imagery, the second about exhibiting institutions – would have gained so much in historical insight if they had included discussion of the Salon and the works exhibited in it.

21. For the purchase of Renoir's *Young Girls at the Piano*, see *Renoir* (cited in n. 8), nos. 89–91; for the Caillebotte bequest, see Pierre Vaisse, 'Les Legs Caillebotte d'après les documents' and Marie Berhaut, 'Le Legs Caillebotte, Vérités et contre-vérités', both in *Bulletin de la Société de l'Histoire de l'Art Français*, 1983 (published 1985).

ings whose place in the French tradition was already comparatively secure. Of the few pioneer collections bought from the painters in the 1870s, only Gustave Caillebotte's was even in part given to the State; the other groups of pictures which contribute to the unique early Impressionist holdings of the Musée d'Orsay were assembled in retrospect, when the painters' stock was assured – they were mainly made, indeed, in the years in which Bénédite was promoting Impressionism so strongly. It was, again, early Impressionist painting which the French State primarily promoted in the years after the painters' deaths, for instance in the major series of retrospective exhibitions organised by the Musées Nationaux in the 1930s; this was particularly evident in the 1933 Renoir show, which gave scant notice to the painter's last works, which had aroused such interest among young artists when shown at the Salon d'Automne in 1920, shortly after Renoir's death.

However, during the same years, Impressionism's role in the modern movement was ambivalent. It was largely bypassed in the pioneering presentations of the modern tradition, from Roger Fry's *Manet and the Post-Impressionists* of 1910 to the formative policy of the Museum of Modern Art, New York, from 1929 onwards. The Impressionists' preoccupation with nature – with light and atmosphere – seemed to neglect painting's crucial concern with its own means, whereas Manet's concern with the *tache*, the patch of colour, could readily be assimilated into the modernist viewpoint. The genesis of this way of seeing paintings has to be traced back, through Maurice Denis's celebrated insistence on the primacy of the flat pictorial surface in 1890, to Zola's discussion of Manet's use of the *tache* in 1867. But, once again, the earlier writers cannot simply be subsumed within later priorities; both Denis and Zola demand to be discussed in relation to the debates current at the moment when their essays appeared, and in each case this emphasises their distance from the mature 'modernist' position of the twentieth century.[22]

Courtauld's collection, largely formed in the 1920s and 1930s, occupies an intriguingly anomalous position between these two versions of the modern tradition; its balanced, yet notably diverse, group of fine and mainly early works by the principal Impressionists allies it with French official taste, whereas its outstanding Gauguins, Seurats and particularly Cézannes relate closely to the viewpoint which Roger Fry was propounding at the time and, as Dennis Farr's essay in this catalogue shows, Courtauld knew Fry's writings well, and very probably knew him personally.

These two strands of the modern tradition seem to have been brought together only in 1946, with the appearance of John Rewald's remarkable book *The History of Impressionism*, published by The Museum of Modern Art, New York, the prime promoters of the modernist tradition. It was in the late 1940s, too, that the writings of critics such as Clement Greenberg assimilated Monet's late paintings, notably his *Water Lilies*, into their presentation of this tradition. Rewald's book was followed by his *Post-Impressionism* in 1956; this marked the final acceptance of Fry's awkward term, which until then had not become firmly established. In his two books, both Impressionist and Post-Impressionist painters are presented as pioneers of a new vision, leading ever forward, while the contemporary contexts which gave their enterprises their point and significance are treated merely as the dead wood of reaction.

This essay has described two histories of Impressionism which might be written. In time, closer analysis of these questions will make us see more clearly what the Impressionists' art signified on its appearance in Paris in the 1860s and 1870s, and also how their paintings subsequently contributed to the emergence of the modern tradition. But we must not allow these two very different stories to be assimilated into a single, unproblematic account.

22. Maurice Denis, 'Définition du néo-traditionnisme' (1890; reprinted in *Théories*, Paris, 1910); Zola, 'Edouard Manet' (1867; reprinted in *Mon Salon, Manet, Ecrits sur l'art*, ed. A. Ehrard, Paris, 1970); on the latter, *cf.* House (cited in n. 10), pp. 8, 14, 17.

Robert Bruce-Gardner,
Gerry Hedley,
& Caroline Villers

Impressions of Change

In 1983, for the first time collectively, the paintings of the Courtauld Collection were thoroughly documented and examined in the Department of Technology in order to assess and prepare them for a major loan exhibition. The cumulative observations have, it is hoped, helped to clarify three main and inter-related areas: firstly, the condition of the painting, which is primarily concerned with its stability, but also alludes to its technical history; secondly, the techniques employed, the materials and their application, which call for the exploration of the enormous diversity, not only of those artists embraced by the term Impressionism, but of individual painters within the context of their own oeuvre, and even in a single masterpiece; and finally, the working methods, and the attempt to chronicle the evolution of a particular composition, with its insights into the artist at work, based upon the technical evidence gleaned.

The methods of examination, predominantly routine, included X-radiography, inspection in infra-red and ultra-violet fluorescence, surface microscopy and, occasionally, paint cross-sections, yet the value of scrutinising an unframed painting in good light and at close quarters was never underestimated. Used in conjunction with documentary sources, these methods can assist in re-presenting the painting, in allowing the opportunity to understand not only how the painting was executed but even to imagine how it might have appeared at the moment of completion, bearing in mind the factors that contribute to the way we see it today.

Perceptions of Change

It is well established that an old master painting will have altered significantly with the passage of time; it is either self-evident or, even in the case of a recently cleaned and thoroughly restored painting, an assumption that the observer has been encouraged to make. Less familiar, however, is the cautionary notion that Impressionist paintings are also to be viewed as an approximation and sometimes even as a distortion of the way that they appeared on completion barely a century ago.

It is perhaps the association with their comparative modernity that diverts the attention from the less developed and obvious changes that have nevertheless occurred; and when these changes are assessed in the context of the importance put upon the Impressionist technique by the artists themselves in pursuit of their goals, and by ourselves in our attempts to appreciate and evaluate them, they assume major significance.

There are two main agencies responsible. Over the years there are the more natural consequences of the physical and chemical inter-reaction of the structure of the painting, both internally and with the environment in which it has been kept; and secondly, often more critically, there are factors that can be described as human intervention. The first category would include the familiar threats posed by dimensional fluctuations, instability or natural deterioration of constituent and perhaps incompatible materials, or the fading of certain pigments on prolonged exposure to light, a phenomenon that can be noted in Gauguin's *Haymaking* (no. 39), atmospheric pollution also takes its toll and, as well as contributing to the degradation of the canvas and exposing some pigments, such as cadmium, to chemical action, it is partially responsible for changes to the appearance of the ground – one of the most subtle but significant changes to occur in Impressionist paintings.

The colour and texture of the ground layer has always had, but in varying degrees, a significant effect upon the optical and behavioural properties of the paint applied over it; but never had it played such an integral and crucial rôle as it was to assume in the Impressionist movement. In almost every painting in the collection the exposed or thinly veiled ground can be discerned; it plays a part, either in the ability to impart luminosity to the even and thin paint of Rousseau's *The Customs Post* (no. 42) and the glazes and scumbles of Toulouse-Lautrec's idiosyncratic execution of *The Tête-à-Tête Supper* (no. 44), or assumes an independent tonal value and hue, not so much in affecting what is to lie over it, but what is to lie adjacent to it. As can be seen in Sisley's *Boats on the Seine*, the ground had become an over-all and unifying element, and, knowing that it was to be incompletely covered, the Impressionists made an acutely conscious choice.

By the latter half of the nineteenth century, commercially prepared canvas was readily available, offering a range of standard sizes, and a variety of weaves and grounds; although the tinted grounds extended from light to almost mid-tone, most were predominantly within the myriadic variations of white. Some artists applied a second ground, either locally, as in Sisley's *Snow at Louveciennes* (no. 17), where only the leaden sky is painted over a light warm pink, or over the entire surface, to modify its value to one more suitable, as in Manet's *Le Déjeuner sur l'herbe* (no. 1), Renoir's *Portrait of Ambroise Vollard* (no. 15) and the second, grey ground of Modigliani's *Nude* (no. 48); or another ground may have been required to create a more absorbent underlayer as seems to be the case in Seurat's *Young Woman Powdering Herself* (no. 36).

There are instances in which the artist prepared his own ground. Cézanne's *Man with a Pipe* (no. 27) lies on a ground that includes traces of an arbitrary range of pigments and aggregates which points firmly to its preparation in the studio, while for *Te Rerioa* (no. 41) and *Haymaking* (no. 39) Gauguin's grounds – the coarse open texture of the former, and the chalky absorbency of the latter – create the surface he sought, and allowed the retention of the dry, flat handling of the brushstrokes that dominate the images.

Not only is it likely that these carefully selected or especially prepared grounds will have imbibed a considerable amount of air-borne surface dirt, particularly those more absorbent ones, and so become muted and deadened, but it is also likely that the lead constituent in the white of the ground may have been affected and darkened during inter-reaction with atmospheric pollutants. The difficulties implicitly encountered in any attempt to describe accurately the colour of a ground in isolation from the surrounding or overlying paint are thus further compounded; any observations must necessarily relate to a description of what we see now rather than any unqualified assumptions of the original state.

The most expedient protection so frequently offered against such pollution is a layer of varnish, but this is itself an agent of change, both immediate and, in some cases, striking, for it can transform not simply the appearance but, *in extremis*, the visual language of a painting. The decision, taken by anyone but the artist, to varnish a painting is the first and most obvious of the human interventions.

The reason for varnishing the works as a means of protection may have been compelling, but we know that this has been done expressly against the wishes of the majority of artists represented in this collection, for many of them stated that they preferred that their paintings be glazed rather than varnished; this directive seems, before long, to have been largely ignored. The responsibility for the appearance of a painting soon fell to the art market; firstly to those specialist dealers who sought to promote Impressionism and who often knew the artists and their wishes intimately, and then in turn to the collectors, and, ultimately, to institutions, as museums and galleries began to acknowledge their importance. It could have been as an oblique consequence of the well-known plea for 'more finished pictures' that such a step as varnishing was taken.

Gauguin was not alone in his concern about the way in which his paintings should be displayed, and his letters to his dealer Daniel de Monfried contain references not only to the waxed surface he thought appropriate in some instances, but to the plain wooden battens that should form the frame of particular compositions, that they might appear flat, 'like a mural'. Even if his instructions were followed, they were probably quickly superseded and the paintings placed in the ornate gilt frames that are now so familiar as the inseparable adjuncts to Impressionist and Post-Impressionist art. The same fate befell the works of Seurat, whose equal concern for the completeness of the exhibited image can be seen in, for instance, *Young Woman Powdering Herself* (no. 36), where the margins have been painted in considered colours and tones which would have served as the transition of the composition to its immediate surroundings.

The immediate effect of all but the thinnest varnish is to saturate and deepen the hues, to darken the tones and homogenise the surface with a uniform gloss. Where the artist had used an absorbent ground and perhaps a paint with some of the oil drained from it, the effects created with lean matt-strokes or almost sculpted impasto – that were exploited to render and record the rich and complex textures and sensations derived from nature – could at once be subdued or negated by a coat of 'unifying' varnish.

Toulouse-Lautrec, *Tête-à-Tête Supper*, photographed with transmitted light to illustrate the thinly veiled ground

Nor might this be the only effect; for as the natural resin varnishes begin to age and yellow, an entirely inappropriate colour-cast may subjugate and distort all nuance, making impossible any attempt to appreciate the highly developed exploration of the colour theories that are inseparable from an understanding of Post-Impressionism. Seurat's *Man Painting a Boat* (no. 31) and Boudin's *Deauville* (no. 20), when returned to the collection after many years on loan, were virtually illegible under a degraded yellow film. When the varnish was removed from the Seurat panel it was significant that a considerable amount of surface grime was found to be embedded in the impasted brushstrokes, indicating that some considerable time had elapsed before it was coated. The recovery of the Boudin was spectacular, allowing the sun, albeit figuratively, to shine and illuminate while revealing the sky, with its subtle manipulation and juxtaposition of two different blues, and the diaphanous but energetic forms of the clouds above a flat beach that now once again recedes to a perceptible distance while the sea now too stretches back to its horizon. To a much lesser extent the modifying effect of a slightly discoloured varnish can still be observed on, for instance, Cézanne's *Still Life with Plaster Cast* (no. 28) and *Pot of Flowers with Pears* (no. 25).

The materials and techniques of the Impressionists presented problems that were new, if the artists' intentions were to be acknowledged and honoured; just as the innovatory exploitation of grounds and the diversity of paint qualities should have demanded special attention if they were to be preserved intact, so should the characteristics of the actual canvas, the chosen weight and weave of which were far from arbitrary. Ultimately, the surface texture is dependent upon it, and its role can be critical.

In this collection the diversity of thread counts range from the coarse hemp of Gauguin's *Te Rerioa* (6:7 per cm^2) to the extremely finely woven linen of Manet's *A Bar at the Folies-Bergère* (30:32 per cm^2). As a direct result of the limited methods of lining available in the first half of this century there have been instances where relatively unobtrusive but irretrievable alterations to the surface texture have been induced; it is, however, impressive to note how intact are the individual brushstrokes of, for instance, van Gogh's *Peach Blossom in the Crau* (no. 38), which has been both lined and wax-impregnated.

Lining, sometimes executed as a 'precautionary' measure, was occasionally an early necessity, as Gauguin was cogently aware; in a letter of 1897 to Daniel de Monfreid, he even recommends such action to remedy any structural damage incurred in the transport of his work from Tahiti.

Most of the orthodox lining techniques used would have employed, in combination, heat and pressure, and in such conditions the surface may be at risk. Boudin's *Deauville* (no. 20) has been lined with a glue-paste adhesive, and, during the process, the slightly softened paint and ground have been compressed into the interstices of the canvas, so that the extent to which the weave is now apparent is greatly exaggerated. In 1931, Manet's *A Bar at the Folies-Bergère* (no. 3) was said to be in a perilous condition, with the paint in danger of delamination; the painting was wax-lined, thus impregnating the canvas and ground and so re-affixing any loose paint, and, simultaneously, giving additional support to the seemingly frail canvas. One of the attendant dangers of wax-impregnation lining is that the infusion of wax will darken the canvas and ground, and so unbalance a key tonal value. Although this may be the case in Renoir's *La Loge* (no. 14), treated similarly in the same decade, it does not seem to have affected the *Bar* to a noticeable degree. But as a result of the liner's choice of a backing canvas three times more coarse than the original, the surface now displays the irregular and spurious texture associated with weave interference; in all other respects the painting is in excellent condition.

The same cannot be said of van Gogh's *Self Portrait with a Bandaged Ear*, the only painting to be excluded from the exhibition on account of its fragility. An impenetrable lining adhesive now prevents the introduction of a general consolidant from the reverse, nor can the adhesive safely be removed, given the voluptuous impasto which has a recorded history of flaking.

Degas's *Woman at a Window* (no. 7) is a painting on paper, the appearance of which can now almost be mistaken for canvas for the weave imprint of the fabric onto which it has been laid has been transferred into its fibres. The medium and technique, *à l'essence* – that is a reduced oil paint greatly diluted – are here appropriately used directly on paper, in a manner similar to water colour; thin staining washes, lucid, fluent brush drawing in black, and the dry, white scumble resembling the use of gouache body colour highlights. There is little doubt that this varnished painting has darkened considerably.

A final example, again on paper, that clearly illustrates the inherent dangers of an inappropriate secondary support is to be found in Cézanne's *Still Life with Plaster Cast* (no. 28). From the evidence of small tears and fractures, the paper was in a fragile and embrittled state, and was laid onto a wood panel that has a cradle on the reverse; this expedient measure was perhaps short-sighted, for the paper is now prone to the notoriously unpredictable behaviour of constrained wood, and the corrugation often associated with cradles is already incipiently evident, as well as a slight convex warp.

The changes that have been noted are largely confined to the less obvious aspects of the appearance of the paintings. For the most part their condition is rather remarkable: one eighth of the collection is unvarnished, over a quarter is unlined and the majority can be seen as only slightly modified versions of the dazzling original. Despite this it is as well to be aware that subtle but significant changes have already occurred and will continue to occur.

Changing Techniques

Impressionist painting with its various concerns with modernity, spontaneity, and the capturing of sensations of light and colour, was compelled to evolve new ways of painting, new techniques. If artists as varied as Monet, Manet and Renoir have, at various times, all come under the aegis of Impressionism, it is hardly surprising that the technical methods they evolved should be equally diversified, nor were those of any one artist constant for any great length of time. Many of these techniques can be perceived simply by a close examination of the surface of the paintings aided by low power, binocular microscopy.

Monet's *Autumn Effect at Argenteuil* (no. 11), painted in 1873, is an intriguing example of his early, still developing, Impressionist technique. On the one hand, his use of a lightened palette, with limited value contrasts, is crucial to the Impressionist rendering of natural effects of light and atmosphere. On the other, the paint is rather thickly applied, almost encrusted in parts, with the ground playing little or no optical role in the final image. At this time, in other works, Monet was already painting more thinly. The tendency to cover less of the canvas, in order to allow the colour of the ground to set off the applied strokes of paint, was to be a key factor in many of his later paintings.

For *Autumn Effect at Argenteuil* the ground is applied to the typically fine weave linen favoured by the Impressionists. The edge of the now grey-white priming and the canvas can be seen clearly at the top left-hand corner of the painting. A closer examination of the surface of the paint shows that, in addition to the ground being largely obscured by succeeding

paint layers, there must have been several campaigns of painting. For much of the rather lean paint can be seen to surmount underlying, already dry, layers. As with many Impressionist paintings the apparent sense of spontaneity relates to the appearance of the finished picture, rather than to its production.

It is fortunate that the varnish coat on this painting is now extremely thin, and we are thus able to get a better sense of the matt and desaturated surface which Monet would have sought with his stiff dry paint. It is possible that he leached oil out of the tubes of paint he obtained from artist's colourmen, so as to enhance this aspect. In addition, by mixing his palette extensively with white lead he could raise the tone of the painting to a value appropriate for this outdoor scene.

The sky is confidently rendered, swirls of lively brushstrokes establish the clouds, and contrasting hues of blue and pink create a vibrant sense of light. As the sky, mostly blue at the top of the painting, approaches the buildings of Argenteuil, this use of contrasts, between a prevailing cool, light blue and a warm pink, becomes more predominant. In the water, immediately in front of the buildings, this relationship is neatly reversed with cool blues playing a minor role to the warmer pinks.

The buildings themselves exemplify some of the problems of creating form within the framework of Monet's Impressionist technique. They are modelled by the use of descriptive brushwork and with colour contrasts not too far removed in value. For instance, the wall of the second white building from the right, is a slab of richly textured paint applied in only a few strokes. Darkish blues define roofs but, by restricting the range of tonal contrasts, Monet prevents the buildings from becoming too clearly structured and thereby drawing the eye.

This lack of a conventional focus for the scene is further elaborated by the technique used to paint the foreground water. The brushstrokes become larger and coarser, more systematically horizontal, and the colour evolves to a predominantly cool blue-green. The water is thus warm in hue in the distance, and cool in the foreground, reversing the usual convention for establishing a sense of depth. The combined effects of cool foreground and coarse, broad, horizontal working tend to flatten the picture plane, and to resist the implied perspective of the trees at each side, leading the eye towards Argenteuil. We are presented with the scene as a whole.

In the relatively thinly painted sky and water, we certainly see Monet's emerging mastery over a technique for the depiction of these aspects of nature. However, he is rather less assured in his representation of the densely foliated trees and their reflections. These, especially on the left, show somewhat heavy and congested paint. There is evidence of many reworkings. Most striking are the scratch-marks, no doubt made with the end of a brush, running diagonally through the trees. Monet has largely over-painted them on the left, but they remain visible in the tree on the right. This scratching, uncommon in Monet's work, even extends to the reflected foliage in the middle left.

What seems most likely is that, in searching for the right contrasts to establish both light and form, he was tempted to apply ever more paint. In these areas, greens, yellows, orange, pinks and blues abound, mostly admixed on the palette, and worked over previously dry paint. At some stage, perhaps, the opacity of so many applications began to dull the effect and Monet sought to return to the ground as a means of re-introducing vibrancy and fresh luminosity. Partly because of this *Autumn Effect at Argenteuil* is particularly sensitive to illumination conditions. Seen in dull light, the trees can appear flat and undifferentiated, yet under bright conditions they come suddenly to life and we grasp something of what Monet was seeking.

Detail of Monet, *Autumn Effect at Argenteuil*

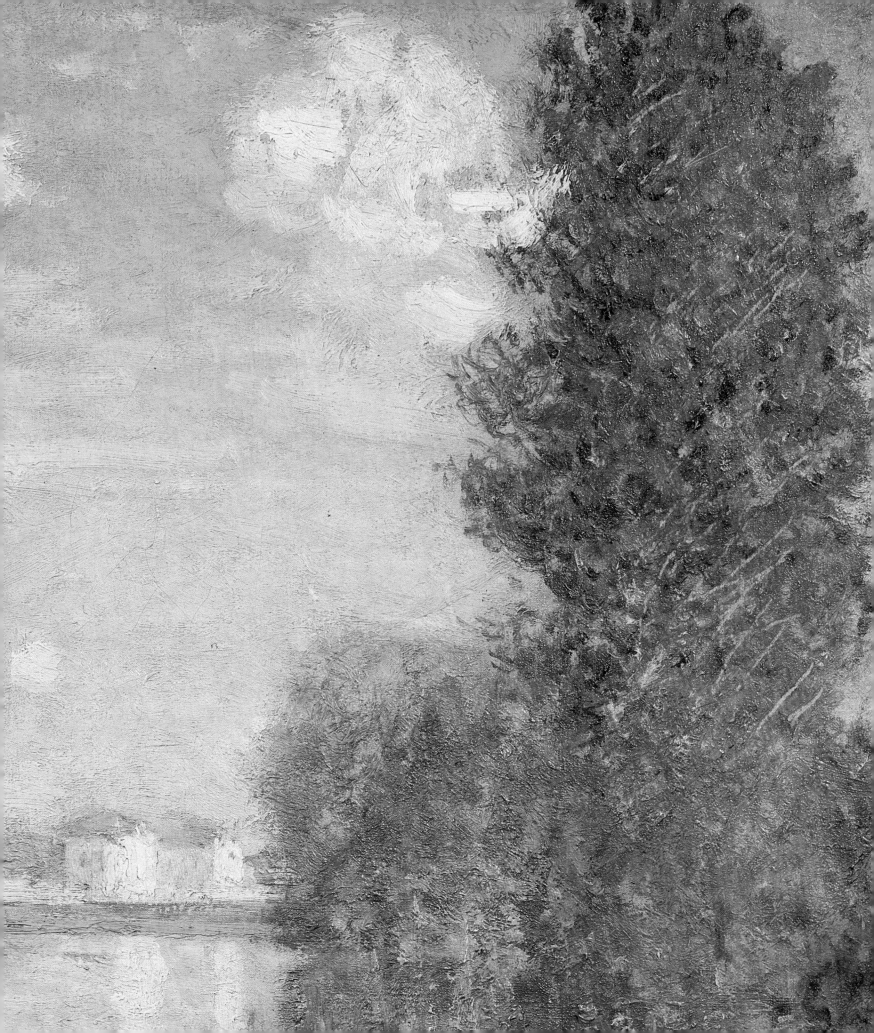

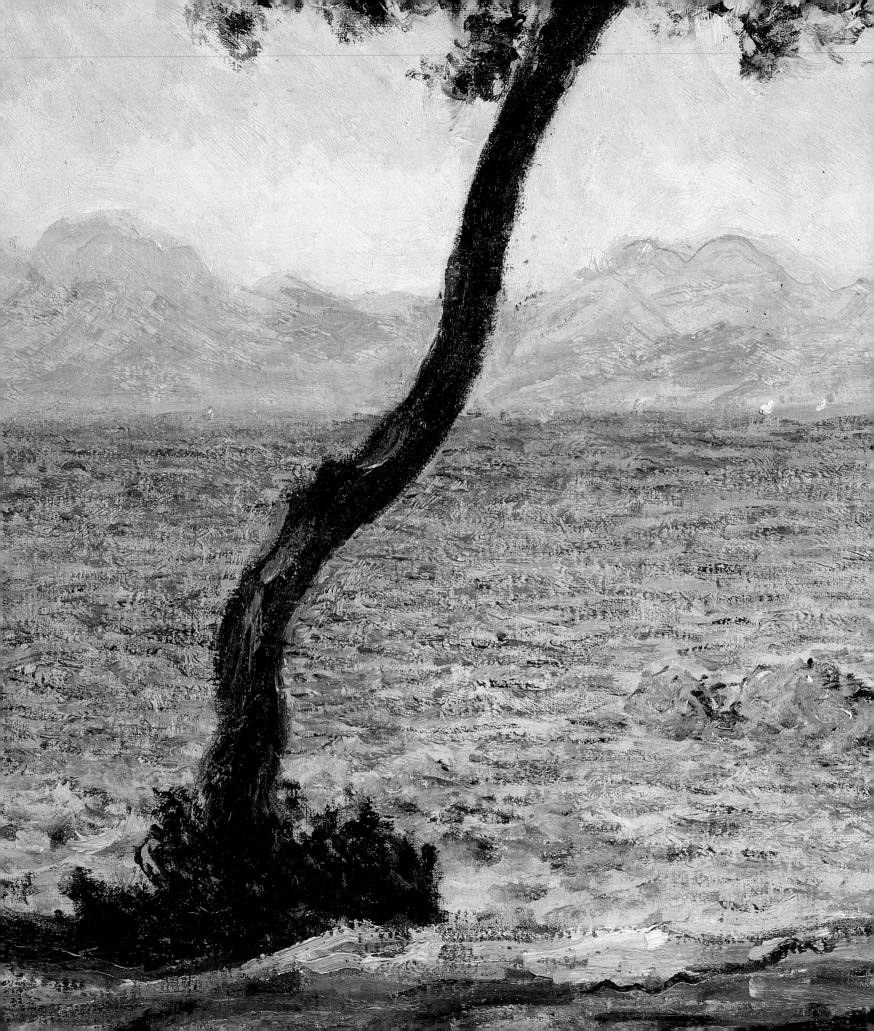

Antibes (no. 13) is never anything but resplendently bright. Painted by Monet in the south of France, in 1888, it also serves as an illuminating technical contrast to *Autumn Effect at Argenteuil*. The motif is less informal, more consciously contrived. Where *Autumn Effect at Argenteuil* was revolutionary if sometimes unsure, *Antibes* is an accomplished demonstration of a technique well understood and widely versatile. The canvas is a fine weave linen commercially primed with a ground which is now slightly off-white. The ground can be seen in the foreground just to the right of the foot of the tree. It also appears extensively, though toned down, through the tree's leaves.

Technically the production of the image is rather more organised than might be imagined. In the early stages, Monet seems to have laid in initial layers for both the sky and sea. These layers fulfil, in a more nuanced way, the role of the ground in many earlier paintings. The sea, over the underlayer, is painted in wide horizontal strokes of green, light blue and dark blue. The technique is remarkably simple – bluer in the distance and greener in the foreground, and it also gives the light blue underlayer a unifying optical role. In the sky, blues of various saturations are applied diagonally and broadly, and occasionally in bold waves. This pattern of strokes, diagonal in the sky and horizontal in the sea, is repeated in a number of the works executed during Monet's stay at Antibes. The vigorous diagonals appear strongly in the X-radiograph. Throughout this highly contrasted X-radiograph image Monet's rhythmic and bold handling is apparent. Amongst the finest examples of his flowing brushwork are the distant Montagnes de l'Estérel. They are defined by waves of descriptive strokes along their crests, and modelled in contrasting light pinks, blues and violet.

The dramatic sweep of the tree has been emphasised during the course of painting. A ridge in the sea, a little to the right of the lower trunk, shows a former position of the tree. It used to run straighter and to the right of the present image. This alteration, and the varied brushwork directions in the mountains, sea and sky, is captured by the high relief of the raking-light photograph. The X-radiograph reveals the hesitations Monet had as to the exact line of the tree trunk. It seems the final form enhanced the Japanese aspect of the motif. This appears to be the only important area of change within the painting.

(*Facing page*), detail of Monet, *Antibes*

(*Left*) *Antibes*, X-radiograph
(*Right*) *Antibes*, raking-light

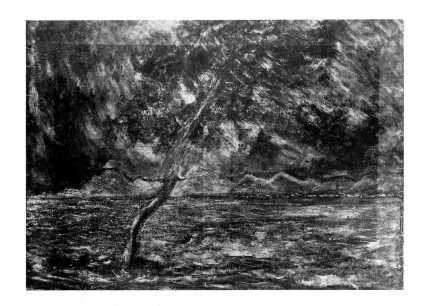

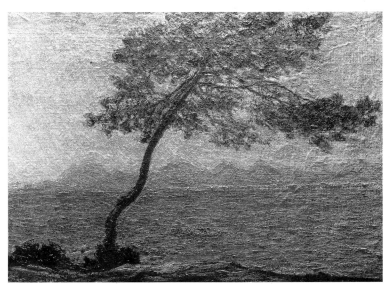

Antibes seems rather more finished than is usual and could well have been worked up in the studio, for, as letters to his dealer Durand-Ruel reveal, Monet had done this with some of the earlier series at Bordighera. In any case the painting does make some concessions to the traditional conventions of landscape art. It has a strong, even a little idealised, composition. There is, too, a sense of space from the warm foreground and the aerial perspective. All these would have combined to produce a more readily accessible work. However, in the rocks just out to sea there is a superb example of Monet's more general technique. Contrasting yellow, red and a darker blue, he creates the form as well as colour and light. The reflections are violet and pink, impasted strokes describe the shapes of the rocks. It is a tiny detail which could almost stand alone as a statement of his technique.

Still, *Antibes* is too striking and powerful for details to take pride of place. What is most fascinating is that the relationship between the technique and the composition should be so exact. A bold, rhythmic and dramatic subject is matched by the same qualities of execution. If the choice of image might be seen as an exercise in dramatic compositional display, then the technique is no less a virtuoso demonstration of control over the technical tools Monet had developed.

Though Monet was prepared to strive for a consistent technique across the painted surface even in the face of obstacles, by no means all painters of Impressionist works adopted such a rigorous approach. In *La Loge* (no. 14), for instance, Renoir has selected different techniques for various passages of the painting, applying each where it seemed most suited to his ends. Painted in 1874 and exhibited at the First Impressionist exhibition it depicts an outing to the theatre. At the same time it deals, albeit gently, with the sexual manners of the middle classes. The visit becomes an opportunity for both display and its attendant flirtation, and the painting engages us in these interactions. The variety of techniques used to create the painting is no less sophisticated and seductive.

Renoir worked over a warm-white ground on a commercially prepared, finely woven, linen canvas. The thin ground can be seen most clearly on Nini's right arm, just above her glove, where it serves as a flesh colour. In fact, the ground plays a larger role in this painting especially in the blue-white stripes of Nini's dress where it is set against lead white and cobalt blue paint. The consistency of this paint is quite different from the stiff dry matière of Monet. It is much more fluid, allowing the thin applications to blend and merge without obscuring each other. The brushwork runs in many directions in short fanning strokes made by a large brush. This fluidity helps to create the richness of an opulent setting. However, in his handling of shadows, Renoir is rather closer to Monet. He avoids black admixtures and uses instead the pure hue of cobalt blue. This is evident in Nini's gloved hands. But, unlike Monet at this time, he does utilise black paint, though it is used as a colour rather than as a means of creating form. The man's coat is a pure carbon black. This pigment is found too in the dark regions of Nini's dress. Here, though, it is mixed with cobalt blue. Sometimes larger areas of cobalt blue were used against the blue-black as can be seen on the right of the neckline.

Renoir's paint may have been fluid, but for the most part his successive layers were not applied till those below had dried. Again we have an impression of spontaneity which would have taken a considerable time to achieve. By contrast, some passages are handled wet in wet and must have been painted quickly and surely. Amongst them, Nini's eyeglasses, fan, earrings and flowers are particularly fine.

Nini's face is the focus of the painting. To paint it Renoir has opted for more traditional methods. It is modelled smoothly and delicately to

Detail of Renoir, *La Loge*

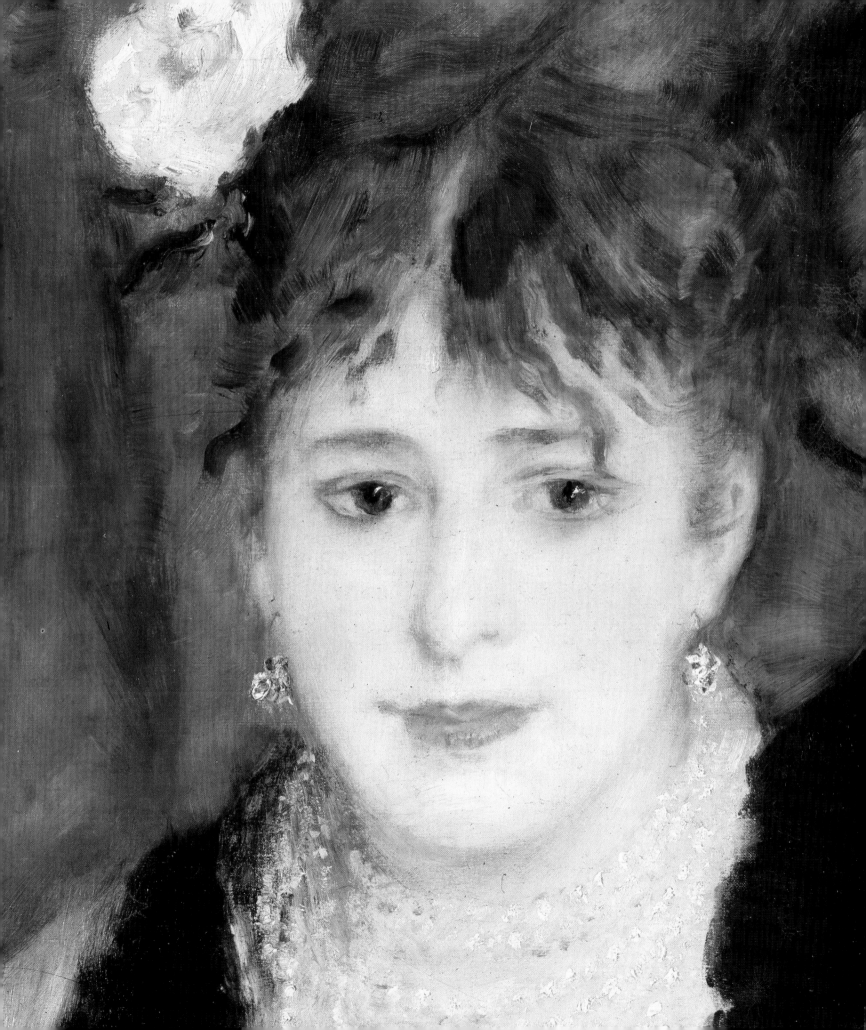

emphasise the form. This is in recognition of the fact that although Impressionist techniques, such as those used by Monet, could recreate light and atmosphere, they were not so suited to building an illusion of form on a two-dimensional canvas. Yet, Renoir has employed cobalt blue, not black or earth colours, to produce the shading in the face. This procedure is linked, of course, to artists like Rubens, but it also falls within Impressionist ideas as to colour if not to handling. A looser, more Impressionist treatment would have created a diffuse image, perhaps less able to attract our attention, and certainly less finely delineated. How appropriate that Renoir should have used this looser technique for the face of the woman's companion. To this less central figure the Impressionist handling is ideally suited.

An unusual aspect of the painting is the application, in a number of places, of a thin, semi-transparent, yellow layer. Functioning almost like a glaze it can be seen, for instance, on the string of pearls which Nini wears. Possibly the layer has yellowed a little more with time because of changes in the medium. In any event, it is now apparent over the background to the left, around Nini's eyes and on the cuffs of her dress. It could be that Renoir wished this layer to simulate a feeling of the artificial light inside the theatre. What is certainly true today is that when the painting is seen in warm lighting, it develops quite a strong greenish-yellow cast. Natural light or cooler artificial light diminish the influence of the yellow.

La Loge is a chic and somewhat calculated view of contemporary life in Paris designed to appeal to Renoir's clients. Technically, what impresses is the manner in which it is equally urbane in marshalling such a range of treatments to resolve the problems of its composition.

Change in the Making

In many instances, the application of quite routine methods of technical examination has given fundamental insights into the artist's original intention and the methods by which he contrived to achieve his effects. The examples of Manet and Gauguin may serve to illustrate the increasingly indivisible link between the art historical appreciation of the surface and the technological study of its nature and evolution.

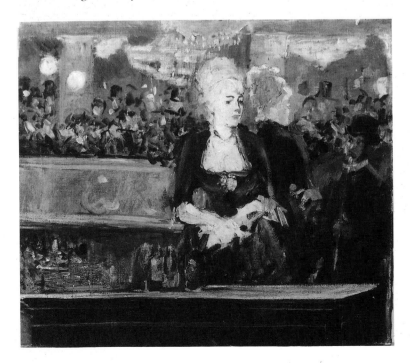

For Manet the process of constructing an image began with a record of things seen, sketched or painted from life or a model, but the evolution of the final image has been shown to take place on the canvas during painting.[1] The most important information yielded by the X-radiograph of *A Bar at the Folies-Bergère* (no. 3) is the fact of the similarity of the initial compositional lay-in to the finished form of the Amsterdam oil sketch, and from a close examination of the X-radiograph we can trace the process of its transformation into the present, highly resolved image and its rich diversity of implications.

Originally the bar-waitress, Suzon, stood, left hand resting on her right forearm, in a pose more casual and asymmetrical than the final one. The arms were first sketchily painted, perhaps only broadly blocked in. There is a suggestion of modelling in the right hand, while the left arm seems little more than a few opaque strokes. The decision to change the position of the arms inevitably entailed some reworking of the rest of the figure, the X-radiograph shows how Manet broadened the shoulders, redefined the waist with dense opaque paint and corrected the contours of the figure. The X-radiograph also indicates that the foreground still life had been at least partially painted before the change. The paint is very thick in the area of the right forearm, this is particularly clear in a raking-light, and the extreme opacity of the X-radiograph here suggests that the edge of the glass bowl of mandarins originally underlay it. On the left, a painted reflection of a champagne bottle can be seen continuing under the upper arm. Although dark areas on the X-radiograph generally correspond with passages where the paint is thinly or sparingly applied one must add a caveat with regard to the interpretation of the X-radiographic image. Sometimes, darkness on the film may simply be the result of the presence of pigments with low X-ray absorption. This is what has occurred in Suzon's blue dress where Manet has used Prussian blue with a little cobalt blue, both pigments with very low X-ray absorption. It is in fact thickly painted and has even cracked in such a way as to suggest one layer of paint has been applied over another that was not yet completely dry.

The clarity of the modelling of Suzon's head on the X-radiograph contrasts with the alterations to the rest of the figure. There is no evidence of the paint being scraped away as we know was Manet's practice from the other X-radiographs and contemporary descriptions. This suggests that the idea that Suzon should face the viewer, confront us rather than turning away into the narrative as she does in the sketch, was indeed part of the initial conception of our painting. She was, of course, always much larger in proportion to the entire painting than the waitress in the sketch and both devices serve to close the distance between the viewer and the scene.

As the waitress' pose was transformed so was the reflection in the mirror and the sacrifice of accurate perspective in the reflection is a direct consequence of the extraordinary psychological and compositional focus on Suzon. The reflected image of the waitress has three positions: the first repeats the Amsterdam sketch, and in being close to and partially overlapped by the 'real' figure, the head would have obscured the round light in the background. It assumes a normal correspondence between the viewpoint for the figure and the reflection. The small figure of a man in a hat, cane raised jauntily to his chin can be made out on the right, again repeating the Amsterdam sketch even in the precise nature of its notational brushwork, an identity of handling that underlines the directness of the connection between the two works. Opaque strokes indicate the nose and some of the modelling of his face, a broad horizontal stroke marks his collar, although the black of his coat does not register on the X-radiograph it can still be detected appearing between later brushstrokes on the paint

surface. Perhaps too much of the reflection was obscured by the waitress' arm resting on the counter, perhaps the impact of the isolated 'real' Suzon was diminished by the proximity of her mirror image, it was in any case, at this stage, that Manet began to move the reflection. His first solution was to shift it to approximately midway between the first and final positions. Here Suzon's reflection would have begun to overlap that of the customer as well as to make him appear disconcertingly small by comparison and it must have led Manet to reconsider the relationship between the two figures, eventually reversing it so that the customer now looms larger. The final reflected head of the waitress appears very opaque on the X-radiograph and examination of the paint surface shows it to be one of the most reworked and least satisfactory passages in the entire painting. The brushwork is congested and lacks lucidity. This is in complete contrast to the man's head which is painted directly and confidently in a brief, sketchy technique that recalls Manet's late portraits and is clearly legible on the X-radiograph.

The changes in the positions of the reflected figures tend to stress the

(*Facing page*). Manet, *Sketch for Bar at the Folies-Bergère* (Stedelijk Museum, Amsterdam)

Manet, *Bar at the Folies-Bergère*, X-radiograph

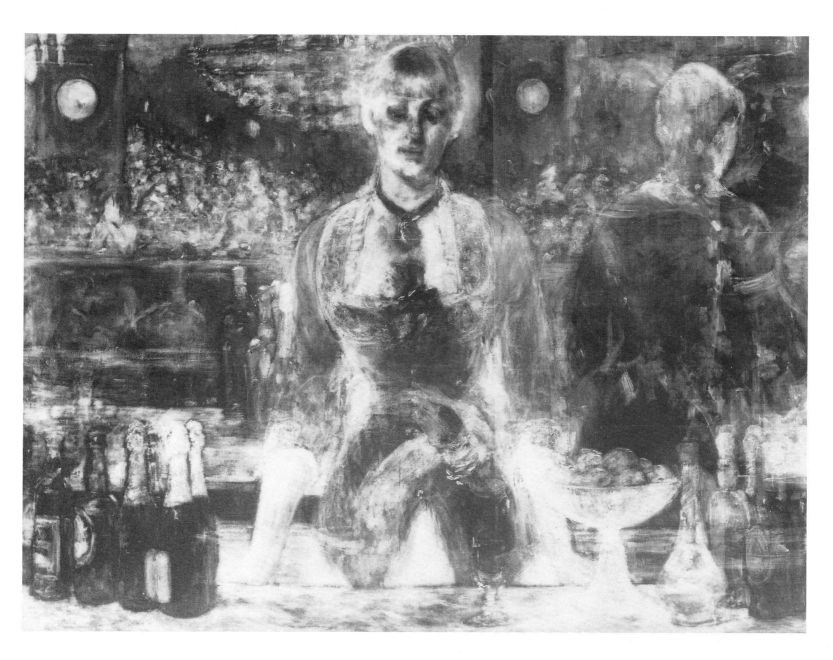

icon-like detachment of Suzon and to transform a casual physical conjunction into a more ambiguous relationship of greater dramatic intensity. The artificial perspective of the background is a result of this development and is itself stressed by the changes Manet made to the still life on the left of the painting, most notably the suppression of a bottle of Bass beer and its reflection, and the reduction in the length of the reflected counter. It is clear from the X-radiograph that Manet did not achieve the full articulation of these ideas either easily or immediately: complexity of meaning is matched by complexity of process.

Gauguin maintained that his artistic centre was in his brain. By this he meant that he was independent of current art movements, but it is also an accurate comment on his working methods.[2] As van Gogh told his brother when Gauguin was working with him at Arles: 'just now he is doing some women in a vineyard, completely from memory, but if he does not spoil it or leave it unfinished it will be very fine and unusual' (November 1889). *Haymaking* (no. 39), painted at Pont Aven in 1889, illustrates just how Gauguin manipulated remembered images to achieve a rhythmic surface patterning effect. Using infra-red photography and X-radiography it is possible to trace the alternating process of drawing, painting, redrawing and repainting that are typical of Gauguin's technique. It contrasts in every way with that of van Gogh where the impact of things seen finds direct expression in the brushwork, exaggerated to emphasise the emotion but always descriptive of his own vivid experience of nature.

Gauguin used the pigment Prussian blue both to sketch in the com

position and to give final definition to the forms once painted. As Prussian blue appears dark in infra-red, it is possible to see the degree of reworking that exists and the difficulty that Gauguin had with the composition. The most striking changes are those around the two women on the right of the painting and in the backs of the cows. To the left of the two women another woman can be discerned in the infra-red photograph. She is standing upright and it is possible to make out her eyes and the top of her nose in three-quarters view. As she is drawn so near to the left hand figure of the pair it may be suggested that the upright figure was in fact not an additional figure but the original position of the woman we now see and that Gauguin changed her, as he changed the cows, to make more compositional sense of the picture. The effect of the changes is to stress the arcs of the women's arms and the oblique angles of the backs of the cows. Less legible are the underdrawings above and to the right of the right-hand woman. The latter may be some piece of harvesting paraphernalia, the former echoes the shapes of the women's heads although as a head it would have been out of scale with the others. From the X-radiograph it can be seen that the changes continued during the painting. The upright woman must have been partially painted because Gauguin has had to block her head out with opaque pigments, probably a mixture of lead white and chrome yellow. The same opacity is visible all around the heads and arms of this group adjusting and emphasising the clarity of outline. The rake of the second woman from the left was originally longer and wider, it extends under the bending woman, who may, therefore, have been a late addition.

Gauguin's brushwork, mainly loose, right-handed, hatching-strokes that skip over the tops of the canvas weave, is particularly clearly recorded on the X-radiograph because he has used an unpigmented chalk ground that has a very low X-ray absorbency compared with the paint which must contain lead white pigment.

The changes from the underdrawing in the backs of the cows is partially visible from the surface because of the increased transparency of oil paint on ageing. As we can see that both cows were originally painted red, the changes must have come at a relatively late stage.

Nevermore and *Te Rerioa* (nos. 40–1) were painted in Tahiti in 1897, within weeks of one another. Stylistically, the sense of surface pattern is increased in both paintings by the use of more integrated brushwork and blocks of colour. Yet the two canvases also differ dramatically from each other in surface finish: the thick paint and very smooth surface of *Nevermore* is highly unusual for Gauguin and particularly so by contrast with the coarse, hairy, hemp canvas texture of *Te Rerioa*.

Detailed visual examination of *Nevermore*, together with X-radiograph and cross-section analysis, revealed that the difference between the two paintings was due to the fact that *Nevermore* is painted over what appears to be a finished landscape. The landscape composition is visible along the top tacking edge where the canvas was cut down to its present size. In this small portion brushstrokes can be seen which have been applied over other, already dry, strokes implying an advanced stage of execution of the landscape. Two ground layers, both applied by the artist, are visible in the cross-section. The first ground applied to the canvas was an absorbent chalk and glue ground and over this the landscape was painted. The second ground is lead white in oil presumably chosen for its greater hiding power in masking the underlying landscape. The significance of the nature of the

(*Facing page, left*) Gauguin, *Haymaking*, infra-red photograph (detail)
(*Facing page, right*) Gauguin, *Haymaking*, X-radiograph (detail)

Gauguin, *Nevermore*, X-radiograph: the original landscape composition dominates the image

surface is, of course, open to speculation: Gauguin was under pressure to paint for the market and, as his dealer Ambroise Vollard reminded him, this meant painting thickly, so in spite of his protests about lack of money, materials and the exigencies of a tropical climate, *Nevermore* could be seen to represent a response to this demand. Perhaps also it might be felt that the handling of the paint is meant to express the sensuality of the nude, 'un certain luxe barbare, d'autrefois' as Gauguin described it. Without rejecting such explanations, our interpretation of the painting is nevertheless complicated by the discovery that Gauguin has achieved the smooth surface of the painting because the figure is painted over two grounds and another entire painting, all of which completely obliterate the canvas texture, rather than as the direct result of an aesthetic intention.

It also emphasises that the relationship between the practical and the aesthetic can be difficult to clarify. With regard to *Te Rerioa* Gauguin says that he took advantage of a ten-day delay in the departure of the ship taking his pictures back to France to paint it: 'une autre toile que je crois encore meilleure que les précédentes malgré le hâte de l'exécution'. Perhaps in this case thinness of painting, over a ground barely filling the interstices of the weave, was simply a matter of speed. Yet, perhaps Gauguin would have chosen this technique of execution anyway, for it heightens the physical reality of the painting in a work whose actual subject is a dream.

It is scarcely surprising then that in focusing attention on the actual process of painting, another dimension to the understanding of the whole work can be gained. This is the more so in an exhibition which covers a period when style, technique and subject matter are more inextricably related than at almost any other time. Part of the meaning of these paintings is to be found within this inter-relationship.

1. *The Hidden Face of Manet*, Courtauld Institute Galleries, 23 April–15 June 1986.

2. *A Study of Paul Gauguin's Correspondence relating to his Painting Materials and Techniques, with specific reference to his works in the Courtauld Collection*. Charlotte Hale, Courtauld Institute Diploma Project, 1983.

Publications relating to the Courtauld Collection
All publications are in London, unless otherwise stated.

R.A. Commemorative Catalogue
Commemorative Catalogue of the Exhibition of French Art 1200–1900, Royal Academy of Arts, London, January–March 1932 (1933).

Jamot–Turner
Collection de tableaux français, faite à Londres, 20 Portman Square, par Samuel et Elizabeth Courtauld, 1914–31: Texte par Paul Jamot et Percy Moore Turner. (50 copies, privately printed, London, 1934.)

Home House Catalogue
A Catalogue of the Pictures and Other Works of Art at Home House, 20 Portman Square, London. (Published by the Home House Society Trustees, London, 1935.)

Tate Gallery, 1948
Catalogue of the Samuel Courtauld Memorial Exhibition, held at The Tate Gallery, London, May–June, 1948.

Cooper, 1954
Douglas Cooper, *The Courtauld Collection. A Catalogue and Introduction*, with a Memoir of Samuel Courtauld by Anthony Blunt. (University of London, The Athlone Press, 1954.)

Orangerie, Paris, 1955
Impressionnistes de la Collection Courtauld de Londres. Musée de l'Orangerie, Paris, October, 1955.

Courtauld Centenary, 1976
Samuel Courtauld's Collection of French 19th Century Paintings and Drawings. A centenary exhibition to commemorate the birth of Samuel Courtauld, organised by the Courtauld Institute and the Arts Council. (Arts Council of Great Britain, 1976.)

National Gallery, London, 1983
Paintings from the Courtauld, National Gallery, London, 10 February–27 March 1983 (no catalogue).

British Museum, 1983
Montegna to Cézanne. Master Drawings from the Courtauld, British Museum, London, January–June 1983.

Japan and Canberra, 1984
The Impressionists and the Post-Impressionists from the Courtauld Collection, University of London, Takashimaya, Tokyo, Kyoto and Osaka, 1984; *The Great Impressionists, Masterpieces from the Courtauld Collection of Impressionist and Post-Impressionist Paintings and Drawings*, Australian National Gallery, Canberra.

All but one of the forty-eight paintings shown in this exhibition come from the collection formed by Samuel Courtauld. The exception, Bonnard's *A Young Woman in an Interior* (no. 45), was bequeathed to the Courtauld Institute of Art by Roger Fry in 1934. Samuel Courtauld, in addition to his magnificent gifts and bequest to the Courtauld Institute, also bequeathed paintings to members of his family. Five of these, Cézanne (no. 22), Manet (no. 2), and three Seurats (nos. 30, 32 and 33), have been most generously lent to the exhibition by a Courtauld heir who wishes to remain anonymous. The van Gogh *Self-Portrait with Bandaged Ear* has had to be excluded because of its fragile condition.

The catalogue has been arranged in broadly chronological sequence, taking as a starting-point the earliest work available to us by each artist represented in the exhibition. Where an artist is shown by two or more paintings, we have grouped them together chronologically. Thus, the exhibition begins with an important group of three paintings by Manet (1863–82), followed by a Daumier of c.1870, two Pissarros of 1871 and 1883, then a group of four Degas (1871–2 to c.1889–90), and so on. In this way, it is hoped to give a sense of the general development of French painting as well as the evolution of an individual artist's work wherever possible, within the framework of the Courtauld Collection.

The catalogue is based on material published for the exhibition of the Courtauld Collection that was held in Japan and Australia in 1984, many of the catalogue entries for which were compiled by Dennis Farr. These have been completely revised by John House, who has considerably expanded many of them, to incorporate the results of recent research, some of it previously unpublished. We have also gratefully benefited from the technical data compiled by our colleagues in the Courtauld Institute's Department of Technology, who in addition to their essays, have contributed technical details on each painting, except those loaned from the private collection, in the documentation section which appears as an appendix after the main entries; we are also indebted to Robert Ratcliffe for information and advice about Cézanne.

Dennis Farr
John House

I

Manet, Edouard 1832–83
LE DÉJEUNER SUR L'HERBE *c.*1863?
Oil on canvas, 89.5 × 116.5 cm.
Signed bottom left: 'Manet'

This is a smaller version of the famous *Déjeuner sur l'herbe* (Musée d'Orsay, Paris), which was rejected by the Salon jury in 1863 and exhibited as *Le Bain* at the Salon des Refusés in 1863. The models in the large picture have been identified as Victorine Meurent (a professional model), either Gustave or Eugène Manet (brothers of the painter) and Ferdinand Leenhoff, a Dutch sculptor, whose sister Manet married in 1863. The picture caused much controversy when it was exhibited at the Salon des Refusés, and critics and historians still dispute the artist's intentions. Antonin Proust records Manet's ambition to rework the theme of the Giorgione *Concert champêtre* in the Louvre in a more luminous, outdoor ambience; but the final painting was undoubtedly executed in the studio, apparently based on studies made on the Ile Saint-Ouen, on the Seine on the northern outskirts of Paris. There are other links with Renaissance painting besides Giorgione; the poses of the three main figures are directly based on a group of nymphs and river gods from the right side of an engraving by Marcantonio Raimondi after Raphael's lost *Judgment of Paris*. Manet was also aware of the *fêtes galantes* of French eighteenth-century painters such as Watteau, and of recent popular romantic prints by artists such as Devéria and Morlon, which, in a more 'popular' medium, lent a more overtly erotic content to Watteau-like themes.

The large painting puzzled contemporary critics for several reasons. The juxtaposition of a naked woman with men in modern dress was regarded as indecent; the woman's body was seen as ugly – not conforming to academic canons of beauty – and the men's clothing, particularly the smoking-cap of the figure on the right, led critics to identify them as students; the handling of the picture did not give the figures their due status, but treated them and the background alike, in broad, vigorous touches of paint. Moreover, it was unclear what type of subject it was: its very large scale (about 7 by 9 feet) led them to expect a picture with a significant subject; its naked figure led them to expect nymphs and naiads; and the picnic scene recalled the fête champêtre. However, the painting itself conformed to none of these types, but rather deliberately flouted the conventions of each; in a sense it was a parody of the tenets of contemporary academic 'high' art, enshrining a scene from contemporary bohemian life in the rhetoric, and on the scale, of history painting. Moreover, the gaze of the naked woman, looking away from her companions and directly at the viewer, made it impossible to conceive of the scene taking place in some sylvan glade of the imagination.

The exact status of the Courtauld version has been the subject of much debate, some seeing it as a preparatory sketch, and some as a replica made after the large version, from which it differs in a number of details (the exact placing of the figures and their relationship to the figure in the stream, the colour of the naked woman's hair, and perhaps the model used). X-ray examination of both canvases has clarified the issues. The Courtauld picture shows no significant changes during its execution; the figure group and the background were immediately laid-in on the canvas very simply and directly. By contrast, the large version was very extensively changed, and originally included an open vista with small trees in its left background, instead of the trunk and foliage which now frame it. It thus seems virtually certain that the Courtauld version is a replica, made after the big one was completed, and refining its arrangement in minor ways. The early history of the painting makes this very plausible, since its first owner was Manet's friend the Commandant Lejosne; it seems likely that Lejosne, unable to house the big painting, asked the artist to make a reduced version. We cannot be sure when this was done; indeed, the breadth and simplicity of handling in the Courtauld picture makes it possible that it was executed a few years after the large version.

PROVENANCE
Given by the artist to Commandant Lejosne, Paris; Lejosne family. Maisons-Lafitte (from 1884–1924); with Galerie Druet, Paris; through Percy Moore Turner, London; Samuel Courtauld, June 1928. Courtauld Gift 1932.

EXHIBITED
Tate Gallery, 1948 (36); Orangerie, Paris, 1955 (27); Courtauld Centenary, 1976 (23); *Manet at Work. An Exhibition to mark the Centenary of the death of Edouard Manet 1832–1883*, National Gallery, London, 10 August–9 October 1983 (10); Japan and Canberra, 1984 (48); *The Hidden Face of Manet*, Courtauld Institute Galleries, April–June 1986 (24).

LITERATURE
Paul Jamot and Georges Wildenstein, *Manet. Catalogue critique* (Paris, 1932), I, no. 78; A. Tabarant, *Manet: Histoire catalographique* (Paris, 1931), no. 63; A. Tabarant, *Manet et ses oeuvres* (Paris, 1947), no. 65 and pp. 73–4; Jamot–Turner, no. 7; Home House catalogue, no. 6; Cooper, 1954, no. 32; Denis Rouart and Daniel Wildenstein, *Edouard Manet: catalogue raisonné*, I (Paris, 1975), pp. 74–5, no. 66; Alan Bowness, 'A Note on Manet's Compositional Difficulties', *Burlington Magazine*, June 1961, p. 277 n. 9; Juliet Wilson Bareau, 'The Hidden Face of Manet', in *Burlington Magazine*, April 1986, pp. 39, 92.

TECHNICAL DETAILS
Canvas weave: Twill.
Threads per sq.cm.: 24 × 11.
Ground: 1. commercial application; 2. artist's application; colour: cream.
Wax lined.
Varnished.

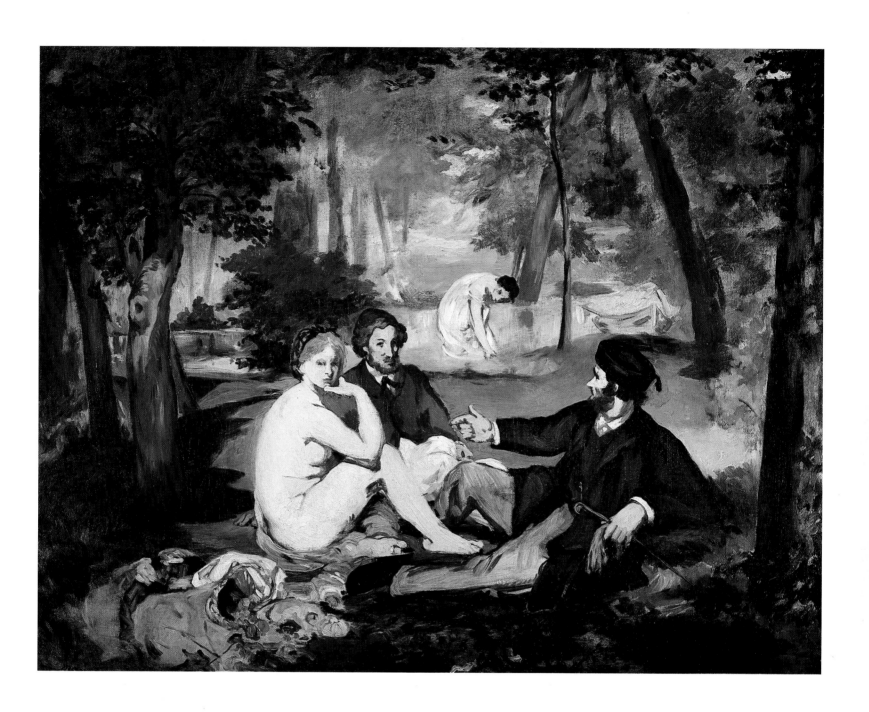

2

Manet, Edouard 1832–83
BANKS OF THE SEINE AT ARGENTEUIL 1874
Oil on canvas, 62.3 × 103 cm.
Signed bottom left: 'Manet '74'

Banks of the Seine at Argenteuil was painted while Manet was visiting Monet at Argenteuil in the summer of 1874; the models were very probably Monet's wife Camille and his seven-year-old son Jean. Manet had refused to participate in the Impressionists' first group exhibition earlier that year, preferring to continue showing at the Salon, but he was on close personal terms with Monet and gave him much financial help in difficult times.

The picture marks Manet's closest approach to the open-air Impressionism by which the movement is best known, with its broken brushwork and vivid, variegated colour; indeed, it was very probably (in part at least) painted out of doors. But comparison with Monet's *Autumn Effect at Argenteuil* (no. 11), painted the previous year, reveals certain important differences. Manet still used black paint for certain salient points in the composition – most notably for the ribbons on the back of the woman's hat, and also on the hulls of the boats. Moreover, he did not record the reflections in the water with any close attention to their actual appearance: the patterns of masts and rigging seen in the water bear little relationship to the forms they reflect, whereas Monet's reflections were always closely observed, spreading down directly below the objects reflected. Nor did Manet systematically indicate shadows by the use of colour.

Strict attention to such notions of naturalism held little value for Manet. Whereas Monet was at this date using the close study of natural effects as the means for rethinking the basic conventions of landscape painting, Manet was primarily concerned with figure subjects, with finding ways of suggesting the unexpected groupings that modern people presented in their surroundings. Though the vivid blue of the water in *Banks of the Seine at Argenteuil* evokes bright summer light, the main focus of the picture is the figures and the boats: the sailing-boats in the river, and the wash-boats along the far bank, and the figures standing inexpressively in front of the scene. The factory chimneys seen over the trees echo the lines of the masts and stress the diversity of the scene.

Whereas Monet exhibited many river scenes of this size, Manet did not show this canvas; as a result of his stay at Argenteuil he painted two larger, more elaborate scenes of figures by the river which he did submit to the Salon (including *Boating*, Metropolitan Museum of Art, New York). However, he did regard it as a fully complete work, and sold it to the wealthy collector, Ernest May.

PROVENANCE
Ernest May, Paris; Auguste Pellerin, Paris; with Durand-Ruel, Paris; Theodor Behrens, Hamburg; with Galerie Barbazanges, Paris; with Knoedler, London; Samuel Courtauld, August 1923; Lady Aberconway, 1948; private collection, London.

EXHIBITED
Centennale de l'art français, Exposition Universelle, Paris, 1889 (490); Exposition Universelle, Paris, 1900 (445); *35 Manet de la Collection Pellerin*, Bernheim-Jeune, Paris, 1910 (6), and at Moderne Galerie, Munich, 1910 (6); *Exposition Centennale de l'art français*, St. Petersburg, 1912 (403); *19th Century French Painters*, Knoedler, London, July 1923 (28); *Masterpieces of French Art of the 19th Century*, Agnew, Manchester, September 1923 (22); Centenary Exhibition, Norwich, October 1925 (45); *French Art*, Royal Academy, 1932 (420); Tate Gallery, 1948 (38); *Landscape in French Art*, Royal Academy, 1949 (247); Courtauld Centenary, 1976 (24); *Manet at Work. An Exhibition to mark the Centenary of the Death of Edouard Manet 1832–1883*, National Gallery, London, 10 August–9 October 1983 (20).

LITERATURE
Jamot and Wildenstein, I, no. 242; Tabarant (1931), no. 216; Tabarant (1947), no. 227; Jamot–Turner, no. 9; Cooper, 1954, no. 33; Rouart and Wildenstein, I, pp. 184–5, no. 220; Anne Coffin Hanson, *Manet and the Modern Tradition* (New Haven and London, 1977), pp. 68, 77, 173; T. J. Clark, *The Painting of Modern Life* (London, 1985), p. 165.

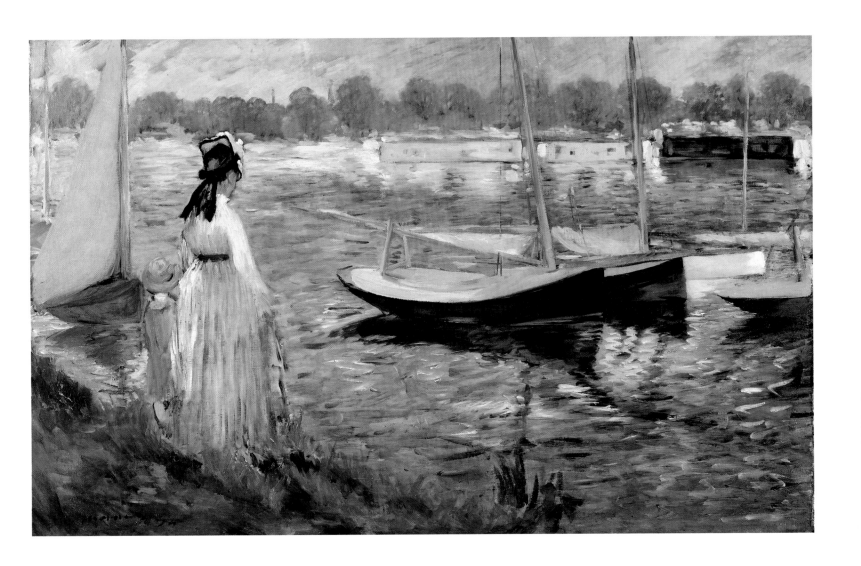

3

Manet, Edouard 1832–83
A BAR AT THE FOLIES-BERGÈRE 1881–2
Oil on canvas, 96 × 130 cm.
Signed on bottom label, bottom left: 'Manet/1882'

A Bar at the Folies-Bergère was Manet's last major completed painting, exhibited at the Paris Salon in 1882, a year before his death. It is the only painting in the Courtauld Collection which was exhibited at the Salon, which remained the most important outlet for contemporary art until the last years of the nineteenth century. It shows the interior of one of the most fashionable café-concerts in Paris, and Manet made rapid preparatory sketches in the Folies-Bergère itself; however, the final painting (and also, it seems, the oil sketch for it) was executed in Manet's studio, using one of the barmaids, by the name of Suzon, who worked in the Folies-Bergère as a model. Georges Jeanniot visited Manet's studio in January 1882 and described him at work on the canvas, with the model posed behind a table laden with bottles and foodstuffs: 'Although he worked from the model, he did not copy nature at all closely; I noted his masterly simplifications. . . . Everything was abbreviated; the tones were made lighter, the colours brighter; the values were more closely related to each other, the tones more contrasting.' Manet insisted that 'concision in art was a necessity'.

In the preliminary oil sketch (Stedelijk Museum, Amsterdam), the barmaid's head is half turned towards the right, with her reflection in the mirror behind the bar in a readily intelligible position, just to the right of the figure, while the reflection of her customer appears near the right edge of the composition, at a lower level; he wears a bowler hat and carries a cane. In the final version, the maid looks out at (or rather, past) the spectator from the centre of the picture with a detached expression, while her reflection has been displaced much further to the right, and her top-hatted customer appears in reflection in the extreme top right of the canvas. Figures are seen in the mirror to the left of the barmaid, seated in the circle seats on the opposite side of the auditorium; the *demi-mondaine* Méry Laurent posed for the woman in a white dress with yellow gloves, the young actress Jeanne Demarsy for the figure immediately behind her, in a box.

In their final form, these reflections cannot be logically understood. The figure of the barmaid is separated far too far from her reflection; the customer is shown in the reflection close to the barmaid, whereas in fact the spectator is placed at some distance from the image that looks out of the picture; and the placing of the bottles in the reflection does not correspond to their position on the bar in the foreground – they are near the 'wrong' edge of the bar. X-ray photographs of the final painting show that initially its forms were close to those in the sketch, and thus were logically coherent; substantial changes were made during the execution of the picture, most notably the moving of the reflection of the barmaid to the right (this took place in two stages), and the replacement of the customer with the bowler hat and cane (as in the sketch) by the man in the top right (for more detail of these changes, see pp. 30–2). Thus the discrepancies between the principal image and the reflections in the final version were introduced absolutely deliberately, and evolved as Manet worked up the picture. The result is that the barmaid is presented to the viewer very directly, as an iconic centre of the composition; but a disturbing dislocation is created, between the apparent directness of her encounter with the man seen in the mirror, and her seeming distance and abstractedness as she faces the viewer.

Much has been written about the possible reasons for these distortions of perceived reality, which would have seemed more unexpected to nineteenth-century viewers, not habituated to the radical anti-naturalism of much twentieth-century painting. Throughout his career Manet had avoided compositions which showed easily legible relationships between figures and presented clear-cut narratives, in favour of subjects where the status of the figures remained unclear, and groupings which defied the viewer's attempts to interpret them (see the grouping in *Le Déjeuner sur l'herbe*, no. 1). This was in part a rejection of the conventions of the fashionable genre painting of the day, but also an attempt to convey a more vivid sense of actuality, in which relationships between people are rarely so clear-cut and unambiguous as they had traditionally been depicted in painting.

The subject of *A Bar at the Folies-Bergère* enshrined particularly clearly many of the uncertainties which many contemporary commentators felt about the social and moral status of the most characteristic types in modern urban society. The Folies-Bergère was a popular place of entertainment for fashionable figures in Parisian society and for the demi-monde, and prostitutes apparently plied their trade overtly in its foyers and galleries. The status of the barmaids was ambivalent: they were primarily there to serve drinks, but they were also potentially available to their clients themselves; they might themselves become commodities, like the bottles on the bar. Manet's picture, with its wilful distortion of perceived experience, seems designed to enshrine this uncertainty. This is enhanced by the way in which it is painted, for the bottles and fruit bowl on the bar are treated with great richness and finesse, while the figure of the barmaid is more broadly and simply treated. Critics had often criticised Manet for failing to distinguish the salient points of his compositions by treating them in more detail (see no. 1), but here this serves the very positive purpose of highlighting the barmaid's merchandise, the primary reason for her presence behind the bar, and thus of bringing out the ambivalence of her own status in the transactions she enacts.

Writing about Manet, and about modern art in general, during the twentieth century, has until recently favoured formalist explanations of the structure of Manet's paintings, and has argued that he was, at base, concerned with aesthetic questions, about the relationships of forms and colours, and that the oddities in the paintings were mere by-products of these formal concerns. However, when his paintings are re-examined within the context in which they were originally displayed, at the Paris Salon, it becomes

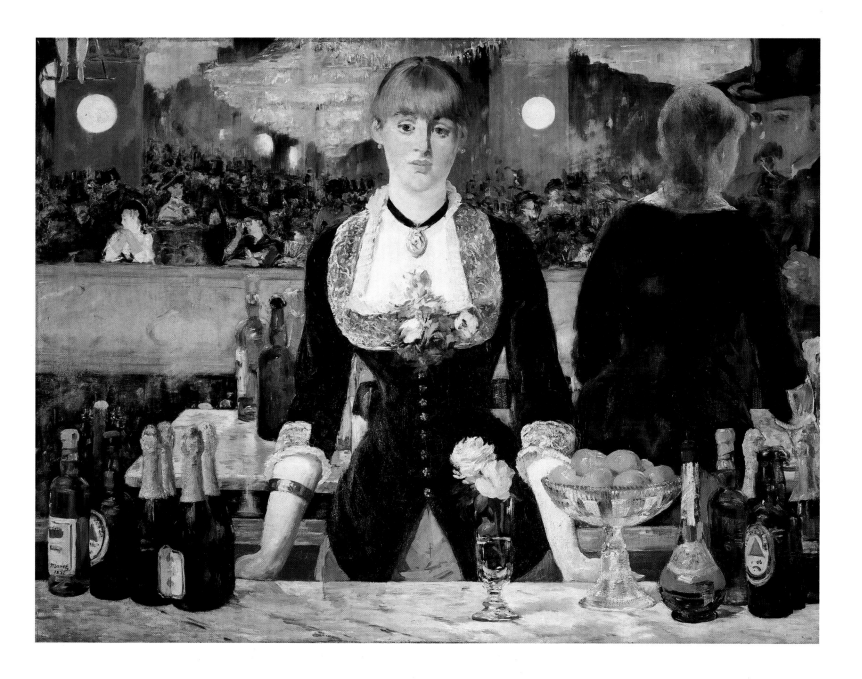

clear that they systematically broke with then-current conventions of representation and undermined the coherence and manageability of the world which these conventions created; Manet's pictorial world was a challenge to social as well as artistic values.

PROVENANCE

Inventory prepared after Manet's death 1883, no. 9; Manet Studio Sale, Drouot, Paris, 4–5 February 1884 (lot 7; 5,850 Frs.) bought Chabrier; Emmanuel Chabrier; Chabrier Sale, Drouot, Paris, 26 March 1896 (lot 8; bought in, 23,000 Frs.); with Durand-Ruel, Paris, May 1897; Auguste Pellerin, Paris; with Bernheim-Jeune, Paris and Paul Cassirer, Berlin; Eduard Arnhold, Berlin; Baron Ferenc Hatvany, Budapest, by 1919; with Justin K. Thannhauser, Munich; Eric Goeritz, Berlin, *c*.January 1924; through Thannhauser, Lucerne; through Percy Moore Turner, London; Samuel Courtauld 1926. Courtauld Gift 1934.

EXHIBITED

Salon, Paris, 1882 (1753); Salon, Antwerp, 13 August 1882 (903); *Exposition posthume Manet*, Ecole des Beaux-Arts, Paris, 1884 (112); *Exposition Manet*, Durand-Ruel, Paris, April 1894 (59); *Manet Exhibition*, Durand-Ruel, New York, March 1895 (3); Exposition Universelle, Paris, 1900 (448); Grafton Galleries, London, January 1905 (93), exhibition organised by Durand-Ruel; *Manet and the Post-Impressionists*, Grafton Galleries, London, 1910–11 (7; lent jointly by Bernheim-Jeune and Paul Cassirer); *Exposition centennale de l'art français*, St. Petersburg, 1912; exhibitions in Frankfurt-am-Main, Vienna, Dresden, and Copenhagen 1912–14; Galerie Thannhauser, Lucerne, 1926; Tate Gallery, London, June 1926; *French Art*, Royal Academy, London, 1932 (405); *Manet*, Musée de l'Orangerie, Paris, 1932 (82); Tate Gallery, 1948 (40); Orangerie, Paris, 1955 (30); Courtauld Centenary, 1976 (26); National Gallery, London, February–March 1983 (no catalogue); *Manet*, Grand Palais, Paris, April–August 1983 (211) and Metropolitan Museum of Art, New York, September–November 1983 (211); Japan and Canberra, 1984 (49); *The Hidden Face of Manet*, Courtauld Institute Galleries, April–June 1986 (62).

LITERATURE

Jamot and Wildenstein, I, no. 467; Tabarant (1931), no. 369; Tabarant (1947), no. 396; Jamot–Turner, no. 10; Home House Catalogue, no. 77; Cooper, 1954, no. 36; Rouart and Wildenstein, I, pp. 286–7, no. 388; George Mauner, *Manet, Peintre-Philosophe* (Pennsylvania, 1975), pp. 161–2; Anne Coffin Hanson, *Manet and the Modern Tradition* (New Haven and London, 1977), pp. 68, 130, 204–5; T.J. Clark, *The Painting of Modern Life* (London, 1985), pp. 205–58; Bareau, in *Burlington Magazine*, April 1986, pp. 76–83, 96; John House, 'Manet's Naïveté', in *Burlington Magazine*, April 1986, pp. 8, 13, 16.

TECHNICAL DETAILS

Oil on canvas, 96 × 130 cm., on stretcher 99.8 × 133.5 cm.
Canvas weave: plain.
Threads per sq.cm.: 30 × 32, very fine.
Ground: commercial application; colour: pale grey.
Wax lined. The lining canvas is very coarse and its texture has been imprinted on the original. Varnished.

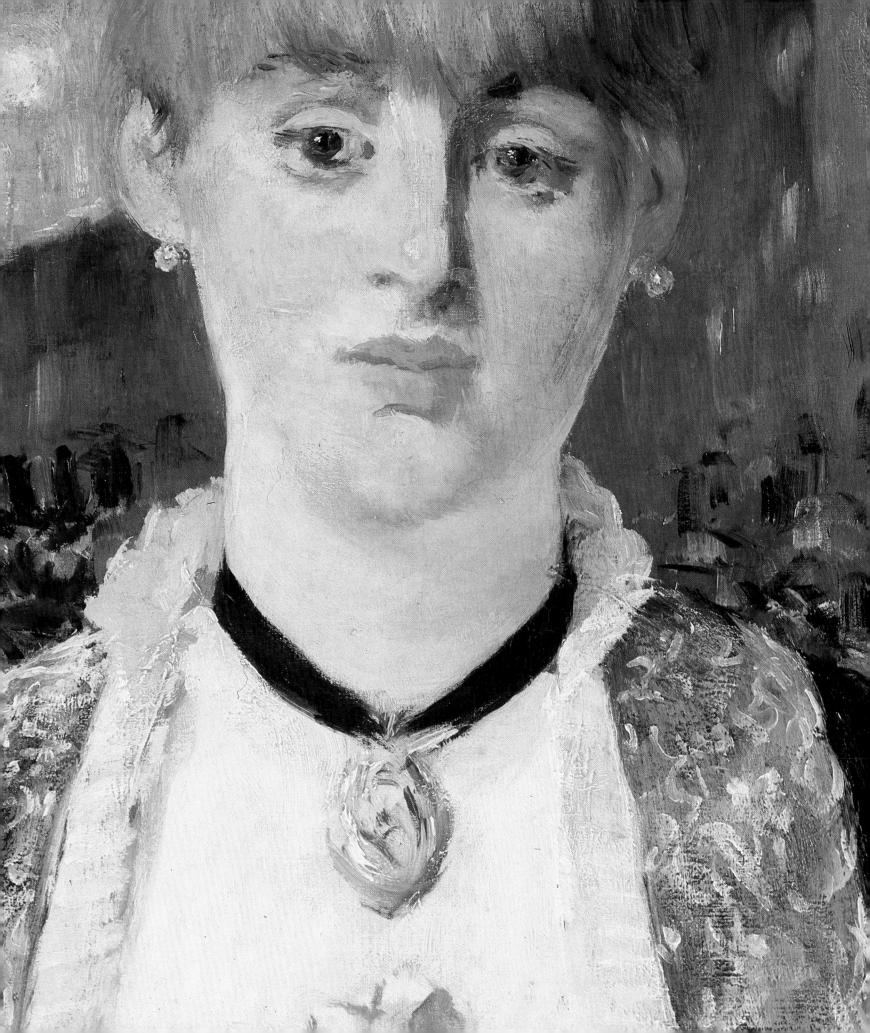

4

Daumier, Honoré 1808–79
DON QUIXOTE AND SANCHO PANZA *c*.1870?
Oil on canvas, 100 × 81 cm.
Unsigned

Daumier's activity as a painter was largely private: he exhibited a few canvases at the Salon around 1850 (including one Don Quixote subject), and one in 1861, but otherwise his paintings remained unseen by the public until, just before the artist's death, the dealer Durand-Ruel put on a major display of his paintings in 1878.

His few more highly finished oils suggest that he had great difficulty in completing paintings on a larger scale. The vivid undulating line which he could use to such effect in his lithographic caricatures, by which he won his fame, did not readily translate into oil paint and on to a large scale, in such forms as nineteenth-century viewers would have regarded as making a finished painting. However, to twentieth-century viewers these bold notations have had a great appeal; Roger Fry spoke of the tragic overtones of this painting, which he likened to a work by Rembrandt, and regretted that Daumier was forced to spend so much of his creative activity in producing humorous caricatures for journals like *Le Charivari*, instead of being able to devote himself to painting. In the nineteenth century, certain connoisseurs of taste, and fellow artists, had appreciated such rapid sketches, seeing them as reflecting an artist's true creativity, but the public celebration of rapidly brushed, unfinished surfaces as the essential form of artistic expression is a phenomenon of the twentieth century.

Themes from the Don Quixote story recur in Daumier's painting; he was clearly fascinated by the contrast between the gaunt elongated figure of the Don, and his roly-poly companion. His work in oils is notoriously hard to date, but the present canvas, one of the largest and grandest of all his oils, was probably executed quite late in his life; in 1867 he had painted a rough sketch of a Don Quixote subject as a decoration for the house of his friend the landscapist Daubigny at Auvers (now in the Musée du Louvre, Paris), and the present picture may have been painted soon after this. The figures are treated as vivid silhouettes against the hillside, with flowing ribbons of grey paint beginning to suggest their forms over the initial rapid brown underpainting.

PROVENANCE
Ambroise Vollard, Paris; with Paul Rosenberg, Paris; with Bignou, Paris; with Lefèvre and Son, London, from whom acquired by Samuel Courtauld in May 1923. Courtauld Gift 1932.

EXHIBITED
Daumier, Ecole des Beaux-Arts, Paris, May 1901 (89); *Daumier*, Galerie Rosenberg, Paris, April 1907 (32); *Art français au 19eme siècle*, Paul Rosenberg, Paris, June 1917 (20); *L'Art français*, Basel, May 1921 (52); *Grand maîtres du 19me siècle*, Paul Rosenberg, Paris, April 1922 (34); *Impressionist School*, Lefèvre Gallery, London, May 1923 (17); *French Art*, Royal Academy, London, 1932 (376); Tate Gallery, 1948 (20); Orangerie, Paris, 1955 (17); *Daumier: Paintings and Drawings*, Arts Council at Tate Gallery, June–July 1961(97); Courtauld Centenary, 1976 (15); Japan and Canberra, 1984 (19).

LITERATURE
Jamot–Turner, no. 3; Home House Catalogue, no. 2; Roger Fry, 'French Art of the Nineteenth Century', *Burlington Magazine*, XL (June 1922), pp. 277–8; Erich Klossowski, *Honoré Daumier* (2nd rev. ed., Munich, 1923), no. 51; Eduard Fuchs, *Der Maler Daumier* (2nd ed., Supplement; Munich, 1930), no. 165; Jacques Lassaigne, *Daumier* (Paris, 1938), pl. 155; Cooper, 1954, no. 20; K.E. Maison, *Honoré Daumier, Catalogue Raisonné of the Paintings, Watercolours and Drawings* (London, 1968), I–227 and pl. 168.

TECHNICAL DETAILS
Canvas weave: plain.
Threads per sq.cm.: 22 × 18.
Grounds: 1. commercial application; 2. artist's application; colour: white.
Lined.
Varnished.

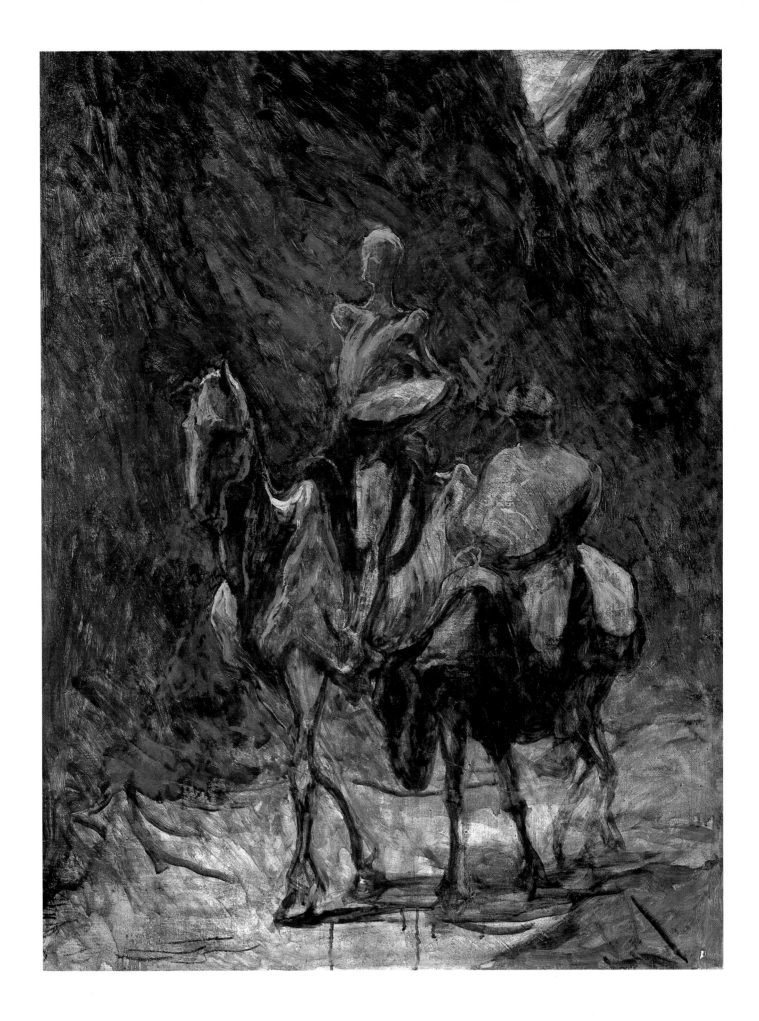

Pissarro, Camille 1830–1903
LORDSHIP LANE STATION, DULWICH 1871
Oil on canvas, 44.5 × 72.5 cm.
Signed, bottom right: 'C. Pissarro 1871'

Pissarro painted this picture while living in London as a refugee from the Franco–Prussian war in 1870–1. Formerly known as *Penge Station, Upper Norwood*, its correct location has recently been identified as Lordship Lane Station (now demolished) on the old Crystal Palace (High Level) Railway, seen from the footbridge across the cutting to the south of the station. The line was opened in 1865 to cater for the crowds coming to the Crystal Palace, very popular as a recreation and exhibition centre since its reconstruction in this South London suburb in 1852–4. Thus the scene shows a modern landscape in the making, with the rows of new houses on either side of the station framed by still-undeveloped open land. Many of Pissarro's canvases painted while he was living in nearby Norwood focus on the burgeoning suburban developments around the Crystal Palace, and some show the palace itself.

Here the chosen subject is deliberately anti-picturesque, with the wide, scrubby slopes and drab fences framing the central motif of tracks and train. Several of the Impressionist group painted railway trains, including Manet and Monet, but this canvas seems to be the first occasion on which one of them made a train into his central motif. It may echo Turner's famous *Rain, Steam and Speed*, which Pissarro saw in the National Gallery in London, but, in place of Turner's lavish atmospherics, Pissarro adopted a far more detached view, closer in its treatment to contemporary topographical prints of the new railway landscape. The signal, silhouetted against the sky in the exact centre of the picture, can be seen as an utterly secularised equivalent of a crucifix – an overt rejection of traditional elevated subject matter, in the search for the truly contemporary.

The picture is quite subdued in colour; the effect of an overcast day is evoked by varied greens and soft red-browns, with the white of the smoke and the clear black of the engine as a central focus. This comparatively tonal treatment, with nuances of a restricted range of colour, is in marked contrast to the lavish colour which, soon afterwards, Monet began to adopt in sunlit scenes (see no. 11), and to the multicoloured interplay of touches which Pissarro himself later adopted (see no. 6). The brushwork is softly variegated to suggest the different textures in the scene; there is no dominant rhythm to the touch, which stresses the diversity of the elements which went to make up this characteristically modern landscape. By contrast, twelve years later at Rouen, Pissarro subordinated the elements in an industrial scene such as no. 6 to an overall play of coloured touches. This change, from a concentration on the distinctive elements in a subject to a preoccupation with overall unifying effects of light, is fundamental in the development of Impressionism in these years.

X-ray and infra-red photographs show that there was originally a figure, perhaps holding a scythe, on the bank to the right of the tracks, above the point on the bottom edge of the picture where the grass meets the ballast of the track. The position of the arms was altered before the figure was painted out altogether.

PROVENANCE
With Alexandre Rosenberg, Paris; Lazare Weiller, Paris; Lazare Weiller Sale, Paris, 29 November 1901 (lot 34; 1,750 Frs.); with Tavernier, Paris; Pearson, Paris; Pearson Sale, Berlin, 18 October 1927 (lot 53); Anonymous Sale, Paris, 23 June (lot 82; 51,000 Frs.); with Schoeller, Paris; Morot, Paris; with Durand-Ruel, Paris; with Arthur Tooth & Sons, London; acquired by Samuel Courtauld, June 1936. Courtauld Bequest 1948.

EXHIBITED
Flèche d'Or, Tooth's Gallery, London, May 1936 (20); Tate Gallery, 1948 (51); *The Impressionists in London*, January–March 1973 (32); Courtauld Centenary, 1976 (34); *Pissarro*, Hayward Gallery, London, October 1980–January 1981 (16), and Grand Palais, Paris, January–April 1981, Museum of Fine Arts, Boston, May–August 1981; Japan and Canberra, 1984 (72).

LITERATURE
L.-R. Pissarro and L. Venturi, *Camille Pissarro, Catalogue de son oeuvre* (Paris, 1939), no. 111; Cooper, 1954, no. 47 (as 'La Station de Penge, Upper Norwood'); John Gage, *Turner: Rain, Steam and Speed* (Harmondsworth, 1972), pp. 67–8; M. Reid, 'Camille Pissarro: three paintings of London. What do they represent?', *Burlington Magazine*, CXIX (April 1977), pp. 251–61.

TECHNICAL DETAILS
Canvas weave: plain.
Threads per sq. cm.: 16 × 14.
Ground: probably artist's application; colour: white.
Lined.
Varnished.

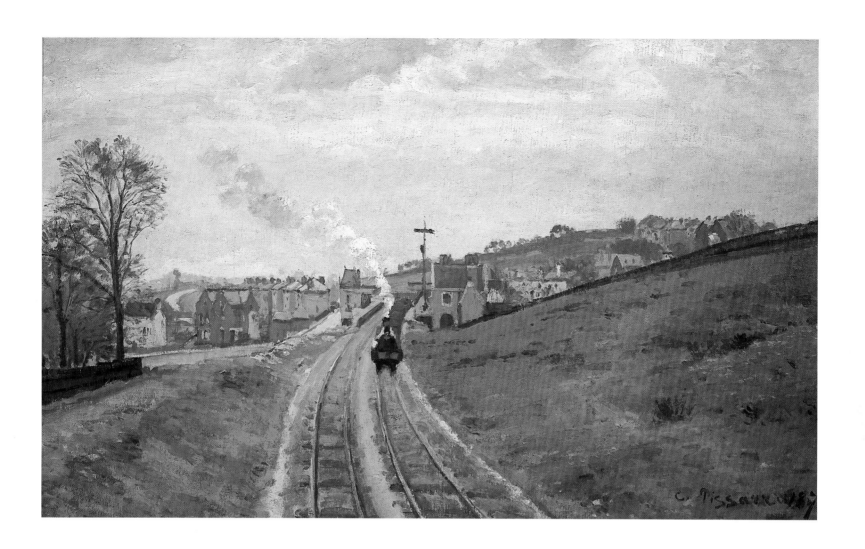

Pissarro, Camille 1830–1903
THE QUAYS AT ROUEN 1883
Oil on canvas, 46.3 × 55.7 cm.
Signed, bottom left: 'C. Pissarro, 1883'

Pissarro spent three months at Rouen in autumn 1883 in a hotel run by Eugène Murer, a professional pastrycook who had met the Impressionist painters through his childhood friend Armand Guillaumin, and made an extensive collection of the work. While in Rouen, Pissarro concentrated on scenes of the banks of the Seine, generally focusing on industrial scenes with boats and docks; in this picture, the view is to the east from the Ile Lacroix, with factories at the base of the Côte Sainte-Catharine across the river, and, silhouetted against the sky, the church of Notre-Dame de Bonsecours, an elaborate Neo-Gothic structure of 1840–2, celebrated as a pilgrimage centre.

The raised viewpoint, above and somehow distanced from the scene, is characteristic of Pissarro's treatment of subjects of this type. By contrast, in his contemporary scenes of peasants in the countryside of the Ile de France, he adopted a closer viewpoint, integrating the figures more fully with their surroundings. This different treatment of different themes is clearly significant, and perhaps expresses the contrasts which he saw between city and country life, in line with the sympathies with anarchist political beliefs which he was evolving in these years: the countryside appears as the repository of a harmonious, coherent way of life, while the activities of the city are more distanced from each other – life is detached from labour. However, there is nothing in this painting, either in the subject or in the way it is treated, which makes any overt social criticism or judgment. The viewpoint is in line with a long tradition of urban topographical prints, to which Monet, too, looked in his urban scenes, and all the elements in the subject are integrated into a densely wrought overall harmony; church and factories, boats, carts and figures are all given equal weight and significance in the ensemble.

The handling of the picture is particularly unified, with virtually every area built up from successions of small dabs and dashes of colour which give it a constantly mobile surface, allowing Pissarro to introduce variations of colour throughout it, in order to evoke the play of coloured light and atmosphere. Though each area has a dominant colour, small touches of other colours recur, which relate to other areas of the picture, linking lit and shadowed areas, foreground and distance; with this calculated device, Pissarro suggested the effect of the unifying hazy sunlight. The paintwork is broader where the surface is more thinly painted, showing that Pissarro began with a simpler, flatter lay-in before elaborating the surface (as Cézanne did in the same period, see no. 23); over this, the final touches refine the effect and give the surface a distinctive rhythm, which is comparable to, though less rigid than, the structures of parallel strokes which Cézanne applied to his more highly finished paintings at this date (seen in parts of no. 23). In Pissarro's Rouen paintings, this refinement of the surface took place, in part at least, after he had taken the paintings back home to his studio; he wrote on his return from Rouen: 'Result of my trip: I return with pleasure to my studio, and look over my studies with greater indulgence, with a better idea of what needs to be done to them.'

In 1898, fifteen years after painting this canvas, Pissarro depicted it hanging on the wall of his studio in *Bouquet of Flowers* (Fine Arts Museums of San Francisco), which suggests that it was a canvas to which he still attached a real value.

PROVENANCE
Private collection, Berlin; with Paul Cassirer, Berlin; Samuel Courtauld 1926. Courtauld Gift 1932.

EXHIBITED
British Institute of Adult Education, Silver End, Essex, March 1935; Tate Gallery, 1948 (52); Orangerie, Paris, 1955 (38); Courtauld Centenary, 1976 (35); Japan and Canberra, 1984 (43).

LITERATURE
Jamot–Turner, no. 6; Home House Catalogue, no. 18; L.-R. Pissarro and L. Venturi, *Pissarro* (1939), no. 601; C. Pissarro (ed. J. Rewald). *Lettres à sons fils Lucien* (Paris, 1950), pp. 59–70 (English ed., London and New York, 1943, pp. 40–8), especially the letter of 1 December 1883; Cooper 1954, no. 48.

TECHNICAL DETAILS
Canvas weave: plain.
Threads per sq.cm.: 15 × 14.
Ground: commercial application;
colour: cream.
Unlined.
Varnished.
Canvas stamp: LATOUCHE 34 DE LAFAYETTE.

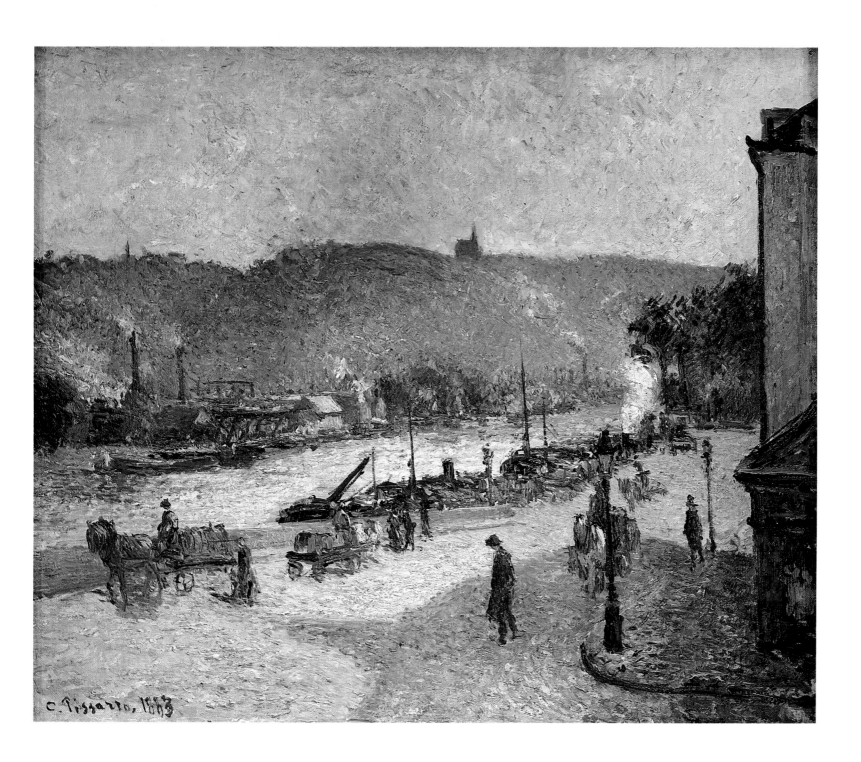

7

Degas, Edgar 1834–1917
WOMAN AT A WINDOW *c.*1871–2
Oil (peinture à l'essence) on paper, mounted
on linen, 61.3 × 45.9 cm.
Signed, bottom right: 'Degas'
Stamped in red, bottom right 'Degas'

The picture is clearly not formally finished, but by very abbreviated means it succeeds in capturing the effect of a figure against a brightly lit window. The play of light on the sitter's left hand is suggested with some delicacy, and the contour of her profile drawn with some care; but the background light is only very broadly blocked in, and the forms of the chair on the left and the seat on which she sits are simply drawn in with fluent black lines of paint, applied with the brush. The figure, seen *contre-jour*, is primarily laid in with black in contrast to the slabs of light beyond, while the brown-toned underlying paper is left bare across much of the rest of the picture; the picture's subsequent treatment has undoubtedly greatly changed the appearance and colour of its surface (see page 23).

Degas was fascinated by the ways in which such effects of light altered the appearance of figures and seemingly dematerialised them (compare the effect of the footlights in no. 8); this is related to his interest in viewing figures from unexpected angles (see no. 9). He was concerned with exploring the ways in which the visible world was actually seen in everyday life, in marked contrast to the conventions of pictorial representation which placed figures in a good light so as to show off their features (as Renoir did in *La Loge*, no. 14).

Although not fully finished, the picture appeared on the market during Degas's lifetime, though we do not know when it left his hands, and whether as a gift or a sale (the majority of his less finished works were still in his studio at his death, e.g. nos. 9 and 10). The English painter Sickert bought the painting from Durand-Ruel around 1901–2 for Ellen Cobden (his former wife with whom he remained on friendly terms); he wrote to his patron Sir William Eden to announce his purchase: 'I have just bought Degas's *finest* work, had my eye on it for 12 years or so!, for £400! for Mrs Sickert, and sold the one I bought for £74 or so to an American for £3000.' The painting he sold was *Rehearsal of a Ballet on the Stage* (the oil version of the subject now in the Metropolitan Museum of Art, New York, which was bought from him by H.O. Havemeyer). When he asked Durand-Ruel why he was able to buy the present picture for a lower price than a pastel, he was told it was 'because the amateur of Degas always wanted ballet girls'.

Sickert recorded that Degas told him the work was painted 'during or soon after' the Siege of Paris; according to an annotation on Sickert's own copy of Jamot's book on Degas, the artist said that the sitter was a *cocotte* and that during the Siege he had bought her a piece of raw meat 'which she fell upon, so hungry was she, & devoured whole'.

The infra-red photograph demonstrates more clearly Degas's exploitation of oil painting 'à l'essence'. When some of the oil medium is soaked from the paint and then thinned with a diluent, it can be used, as here, in a manner similar to a water colour and a brush drawing; in the photograph the tone of the paper is rendered light showing the application of extensive thin washes and astonishingly lucid and fluent line drawing. This use of white to delineate the forms and to point highlights has reduced covering power, and even where vigorously applied retains no trace of impasto. An adjustment to the sitter's right arm can be seen through the white, and the slightly smudged marks on the sitter's face and right hand suggest the dabbing and wiping of the wet paint as a water-colourist might employ a small sponge to soften or thin a tonal wash.

PROVENANCE
Read [i.e. Alexander Reid], Glasgow; Read [Reid] Sale (Vente de M.A. . . .), Paris, 10 June 1898 (lot 26; 2,900 Frs.); with Durand-Ruel, Paris; Mrs Walter Sickert, London; Mrs Cobden-Sanderson, London; Miss M.F.C. Knox, London, 1917; Mrs Cobden-Sanderson, 1917; Miss Stella Cobden-Sanderson, London, 1926; with the Leicester Galleries, London, from whom acquired by Samuel Courtauld 1927. Courtauld Gift 1932.

EXHIBITED
International Society, The New Gallery, London, 1908 (86, wrongly described as 'watercolour'); Goupil Gallery Salon, London, 1923 (72); *Degas*, Musée de l'Orangerie, Paris, April 1937 (not catalogued); Tate Gallery, 1948 (22); *Degas*, Edinburgh and London, 1952 (13); Orangerie, Paris, 1955 (19); Courtauld Centenary, 1976 (16); Japan and Canberra, 1984 (22).

LITERATURE
Home House Catalogue, no. 14; Paul Jamot, *Degas* (Paris, 1924), pp. 56, 140; P.A. Lemoisne, *Degas et son oeuvre*, II (Paris 1946), p. 206, no. 385; Walter Sickert, in 'Monthly Chronicle: Degas', *Burlington Magazine*, XLIII (December 1923), p. 308; Jamot–Turner, no. 12; Cooper, 1954, no. 22; Denys Sutton, *Walter Sickert. A Biography* (1976), pp. 111–12.

TECHNICAL DETAILS
No ground, paper toned brown.
Manufacturer's water mark on left-hand edge.
DE CANSON — FRERES — VIDALON — LES — ANNONAY.

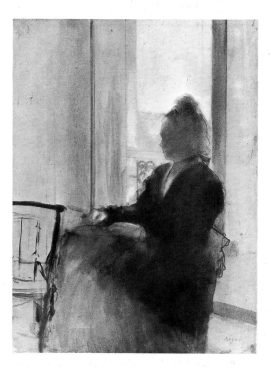

Infra-red photograph

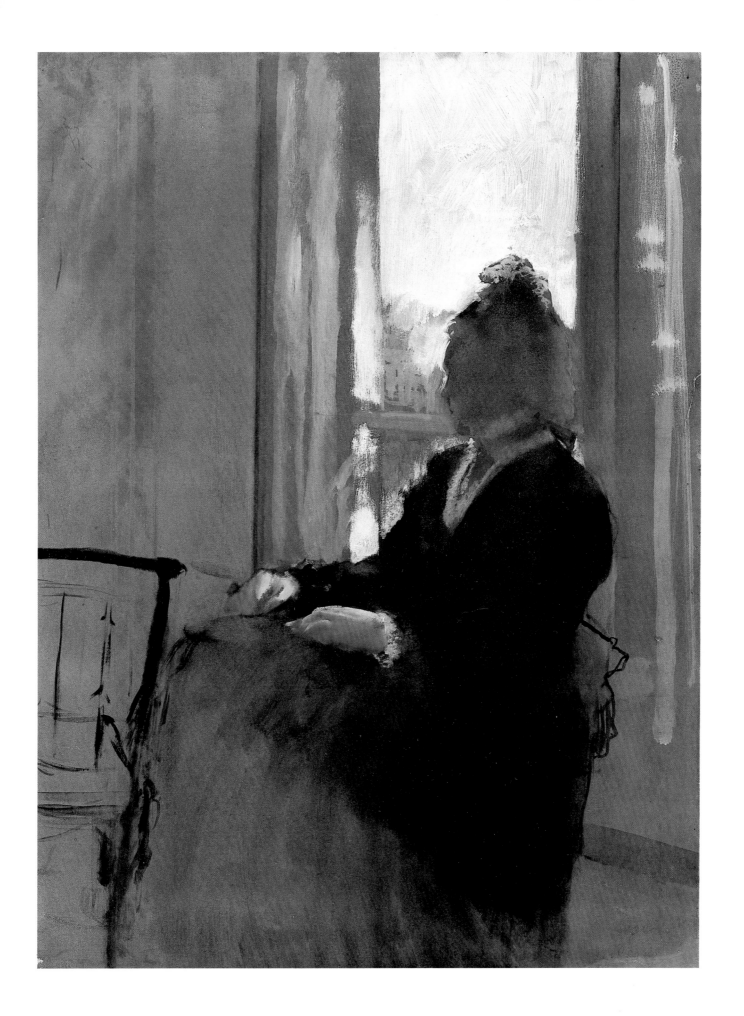

Degas, Edgar 1839–1917
TWO DANCERS ON THE STAGE 1874
Oil on canvas, 61.5 × 46 cm.
Signed, bottom left: 'Degas'

This composition is closely related to a group of three compositions with many figures, which show dancers rehearsing on a clearly defined stage, with other waiting dancers and the ballet master (two in Metropolitan Museum of Art, New York, one in Musée d'Orsay, Paris). Here, though, Degas concentrated on the two figures, with stage-flats beyond them which seem to suggest foliage, but gives no indication of whether we are watching a performance or a rehearsal, or any clue about the action under way. Our attention is focused on their poses, as seen from the unexpected angle of a box virtually above the edge of the stage. The viewer's attempt to see this as a coherent, framed grouping is undermined by the appearance of the edge of a third dancer, her figure cut by the frame, at the far left, set back on the stage, whose presence challenges any attempt to understand the gestures of the other two: they are in standard ballet positions, one *sur les pointes*, the other in fourth position with her arms in *demi-seconde*, but this is all we are told.

This canvas is unusually highly finished for Degas, and was put on exhibition and sold soon after its completion; contemporary reviews show that it was exhibited in London in November 1874 in the Ninth Exhibition of the Society of French Artists, organised by the Parisian dealer Durand-Ruel, and it was bought at this show by the pioneering Degas collector, Captain Henry Hill of Brighton; it was the first painting by Degas that he bought. Degas had exhibited the similarly treated, multi-figure composition in which this pairing of figures appears, at the first Impressionist group exhibition (now Musée d'Orsay, Paris), and these paintings make an interesting contrast to the techniques with which the group is usually associated. The stage-flats in *Two Dancers on the Stage* are treated in free dabs of colour, but the figures are modelled with comparative delicacy. The overall colour scheme is quite subdued, with vivid points of pink, yellow and green on the figures' shoes, flowers, bodices and head-dresses. The generally simple paint surfaces and muted tonality are in marked contrast to the broken touch and vivid colour characteristic of the landscapists in the group (see no.11); this shows how difficult it is to use this exhibition, at which the group was christened the 'Impressionists', as the means of defining the nature of their art (see also Renoir's *La Loge*, no.14).

The canvas is the product of extensive preparatory work, both in the form of the other paintings which show much the same grouping, and in separate drawings; moreover, Degas made a number of alterations to the composition during its execution: the dancer cut off at the left was originally a little larger and about half an inch further to the right; and there are changes in the placing of the feet and legs of the two main dancers.

On occasions Degas painted actual ballet performances, but more often he showed the dancers rehearsing, or left it ambiguous what exactly they were doing, as here. The ballet, with its precision of movements, fascinated him, but he always presented it in ways which revealed its artificiality, by including other extraneous elements – figures who do not watch the dancers, waiting dancers scratching themselves, or dancers who play no part in the main action, like the figure on the left here. His interest in this theme is also part of his attempt in the 1870s to study the visible world from many angles which had not been sanctioned in previous art, but which seemed to him characteristic of the ways in which everyday life appeared in the modern city.

PROVENANCE
Captain Henry Hill, Brighton (by 1874); Hill Sale, Christie's, 25 May 1889 (lot 31, £64.05), bought Goupil (i.e. Theo Van Gogh); Victor Desfossés; sold by Desfossés 4 November 1889 to Goupil-Boussod Valadon successeurs (5,000 Frs.); Goupil-Boussod Valadon successeurs, sold 13 November 1899 (6,000 Frs.) to Paul Gallimard, Paris; with Alex. Reid, Glasgow; Sir James Murray, Aberdeen, sold Christie's 29 April 1927 (lot 41, repr. £7,200); with Knoedler, London; Samuel Courtauld, June 1927. Courtauld Gift 1932.

EXHIBITED
Ninth Exhibition of Society of French Artists, Paul Durand-Ruel, London, November 1874 (9) as 'Scene de Ballet', Galerie 'Les Arts', Paris, June 1912 (16); *French Impressionists*, Lefèvre Gallery, London, May 1920 (8); Opening Exhibition, Modern Foreign Gallery, Tate Gallery, June 1926; *Degas*, Musée de l'Orangerie, Paris, April 1937 (26); Tate Gallery 1948 (24); *Degas*, Edinburgh and London, 1952 (16); Orangerie, Paris, 1955 (21); *Impressionism*, Royal Academy, London, February–April 1974 (56); Courtauld Centenary, 1976 (17); Japan and Canberra, 1984 (23).

LITERATURE
Home House Catalogue, no. 25; Jamot–Turner, no. 11; Lemoisne, *Degas*, II, p. 234, no. 425; Lillian Browse, *Degas Dancers* (London, 1949), pp. 56, 355 and pl. 50; Cooper, 1954, no. 24 (as '*c*.1877'); R. Pickvance, 'Degas's Dancers: 1872–6', *Burlington Magazine*, CV (June 1963), pp. 263–6; John Rewald, 'Theo Van Gogh, Goupil and the Impressionists – Part II', *Gazette des Beaux-Arts*, LXXXI (February 1973), p. 90.

TECHNICAL DETAILS
Canvas weave: plain.
Threads per sq.cm.: 27 × 30, very fine.
Ground: commercial application;
colour: beige.
Lined. The lining canvas is very coarse and its texture has been imprinted on the original.
Varnished.

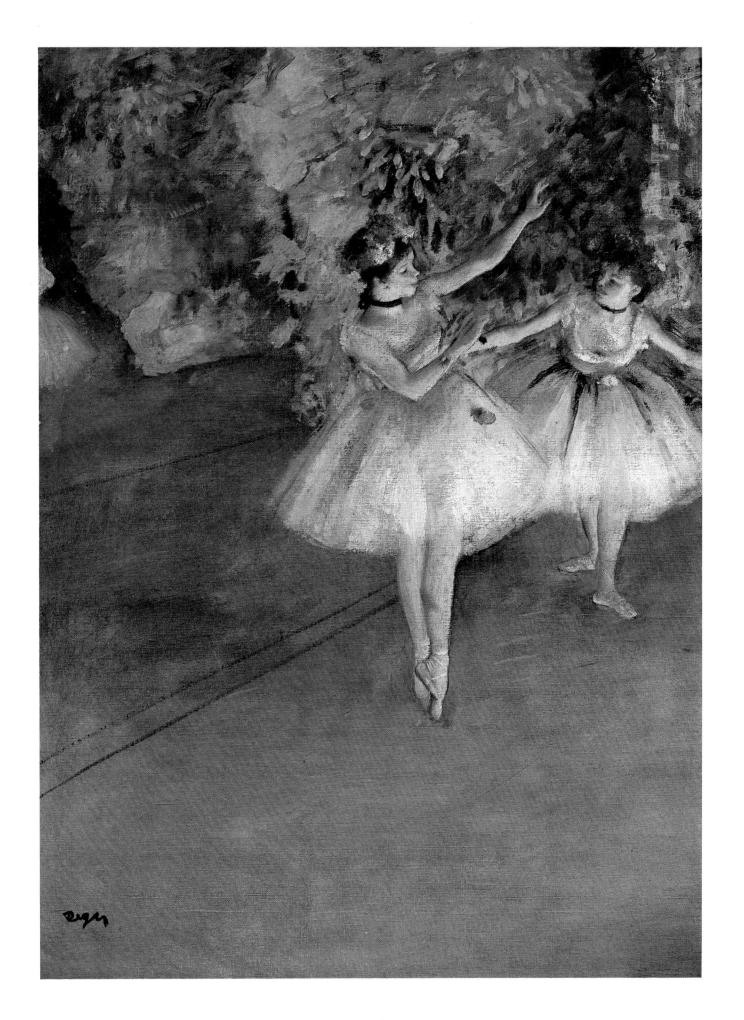

9

Degas, Edgar 1834–1917
SEATED WOMAN ADJUSTING HER HAIR *c.*1884?
Chalk and pastel on paper, 63 × 59.9 cm.
Unsigned
Stamped in red, bottom right: 'Degas' (Lugt 658)

In its present state, this pastel is not a finished work, but it bears a complex relationship to a very similar oil painting. Many changes are visible in the pose of the figure in this pastel, most visibly in the placing of the arms and the line of the left hip, and also in the addition of a wide extra strip of paper across the top of the composition. The oil version corresponds closely to the original state of the pastel before these revisions. Degas more often used pastel in preparatory studies for oils than vice versa, so the present sheet may originally have been a study for the oil; but it was also very probably reworked, and brought into its present form, after the execution of the oil. The relationship between these works, and the final appearance of the present pastel, show how intensively Degas rethought and reformulated his compositional ideas, and how the work of art itself could become a sort of laboratory in which he worked out his ideas, leaving the process very visible when he abandoned the picture.

Seated Woman Adjusting her Hair shows marked differences in execution between its parts; most summary are the notations on the added sheet, and the alterations made to the original composition; the woman's jacket is more fully modelled, and the folds of material at the back of the skirt are unusually crisply treated for Degas's work at this date; the deeply shadowed modelling of these folds is reminiscent of German Renaissance draughtsmanship; Degas had studied Holbein, Cranach and Dürer closely between 1859 and 1864. This elaborate draughtsmanship is set off against the soft reds on the woman's seat and the stronger red verticals of the wall beyond. It seems to have been added late in the execution of the pastel, and thus probably belongs to its reworking, which suggests that Degas was beginning a more complex rethinking of the whole idea, which was left off in this unfinished state.

The subject relates to the theme of the milliners' shops which Degas was exploring in these years. This interest in the world of fashion was part of his wider fascination with the most artifical elements of modern urban life, seen also in his treatment of subjects from the ballet and café-concert.

PROVENANCE
11eme Vente Degas, Paris, 11 December 1918 (lot 94); with Nunès and Fiquet, Paris; with the Leicester Galleries, London, by January 1922, from whom purchased by Samuel Courtauld 1923. Courtauld Bequest 1948.

EXHIBITED
Degas Exhibition, Leicester Galleries, London, January 1922 (42); Tate Gallery, 1948 (92); Orangerie, Paris, 1955 (75); Manchester, 1962 (58); *Degas: Pastels and Drawings*, Nottingham University, 1969 (20); Courtauld Centenary, 1976 (19); British Museum, 1983 (105); Japan and Canberra, 1984 (25).

LITERATURE
Lemoisne, *Degas*, III, no. 781; D. Cooper, 'The Courtauld Collection', *Burlington Magazine*, CX (June 1948), p. 170; Jamot–Turner, no. 13; Cooper, 1954, no. 115; Franco Russoli and Fiorella Minervino, *L'opera completa di Degas* (Milan, 1970), no. 620.

TECHNICAL DETAILS
Chalk and pastel, with extensive rubbing and effacing; on buff hand-made laid paper. The drawing made up of two sheets placed edge to edge (the artist's registration marks in pencil, upper left and right) and laid down on white wove paper (apparently previously 'tipped' at the edges on to millboard).

Degas, Edgar 1834–1917
AFTER THE BATH, WOMAN DRYING HERSELF
c.1889–90?
Pastel on paper, 67.7 × 57.8 cm.
Unsigned
Stamped in red oval, on original backing:
ATELIER/ED. DEGAS

From the mid-1880s onwards, the subject of women bathing in tubs or drying themselves became one of Degas's central preoccupations. At the eighth Impressionist group exhibition in 1886 he exhibited a set of pastels under the collective title *Sequence of Nudes, of Women Bathing, Washing, Drying, Wiping Themselves, Combing their Hair or Having it Combed*; the present pastel probably dates from a few years after this. At around this date he told George Moore that his aims in his pictures of bathing women were to show 'a human creature preoccupied with herself – a cat who licks herself; hitherto, the nude has always been represented in poses which presupposes an audience, but these women of mine are honest and simple folk, unconcerned by any other interests than those involved in their physical condition. . . . It is as if you looked through a key-hole.' Images such as these have at times been seen as misogynist, by critics from J.-K. Huysmans onwards, but they show the same studied detachment of viewpoint as his treatment of many other themes (compare nos. 8 and 9); there is no savagery in the way that his models are presented. The choice of subject, and the way in which he described it to Moore does, though, reiterate the stereotyped male construction of the female, as being concerned essentially with the physical world, while the (male) artist looks in on it from outside and above.

By this date Degas was using the pastel medium with great improvisatory freedom, producing a great variety of bold marks – broad swathes of white for the towel, more broken accents and smudges on the background and the chair at lower right, and long thin raking lines on the model's body which cut across its three dimensional modelling at some points. The figure is treated in soft, pale nuances of pink and green, but surrounded by the strong, hot colour of carpet, wall and chair; blue is sparingly used, only in the bathtub and at points on the carpet.

Despite the informality of the model's pose, the composition is very carefully organised; within a framework of diagonals, of floor and wall, the curving forms of the figure are tucked in between the bath and the chair, and linked to the top left corner by her arm, to the top right by the quickly notated curtain. At a number of points the modelling of the figure is not fully resolved, notably in the treatment of the right arm; moreover, a number of alterations in the position of the figure can be clearly seen, particularly along the line of her left arm and her right knee. Presumably the work was abandoned in a provisional state, like virtually all of Degas's later works, when his activities were increasingly hampered by his deteriorating eyesight, which led him to favour the more rapidly malleable medium of pastel, in preference to oil paint.

PROVENANCE
1re Vente Degas, Paris, 6 May 1918 (lot no. 281, 25,000 Frs.); Trotti, Paris; with Winkel and Magnussen, Copenhagen; with Galerie Barbazanges, Paris; through Percy Moore Turner, London; Lord Ivor Spencer-Churchill, London; through Percy Moore Turner, London; Samuel Courtauld by 1929. Courtauld Gift 1932.

EXHIBITED
Degas-Utställning, Nationalmuseum, Stockholm, January 1920 (30); *Degas Udstilling*, Ny Carlsberg Glyptothek, Copenhagen, March 1920 (30); Tate Gallery, 1948 (93); Courtauld Centenary, 1976 (18); Japan and Canberra, 1984 (24).

LITERATURE
Home House Catalogue, no. 26; Jamot–Turner, no. 14; Lemoisne, *Degas*, III, p. 558, no. 1011; Cooper, 1954, no. 27.

TECHNICAL DETAILS
Pastel, both dry and with use of the (?) damp brush; on very thin buff wove paper. The drawing made up of two sheets (the second sheet added at the bottom of the drawing, apparently quite early during its execution), both laid down on thin buff wove paper and laid down again on millboard faced with cardboard, 67.7 × 57.8 cm. (including the additional lower sheet, 7.9 × 57.8 cm.).

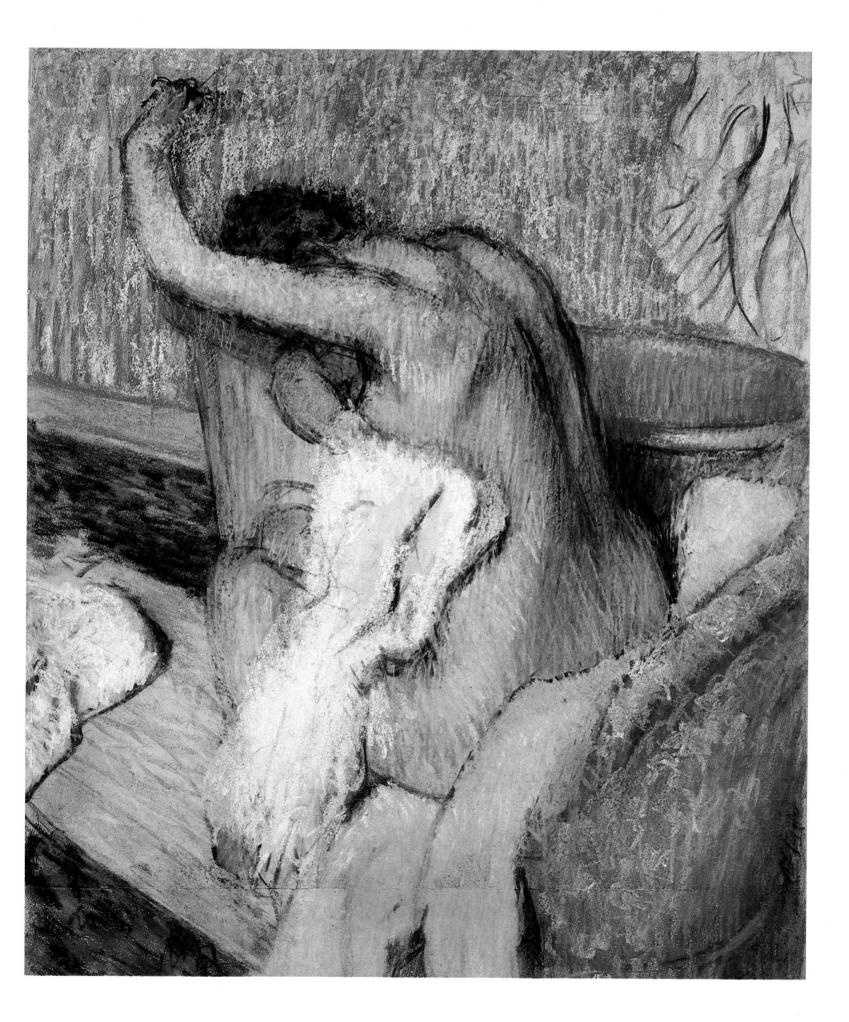

I I

Monet, Claude 1840–1926
AUTUMN EFFECT AT ARGENTEUIL 1873
Oil on canvas, 55 × 74.5 cm.
Signed, bottom right: 'Claude Monet/73'

The town of Argenteuil is in the background, seen looking upstream along an arm of the river Seine, with the Ile Marante on the left; the blue stripe running across below the buildings represents the main channel of the river, flowing from right to left. The picture corresponds closely to Frederick Wedmore's description of a canvas shown at Dowdeswell's Gallery in London in 1883: '. . . palpitating light and golden hue. The whole one side of the canvas is filled with flame-coloured autumn trees which throw their bright reflection of a rosier flame-colour upon a broad river-water otherwise turquoise and coral.'

Of all Monet's paintings of the early 1870s, this is the one in which he most completely abandoned traditional methods of chiaroscuro modelling, by gradations from dark to light tones, in favour of a composition based on clear colours, which are used to model form and evoke space. The picture is dominated by the bold contrast between orange and blue, but the glowing bank of autumnal trees is built up from constantly varied warm hues – pinks and yellows as well as oranges; on the right, soft clear blues indicate the shadows in the trees, and the blues on the far buildings, together with the diminishing scale of the brushstrokes in the water, suggest recession into atmospheric space. The paint surface is densely worked in parts – almost as if encrusted on the trees on the left. Late in the execution of the picture, Monet scraped away some of this paint in long crisp strokes, probably made with the handle of a brush; these are most visible on the right tree, but also appear in the foliage on the left. Presumably they are the result of Monet's dissatisfaction with the density of the paint

layers, but such scraping is extremely unusual in his work.

As often in his landscapes, Monet avoided a direct perspectival lead into the pictorial space, in favour of an open-fronted view across water, so that the viewer is invited to contemplate the spectacle rather than enter into the space in the imagination. At this period Argenteuil was rapidly expanding, both as an industrial town and as a centre for recreational sailing (see Manet no. 2). Often Monet presented the modern facets of the place, but here it appears as if timeless, a few houses presided over by a church spire, framed by the splendour of the sunlit trees.

PROVENANCE
With Durand-Ruel, Paris; Erwin Davis, New York, 1886; with Durand-Ruel, Paris, 1901; G. Hoentschel, Paris, 1904; Comte de Rasti, Paris; with Alexandre Rosenberg, Paris; Hodebert; with Bernheim-Jeune, Paris, 1924; acquired by Samuel Courtauld, May 1924. Courtauld Gift 1932.

EXHIBITED
(?) *La Société des impressionistes*, Dowdeswell and Dowdeswell's (exhibition organised by Durand-Ruel), London, 1883 (16), as 'Le petit bras à Argenteuil'; *The Impressionists of Paris*, American Art Galleries, New York, April 1886, and National Academy of Design, May–June 1886 (282); *Monet*, Union League Club, New York 1891 (68); Tate Gallery, 1948 (44); *Impressionism*, Royal Academy, London, 1974 (71); Courtauld Centenary, 1976 (28); Japan and Canberra, 1984 (64).

LITERATURE
(?) Frederick Wedmore, 'The Impressionists' in *Fortnightly Review*, January 1883, p. 82; 'The Inpressionists' Exhibition' in *The Academy*, 28 April 1883, p. 300; O. Reuterswärd, *Monet* (Stockholm, 1948), p. 283; Cooper, 1954, no. 40; D. Wildenstein, *Claude Monet: biographie et catalogue raisonné*, I: *1840–1881 Peintures* (Lausanne – Paris, 1974), pp. 238–9, no. 290, for full literature; John House, *Monet: Nature into Art* (New Haven and London, 1986), pp. 18, 53, 79, 115, 180, 242 n. 3 (Ch. 11).

TECHNICAL DETAILS
Canvas weave: plain.
Threads per sq.cm.: 27 × 29.
Ground: probably commercial application; colour: white.
Lined.
Varnished.

X-radiograph

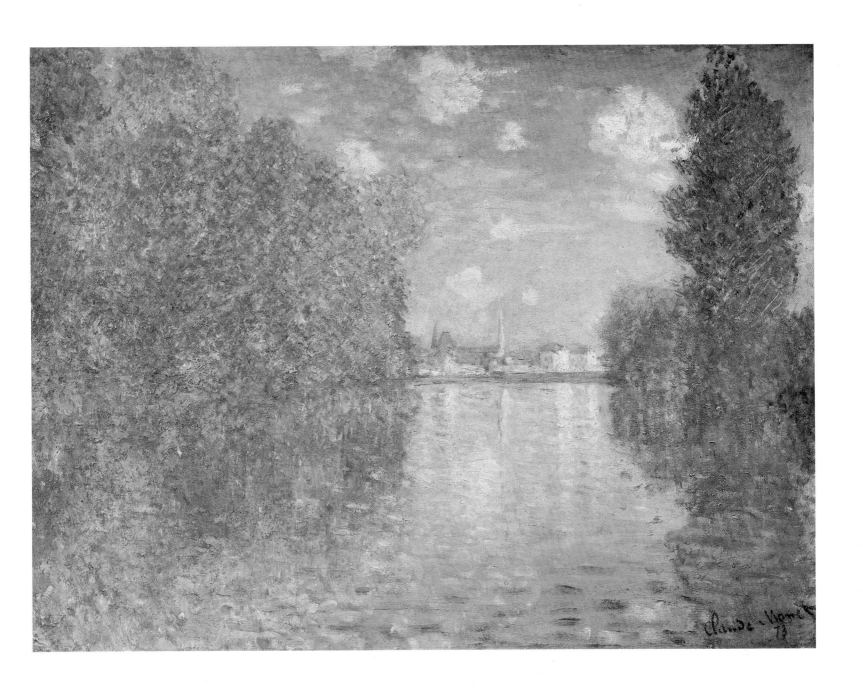

Monet, Claude 1840–1926
VASE OF FLOWERS *c*.1881–2
Oil on canvas, 100.4 × 81.8 cm.
Signed, bottom right: 'Claude Monet'

Between 1878 and 1882, for the only time in his career, Monet concentrated extensively on still lives, alongside his painting of landscapes. In these years he was beginning to find a more regular market for his paintings, and he was able to sell still lives more readily and for higher sums than landscapes; when the dealer Durand-Ruel began to buy his landscapes regularly from 1881 onwards, he soon virtually gave up still life painting. *Vase of Flowers*, a picture of a lavish display of Wild Mallow, very probably belongs to the last group of still lives that he undertook in this phase, a group of particularly large flower paintings, which, his letters show, caused him great trouble.

The final state of *Vase of Flowers* testifies to his difficulties. Although it is densely and elaborately worked, Monet did not complete it for sale at the time of its execution. It was one of many paintings from earlier years which he signed and sold in the last years of his life; indeed, this canvas can be seen hanging on the wall in photographs of his house at Giverny taken around 1920; shortly after this he sold it to the dealers Bernheim-Jeune.

In contrast to the paintings which he completed for sale in the 1880s (such as no. 13, and *Chrysanthemums*, in the Metropolitan Museum of Art, New York, another of the same group of still lives), the forms of leaves and flowers in *Vase of Flowers* are less crisply handled, treated in rapid dabs and dashes of colour which, though complex, do not always define the forms clearly. In his still lives of these years he was seeking to show lavish displays of flowers and fruit which broke out of the more rigid, structured conventions of still life painting in the Chardin tradition, but on this occasion he did not succeed in finding a fully resolved pictorial form for this mass of blooms and greenery. Its vigorous, but slightly crude and even disorderly touch is more akin to twentieth-century tastes than it would have been to those of the buyers of Monet's paintings in the 1880s.

PROVENANCE
With Bernheim-Jeune, Paris; with Alex. Reid, Glasgow, bought by Samuel Courtauld, August 1923. Courtauld Gift 1932.

EXHIBITED
French Art, City Museum and Art Gallery, Birmingham, October 1947 (no cat.); Tate Gallery, 1948 (49); *Monet*, Edinburgh and London 1957 (59); Courtauld Centenary, 1976 (31); Japan and Canberra, 1948 (65).

LITERATURE
Jamot–Turner, no. 17; Home House Catalogue, no. 24; O. Reuterswärd, *Monet* (1948), p. 280; Cooper, 1954, no. 43; D. Wildenstein, *Claude Monet*, I (1974), pp. 382–3, no. 626.

TECHNICAL DETAILS
Canvas weave: plain.
Threads per sq.cm.: 17 × 20.
Ground: commercial application;
colour: cream.
Unlined.
Varnished.
Canvas stamp: H. VIEILLE & E. TROISGROS, 35 RUE DE LAVAL.

Detail of canvas stamp in reverse

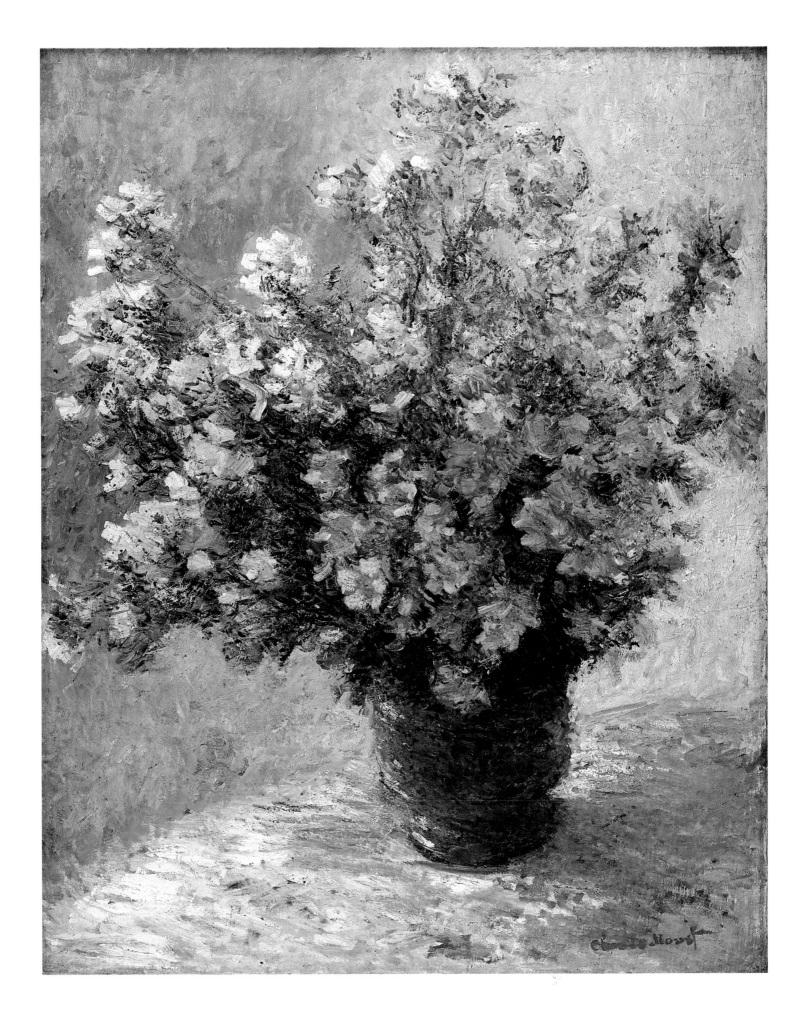

13

Monet, Claude 1840–1926
ANTIBES 1888
Oil on canvas, 65.5 × 92.4 cm.
Signed, bottom left: 'Claude Monet 88'

Monet worked at Antibes from February until May 1888, and on his return exhibited ten paintings of the surroundings of Antibes at the subsidiary branch of the dealers Boussod & Valadon, which was then run by Theo van Gogh, brother of the painter. The present picture was probably one of these. It shows the view south-westwards from the Cap d'Antibes across the Golfe Juan, with the Montagnes de l'Estérel across the background, and the westernmost tip of the Ile Sainte-Marguerite visible at the extreme left. The city of Cannes is just out of sight on the right side of the bay.

In his two spells of painting the Mediterranean in 1884 and 1888, Monet was faced with the problem of capturing the intensity of southern light and colour. He wrote from Antibes about his experiments to Berthe Morisot: 'It's so difficult, so tender and so delicate, while I am so inclined to brutality.' In a letter to Alice Hoschedé, he commented: 'What I bring back from here will be sweetness itself, white, pink and blue, all enveloped in this magical air.' In his southern paintings Monet evoked the effect of the light in part by heightening his colours, but also by co-ordinating the colour relationships throughout the picture, into clear sequences of contrasts. Here, greens and blues are set against sharp accents of pink, red and orange, with related colours recurring all over the canvas. In 1888 an English interviewer described how Monet used colour to unify his paintings:

> One of his great points is to use the same colours on every part of the canvas. Thus the sky would be slashed with strokes of blue, lake, green and yellow, with a preponderance of blue; a green field would be worked with the same colours with a preponderance of green. . . . By working in this way, the same colour appearing all over the canvas, the subtle harmony of nature . . . is successfully obtained without the loss of colour.

It was by combining this weave of colours with emphatic oppositions of complementary contrasts that Monet sought to recreate in paint the effects of the southern sun.

Although it ostensibly conveys a passing effect of outdoor light, the painting is elaborately executed and was clearly extensively reworked. Local preparatory underpainting is visible in the sky and sea. This paint was dry before the upper layers were applied. X-ray examination shows that the sea was originally executed far more boldly, and perhaps originally showed an effect of strong wind, whereas the crisp yet delicate final strokes which enrich the water surface suggest a far calmer effect. During the execution of the picture, he also moved the position of the tree trunk a little to the left; the rich blues on the upper area of the sky were added over a layer of paler colour, and many of the crisp touches which define the outer margins of the foliage were added at a later stage, after the initial painting of the sky had had time to dry. It is possible that many of these adjustments were made at Antibes, where Monet was plagued by changing conditions of wind and weather, but by this date he had come to feel that the final touches on a picture, which gave it its coherence and harmony, needed to be added in the controlled surroundings of his studio. The apparent immediacy and vivacity of his finished paint surfaces was the product of elaborate processes by which he sought to give his canvases an air of spontaneity.

The composition of *Antibes*, with its silhouetted tree and open sides, reflects in general terms Monet's interest in Japanese prints, of which he was an avid collector. In the 1880s he travelled widely, exploring subjects which showed nature at its most lavish and extreme, and his knowledge of Japanese art helped him to find ways of formulating these dramatic effects in pictorial terms. This sort of spectacular subject and treatment is very different from the less obviously picturesque subjects he favoured near home in the Seine valley. In the 1880s, these vivid scenes, often, like *Antibes*, of places which were becoming favoured tourist sites, began to win him buyers; but after 1890 he began to concentrate far more upon nuances of atmosphere in the Seine valley, when he began to paint in long series of canvases showing a single subject under different conditions of light.

Vincent van Gogh was not in Paris when his brother mounted the exhibition of Monet's Antibes paintings, but his friend, the Australian painter J.P. Russell, reported on the exhibition to him. Vincent relayed Russell's reactions back to his brother from Arles, mentioning a painting that is very probably the present canvas:

> [Russell] criticises the Monets very ably, begins by liking them very much, the attack on the problem, the enfolding tinted air, the colour. After that he shows what there is to find fault with – the total lack of construction, for instance one of his trees will have far too much foliage for the thickness of the trunk, and so always and everywhere from the standpoint of the reality of things, from the standpoint of natural *laws*, he is exasperating enough. He ends by saying that this quality of attacking the difficulties is what everyone ought to have.

PROVENANCE
(?) bought from the artist by Boussod Valadon et Cie., June 1888; (?) with Georges Petit, 1888; Mme Vve. Barbedienne, Paris, 1894; sold Drouot, Paris, 24 February 1894 (lot 39), bought Durand-Ruel; Decap, Paris, 1894; with Bernheim-Jeune, Paris, 1907; Baron Caccamisi, Paris, 1907; Mrs Blanche Marchesi, London, c.1910; with Paul Rosenberg, Paris; with Knoedler, London; bought by Samuel Courtauld, August 1923. To Sir John Atkins, London (with a life interest), thence to Home House Society Trustees, a year before Sir John's death, in 1962.

EXHIBITED
(?) *Monet*, Boussod Valadon et Cie., Paris, 1888; *Monet et Rodin*, Georges Petit, Paris, June 1889 (103); *Tableaux par Besnard, Cazin, etc.*, Georges Petit, Paris, 1899 (51); *International Society of Sculptors, Painters and Gravers*, Grafton Galleries, London, 1910 (133); *19th Century French Painters*, Knoedler, London, July 1923 (35); Tate Gallery, 1948 (47); *Impressionism*, Royal Academy, 1974 (77); Courtauld Centenary, 1976 (32); Japan and Canberra, 1984 (66).

LITERATURE
(?) Gustave Geffroy, 'Dix tableaux de Cl. Monet' in *La Justice*, 17 June 1888, p. 1; (?) A. de Calonne, 'L'Art contre nature' in *Le Soleil*, 23 June 1889, p. 1; Arsène Alexandre, *Claude Monet* (Paris, 1921), pp. 87–8; Jamot–Turner, no. 18; L. Venturi, *Les Archives de l'Impressionnisme*, I (Paris, 1939), p. 236; Cooper, 1954, no. 44; John Rewald, 'Theo Van Gogh, Goupil, and the Impressionists', Parts I and II, *Gazette des Beaux-Arts*, LXXXI (January–February 1973), p. 25, Appendix I, (?) pp. 92–3 and 99; Cleveland Museum of Art, *Japonisme: Japanese Influence on French Art, 1854–1910*, 1975, p. 130 and fig. 42; D. Wildenstein, *Claude Monet*, III (1979), pp. 110–11, no. 1192, as 'Montagnes de l'Estérel'; John House, *Monet: Nature into Art* (New Haven and London, 1986), pp. 168–70, 173, 187, 189.

TECHNICAL DETAILS
Canvas weave: plain.
Threads per sq. cm.: 17 × 18.
Ground: commercial application; colour: pale cream.
Lined.
Varnished.

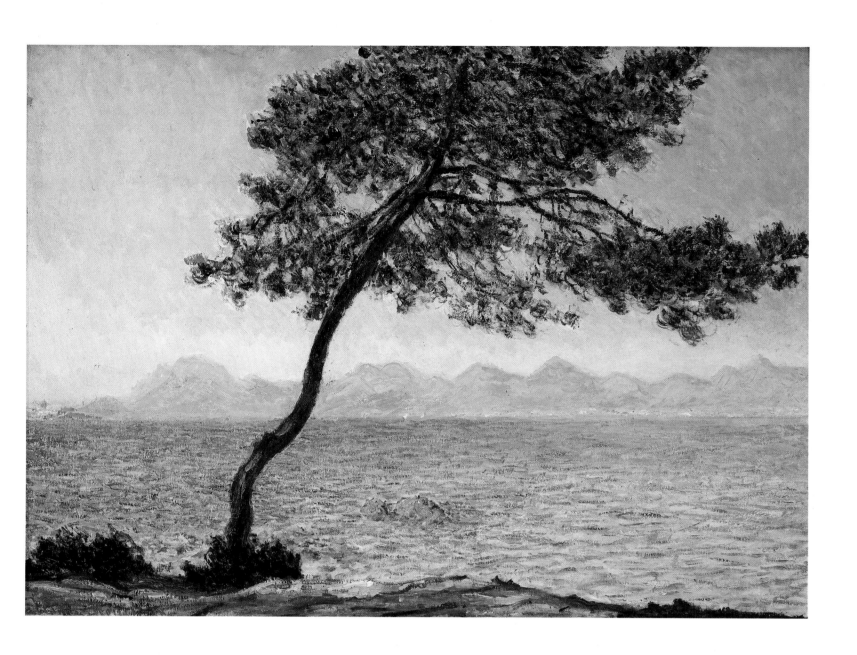

Renoir, Pierre-Auguste 1841–1919
LA LOGE 1874
Oil on canvas, 80 × 63.5 cm.
Signed, bottom left: 'A. Renoir 74'

The artist's brother Edmond and a model, Nini (otherwise known as *Gueule-de-Raie* or 'fish-face'), from Montmartre posed for this painting, which was one of Renoir's prime exhibits at the first group exhibition of the Impressionists in Paris in 1874; the dealer Durand-Ruel then exhibited it in London, but did not buy it, and Renoir sold it in 1875 to another, less ambitious dealer, *père* Martin, for 425 francs – money which Renoir desperately needed in order to pay the rent.

It was at the first group exhibition in Paris in 1874 that the comments of critics about Monet's *Impression, Sunrise* (Musée Marmottan, Paris) led to the group being christened 'Impressionists'. However, Renoir's *La Loge* is very different from Monet's rapid sketch, and far more elaborated than some of Renoir's other exhibits at this show; he continued throughout his career to paint comparatively elaborate, highly finished canvases like this, alongside his more informal canvases.

Yet the technique of *La Loge* is very fluent; forms are delicately and softly brushed without crisp contours, and the execution of the model's bodice and the flowers on it is a particularly virtuoso display. Her face, though, is executed more minutely, its modelling more fully suggested, which makes it the unequivocal focus of the composition. The model's gown, with its bold stripes, gives the composition a strong black and white underpinning; actual black paint is used here, though often mixed with blue to suggest the play of light and shade across it. Around its strong pattern, richly varied nuances of blues, greens and yellow recur in the white materials, set against the soft warm hues of her flesh and the pinks and reds in the flowers on her bodice and hair.

The subject of the theatre box was a favoured one among painters of modern Parisian life during the 1870s. In *La Loge* Renoir makes a play on the contrast between the poses of the two figures: the woman looks out with a half smile on her face and her opera glasses beside her, in her hand, as if to receive the gaze of other members of the audience, while her male companion looks through his opera glasses out from the box and upwards, and thus implicitly at another box, not down at the stage. The caricaturist Gavarni had already explored the same idea in a well-known drawing titled *A Lioness in Her Box*, but with the added satirical point that his woman, seated in the confident expectation of the admiration of her onlookers, is clearly ageing and past her prime, while her male companion peers through his binoculars with evident excitement. Renoir defused this, by presenting his model as young and pretty, seated to receive the gaze of her (male) viewers, while her companion is relegated to the half shadow behind her. In his treatment of his model, Renoir left her exact social and sexual status ambiguous; one of the reviewers of the first group exhibition (where the canvas was well received) described her as a typical *cocotte*, and humorously used her as a warning to young girls of what they might become if they were waylaid by fashion and vanity, while another saw

her as 'a figure from the world of elegance'. Such an elision of the signs of difference was very characteristic of Renoir; unlike Manet (see no. 3), he never painted images which suggested any social uncertainty or division, but, in his paintings of modern Parisian life of the 1870s, he presented all aspects of it as if they were equally harmonious and untroubled.

After the early 1880s he ceased to paint modern Paris altogether (see no. 16), and at the same time adopted a more classical treatment of form and modelling.

PROVENANCE
Bought from the artist by le *père* Martin, Paris (425 Frs.) in 1875; M. Fleurnois, Paris, sold by him to Durand-Ruel, 9 February 1899 (8,500 Frs.); with Durand-Ruel, Paris, sold to Percy Moore Turner, 1925; bought from P.M. Turner by Samuel Courtauld, 1925. Courtauld Bequest 1948.

EXHIBITED
First Impressionist Exhibition, Galerie Nadar, Paris, 15 April–May 1874 (142); Ninth Exhibition of the Society of French Artists, London, November 1874 (12); Exposition des Beaux-Arts, Nantes, 1886 (893); *Renoir*, Galerie Durand-Ruel, Paris, May 1892 (63); *Renoir*, Galerie Durand-Ruel, Paris, April 1899 (74); Exposition Internationale Universelle, Grand Palais, Paris 1900 (562); *La Libre Esthétique*, Brussels, February 1904 (128); Grafton Galleries, London, January 1905 (251); *French Art*, Royal Academy, London, 1932 (415); *Renoir*, Orangerie, Paris, 1933 (17); Tate Gallery, 1948 (56); *Renoir*, Tate Gallery, 1953 (6); Orangerie, Paris, 1955 (39); Courtauld Centenary, 1976 (36); National Gallery, London, 1983 (no catalogue); Japan and Canberra, 1984 (75); *Renoir*, Arts Council of Great Britain, 1985 (26, with bibliography).

LITERATURE
Jamot–Turner, no. 29; Cooper, 1954, no. 51; François Daulte, *Auguste Renoir. Catalogue raisonné de l'oeuvre peint*, I (Lausanne, 1971), pp. 26, 29, 37–8; no. 116; John Rewald, *The History of Impressionism* (New York and London, 4th ed., 1973), pp. 316–34.

TECHNICAL DETAILS
Canvas weave: plain.
Threads per sq.cm.: 30 × 28, very fine.
Ground: commercial application;
colour: cream. Possibly darkened by wax impregnation. Wax lined. The coarse texture of the lining canvas is imprinted on the original.
Varnished.

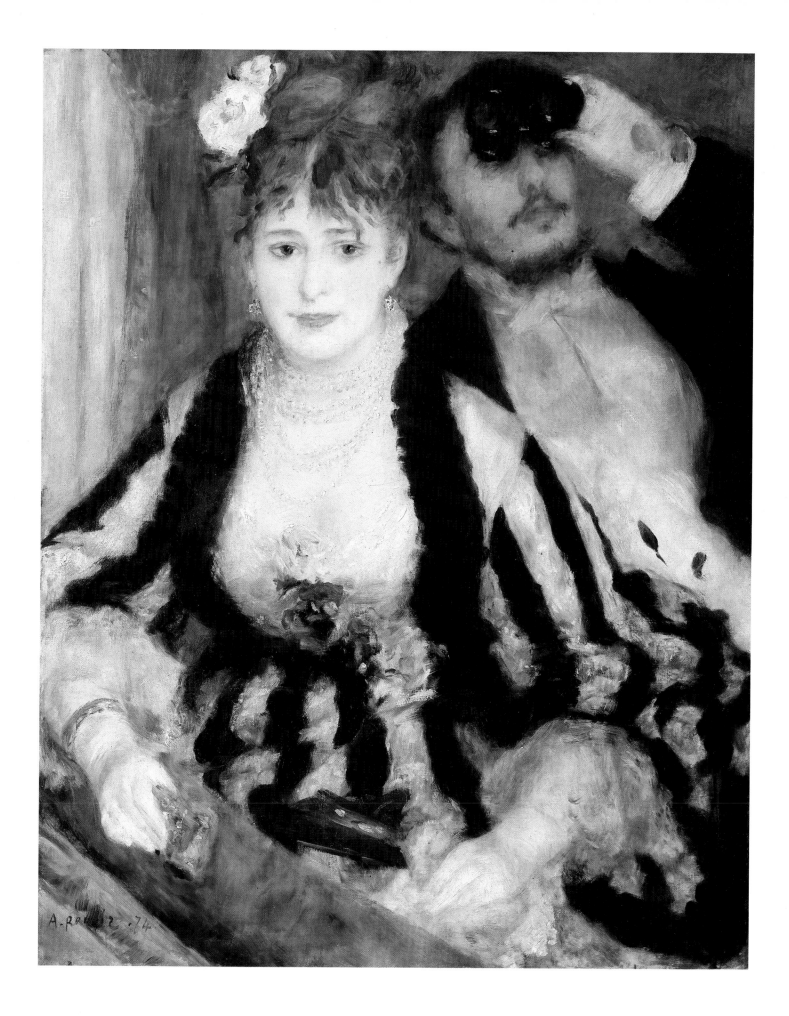

Renoir, Pierre-Auguste 1841–1919
PORTRAIT OF AMBROISE VOLLARD 1908
Oil on canvas, 81.6 × 65.2 cm.
Signed, top left: 'Renoir. 08'

Renoir met the young dealer Vollard around 1895; born on the island of Réunion, Vollard began to buy from Renoir, and after 1900 became one of the principal dealers in his work, though in retrospect his main claim to fame is as the organiser of the first extensive exhibitions of Cézanne's work, from 1895 onwards. Vollard was later to write important books on both Renoir and Cézanne.

Vollard commissioned portraits of himself from many of the artists whose work he bought – from Cézanne, Picasso, Bonnard and others. Of all these, Renoir's is one of the least acute, either as a record of the dealer's ugly, bulldog features, or as an evocation of his cunning, quirky personality. Rather, Renoir chose to make his picture into an image of an archetypal connoisseur, appreciatively holding a statuette, very much in the tradition of such collector portraits of the Italian Renaissance.

Vollard is shown holding a statuette by Aristide Maillol, the *Crouching Woman* of 1900, apparently in its original plaster form. It was around this time that Maillol, at Vollard's request, visited Renoir to execute a portrait bust of him, and the inclusion of the piece by Maillol here may refer to this. Moreover, the simplified, monumental classicism which Maillol evolved from the late 1890s onwards may well be relevant to the development of Renoir's art during these years. In the 1890s, he had looked in particular to the Rococo painters of the French eighteenth century, but after 1900 he seems deliberately to have adopted a broader treatment and a more monumental type of composition and modelling – a sort of timeless classicism (see no. 16).

This development appears in *Portrait of Ambroise Vollard* in the firmly modelled, rounded treatment of the figure, far more distinctly separated from its surroundings than the figures in *La Loge* (no. 14), and also in his return to grey and black as a means of modelling; black had still been used in *La Loge*, but in the mid-1870s he largely abandoned it, using it only when a particular commission demanded it, in favour of modelling suggested by the play of colour alone. He re-adopted black in the 1890s, partly as a result of his studies of the techniques of the old masters, and thereafter he insisted that it was a colour of prime importance in his palette. In this portrait, the comparatively monochrome treatment of the jacket, enriched only by a few coloured nuances on the folds, is set off against the warmth of the flesh modelling and the background. In marked contrast to his earlier work, blue is only very sparingly used, appearing only at a few points on the tablecloth and in the pottery on the table.

PROVENANCE
Given by the artist to the sitter; bought from Vollard by Samuel Courtauld, June 1927. Courtauld Gift 1932.

EXHIBITED
Portraits par Renoir, Durand-Ruel, Paris, June 1912 (48); *Exposition Renoir*, Durand-Ruel, Paris, November 1920 (21); Tate Gallery, 1948 (48); Orangerie, Paris, 1955 (43); Courtauld Centenary, 1976 (40); *20th Century Portraits*, National Gallery, London, 1978 (30); Japan and Canberra, 1984 (76); *Renoir*, London, 1985 (107, with bibliography).

LITERATURE
Jamot–Turner, no. 30; Home House Catalogue, no. 15; A. Vollard, *La Vie et l'oeuvre de Renoir* (Paris, 1919), p. 217; Cooper, 1954, no. 56.

TECHNICAL DETAILS
Canvas weave: plain.
Threads per sq.cm.: 19 × 21.
Ground: 1. commercial application;
2. artist's application; colour: white.
Unlined.
Varnished.

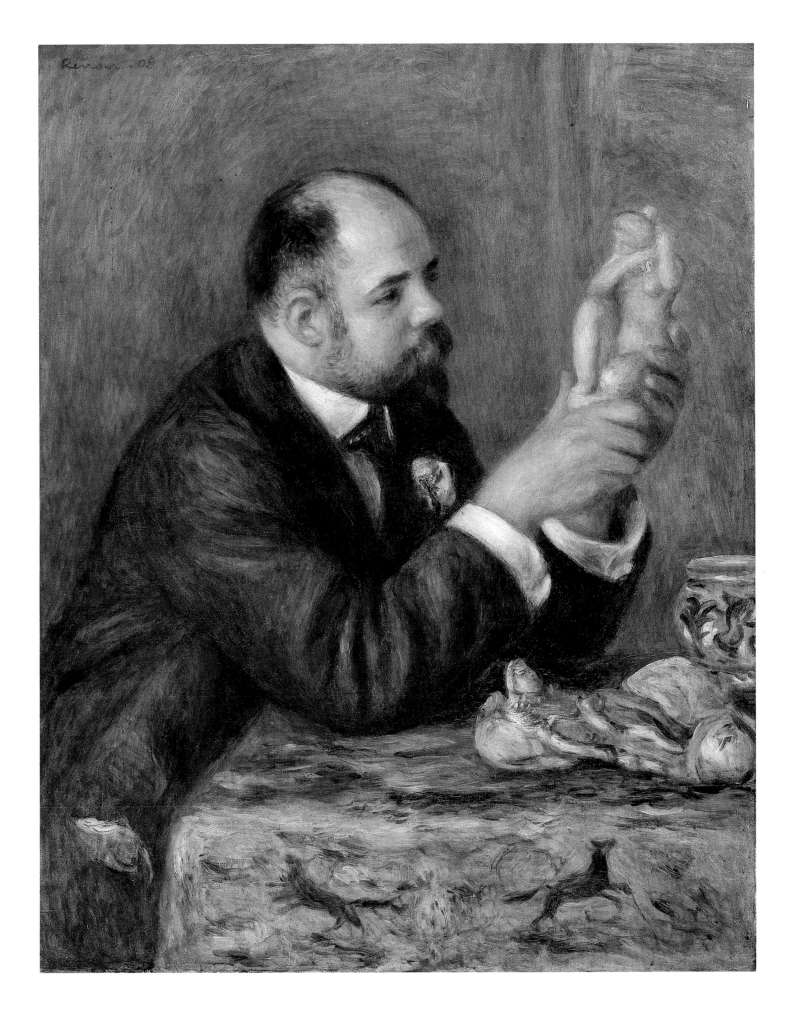

Renoir, Pierre-Auguste 1841–1919
WOMAN TYING HER SHOE c.1918
Oil on canvas, 50.5 × 56.5 cm.
Signed, bottom left: 'Renoir'

One of the first two French paintings bought by Samuel Courtauld (see introduction), this painting was probably executed in 1918 at Cagnes, near Nice on the Mediterranean coast. Renoir had begun to spend his winters in the south in the 1890s, and from 1903 onwards was based in Cagnes, where he built himself a house in 1907–8.

This move was made in part for reasons of health – Renoir was increasingly troubled by rheumatism and arthritis – but it also coincided with important changes in his art. He had become disillusioned with Impressionism's preoccupation with fleeting effects of light and atmosphere, and with the modern Parisian subjects, of fashionable recreations like *La Loge* (no.14), that he had favoured in the 1870s. Instead he came to seek more timeless subjects, treated in a way which drew out the form of the figures, rather than absorbing them in their surroundings; and he looked back to the great tradition of western figure painting, to Raphael, and later to Titian and Rubens.

In his last years, the female nude was one of his principal themes, but he also painted many images of women, dressed or half dressed, engaged in their toilette, playing music, or just seated still. These figures, monumentalised, inexpressive and inactive, express a view of women's role in society to which Renoir clung with increasing insistence – seeing women as creatures of nature, practical, physical and simple, in contrast to man, whose rightful province was the world of intellect and 'culture'.

In his last paintings he evolved a technique which emphasised this surface physicality of woman's world. In *Woman Tying her Shoe* the simple bulk of the figure dominates the composition, with bold ribbons of paint modelling her petticoat, and fine threads of varied colour enriching the treatment of her flesh. Her surroundings are handled in vigorous swirls of colour – the cushions and clothing beyond her and the cushion beneath her feet – which emphasise the lavish physicality of this vision of womankind. The details are deliberately unspecific: the figure is not a modern, fashionable woman, but presented rather as a simple country woman – a creature of 'nature'.

The colour is very rich, dominated by the reds and oranges which Renoir used to evoke the idea of the south as a warm health-giving region where, Renoir said, 'it seems as if misfortune cannot befall one'. The soft blue wall-covering sets off all this warmth below it, but Renoir was no longer using blue to model shadows; for these, he had returned to blacks and greys, used to anchor the parade of warm colour around them.

PROVENANCE
Atelier Renoir, Cagnes; with Galerie Barbazanges, Paris; through Percy Moore Turner, London; Samuel Courtauld, September 1922. Courtauld Gift 1932.

EXHIBITED
Galerie Barbazanges, Paris, June 1922; Independent Gallery, London, September 1922; Tate Gallery, 1948 (61); Orangerie, Paris, 1955 (44); Courtauld Centenary, 1976 (39); Japan and Canberra, 1984 (77).

LITERATURE
Jamot–Turner, no.33; Home House Catalogue, no.13; Cooper, 1954, no.57.

TECHNICAL DETAILS
Canvas weave: plain.
Threads per sq.cm.: 12 × 16.
Ground: commercial application;
colour: white.
Unlined.
Unvarnished.

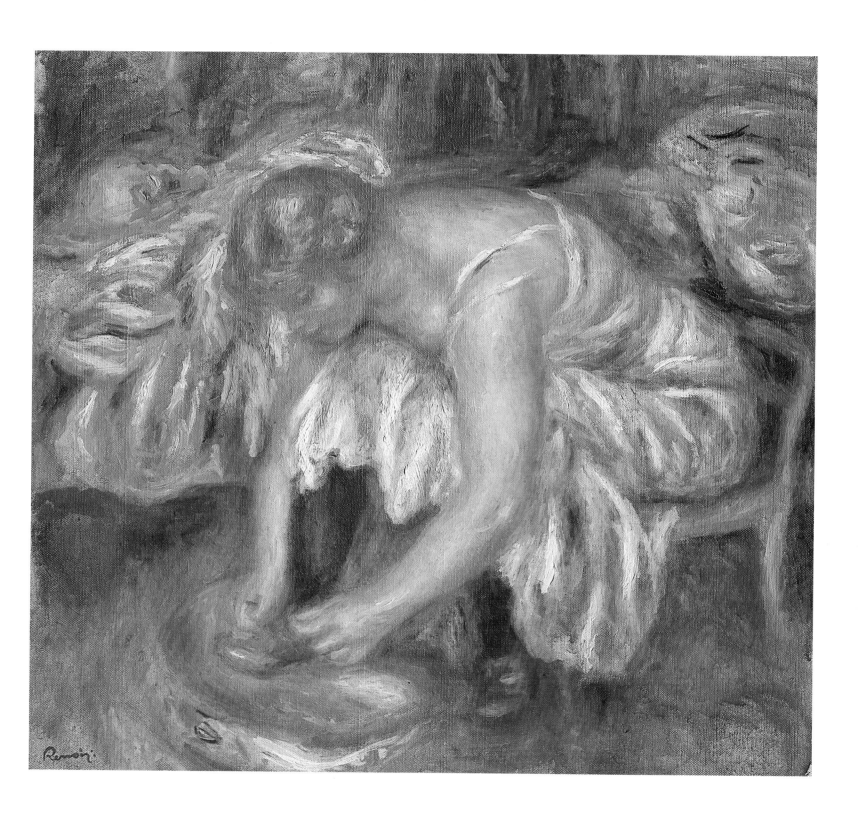

17

Sisley, Alfred 1839–99
SNOW AT LOUVECIENNES 1874
Oil on canvas, 46.3 × 55.8 cm.
Signed, bottom right: 'Sisley'

The village of Louveciennes lies near the river Seine, about ten miles west of Paris; Sisley painted many views in and around the place in the 1870s, and both Monet and Pissarro also painted there. The subject of the picture is a simple, everyday scene, of no obvious picturesque potential: humble houses set along a road, with a particularly uninviting foreground – rough verge, open road, tree trunks and a stretch of wall. The figures give a sense of scale, but, treated very summarily and placed in the middle distance, they do little to characterise the scene. It is by the delicacy of the treatment of atmospheric effects – by the nuances of colour and touch – that Sisley gave this outwardly unprepossessing scene its pictorial interest.

Although the tonality of the painting is comparatively subdued, and the trees to the right and left give it a dark-toned frame, the effect of an overcast winter day is evoked by soft variations of colour – blues across the distant hills and houses set against the soft creams and beiges of the road and nearer buildings, with a scatter of broken touches across the verge on the left. The paint is quite thin throughout the picture; more broadly painted areas alternate with zones built up from successions of varied smaller touches, like the verge at the bottom left. Though the brushwork has no dominant rhythm, the soft variegations of touch and colour give the whole painting a freshness and mobility. The light-toned priming of the canvas shows through the paint at many points and heightens the luminosity of the effect.

In 1875 Sisley painted a second picture of precisely the same subject, in summer, but there is no evidence that he intended the two to be seen as a pair.

PROVENANCE
Ch. de Hèle, Brussels; de Hèle Sale, Amsterdam, 13 June 1911 (lot 13; 2,750 florins); with Bernheim-Jeune, Paris; with Durand-Ruel, Paris; with Paul Rosenberg, Paris; through Percy Moore Turner, London; Samuel Courtauld, June 1926. Courtauld Gift 1932.

EXHIBITED
Exposition Sisley, Durand-Ruel, Paris, February 1902 (6); *Sisley*, Durand-Ruel, Paris, January 1922 (9); *Masterpieces of French Art of the 19th Century*, Agnew, London, July 1923 (1); Tate Gallery, 1948 (75); Orangerie, Paris, 1955 (58); Courtauld Centenary, 1976 (54); Japan and Canberra, 1984 (89).

LITERATURE
Jamot–Turner, no. 5; Home House Catalogue, no. 17; Cooper, 1954, no. 73; François Daulte, *Alfred Sisley. Catalogue raisonné* (Lausanne, 1959), no. 150.

TECHNICAL DETAILS
Canvas weave: plain.
Threads per sq.cm.: 31 × 32, very fine.
Ground: commercial application; absorbent; colour: near white.
Unlined.
Varnished.
Canvas stamp: LATOUCHE, 34 RUE DE LAFAYETTE.

18

Sisley, Alfred 1839–99
BOATS ON THE SEINE c.1877
Oil on canvas, laid down on plywood, 37.2 × 44.3 cm.
Signed, bottom right: 'Sisley'

This canvas is smaller and more sketchily treated than most Impressionist paintings of the 1870s, but the fact that it is signed suggests that Sisley regarded it as a complete work in its own right. Throughout the decade, the landscapists of the group painted rapid sketches such as this alongside more elaborated canvases; the sketches were particularly appreciated by fellow artists and the most 'artistic' of collectors, whereas their more highly worked pictures were more likely to find buyers through the dealer market.

By 1877, Sisley's brushwork had become more broken and energetic (cf. no. 17); the whole scene is animated by hooks, dashes and streaks of colour which capture with great vigour the effect of a sunny, breezy day. However, for all the picture's apparent speed of execution, the light and weather on a day such as this must have changed far too quickly for Sisley to capture them at once, while they lasted; even a picture such as this must have involved a complex act of memory and synthesis, in order to evoke so fresh an effect. The light-toned canvas priming, seen in many places, enhances the luminosity, but the true highlights of the picture are the vigorous white accents in the clouds and on the barges and the far houses. Even the darkest tones in the scene – on the barge and the bank – are coloured, built up of very deep blues and reds, and the distance is suggested by gradations of blue set against the green foliage and the sharp red accents of the distant roofs.

The subject, dominated by the unloading of wood from a river barge, with a passing passenger-ferry on the river, is explicitly modern, presenting the Seine at Billancourt (across the river from Sèvres on the south-western outskirts of Paris) not as a rural retreat but as a commercial and recreational waterway.

PROVENANCE
(?) Richard Samson, Hamburg; with Matthiesen Gallery, London; Samuel Courtauld, 1947. Courtauld Bequest 1948

EXHIBITED
Tate Gallery, 1948 (77); Courtauld Centenary, 1976 (55); Japan and Canberra, 1984 (90).

LITERATURE
Cooper, 1954, no. 75; Daulte, no. 273.

TECHNICAL DETAILS
Canvas weave: plain.
Threads per sq.cm.: 23 × 23.
Ground: commercial application;
colour: light cream.
Marouflaged onto two laminated wood panels.
Varnished.

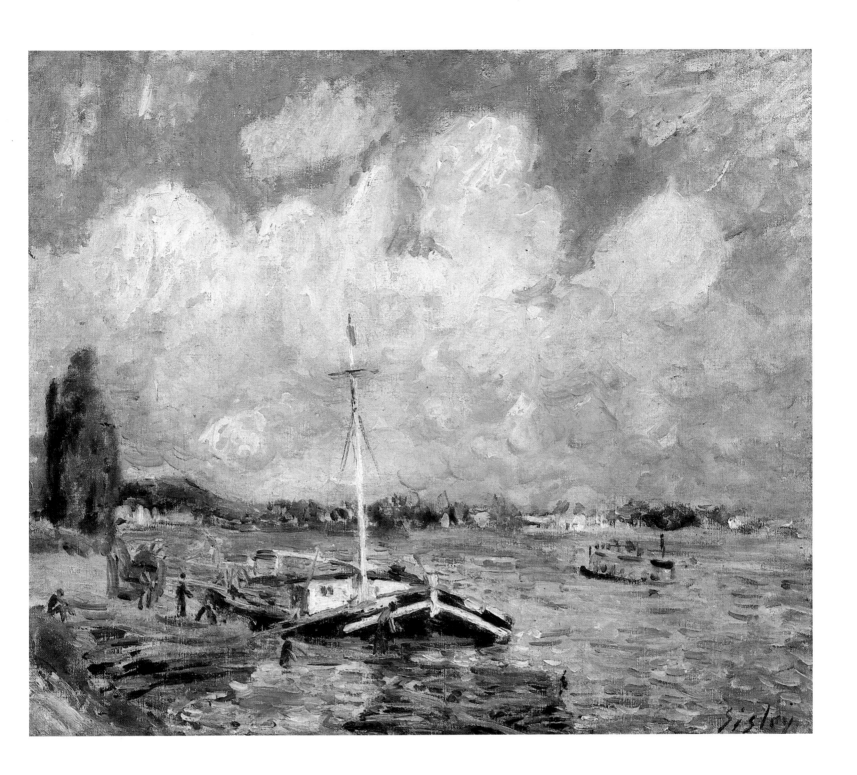

19

Boudin, Eugène 1824–98
THE BEACH AT TROUVILLE 1875
Oil on panel, 12.5 × 24.5 cm.
Signed, bottom left: 'E. Boudin'

In 1862 Boudin began to paint fashionable figures on the beaches of the celebrated holiday resorts of Trouville and Deauville on the Normandy coast. In his previous paintings he had explored the coastline around his home town of Le Havre, just across the Seine estuary from Trouville, but it was with this genre of modern life beach scene that he won a reputation. In 1868 he wrote to his friend M. Martin: 'These gentlemen congratulate me for having dared to put down on canvas the things and people of our own time, for having found the way to gain acceptance for men in great-coats and women in waterproofs. . . . The peasants have their favoured painters . . . but the bourgeois who walk on the jetty towards the sunset, don't they have the right to be fixed on canvas, to be brought out into the light?'

He worked on the beaches in a variety of media – in pencil and watercolours as well as oils. His more elaborate paintings of such figure subjects were very probably reworked, or indeed entirely executed, in the studio, but small, loosely handled panel-paintings like this were very probably painted on the spot. The technique is nevertheless quite complex. Four distinct stages in the painting process can be discerned and clearly seen in the area of the head and shoulders of the woman on the extreme left. Two layers of blue paint were broadly and thinly applied and allowed to dry before the figures were added. The ridges of the brushstrokes of this blue underpainting can be seen under the figures. The figures themselves are swiftly painted, wet in wet. The sky was the final stage in the painting, added around the figure, small marks were scratched into the still wet paint diagonal to the direction of the brushwork revealing the blue underpainting. In this picture, Boudin adopted his characteristic compositional arrangement, of groups of figures loosely strung across an elongated horizontal format, with no clear centre of attention; by this he could suggest the informal clusters of holidaymakers gathered along the beach.

PROVENANCE
Anon.; Louis de Wild, the Hague; sold Hotel Drouot, Paris, 29 May 1920 (lot 11); with Knoedler, London and New York, by 1925–6; Samuel Courtauld, July 1926. Courtauld Gift 1932.

EXHIBITED
Tate Gallery, 1948 (3); Orangerie, Paris, 1955 (2); Courtauld Centenary, 1976 (2); Japan and Canberra, 1984 (4).

LITERATURE
Jamot–Turner, no. 2; Home House Catalogue, no. 20; Cooper, 1954, no. 4; Robert Schmit, *Eugène Boudin 1824–98*, I (Paris, 1973), p. 363, no. 1033 as 'Scène de plage à Trouville'.

TECHNICAL DETAILS
Inscribed, bottom right: 'Trouville '75'.
Poplar panel, 0.5 cm. thick.
Ground: artist's application;
colour: white. It barely fills the wood grain.
Varnished.

20

Boudin, Eugène 1824–98
DEAUVILLE 1893
Oil on canvas, 50.8 × 74.2 cm.
Signed, bottom left: 'Deauville/E. Boudin 93'

In his later work, Boudin concentrated more on the open panoramas of the Normandy beaches than on the holidaymakers who peopled them (contrast no. 19). The figures here are rapidly indicated – holidaymakers, it seems, over by the water, working men with their cart and horses on the left – so that we sense the varied uses of the beach. But light and atmosphere form the principal subject of the painting.

Though Boudin had worked closely with Monet in the 1860s, and exhibited in the first group exhibition in 1874, he never fully adopted the broken touch and lavish atmospheric colour of the Impressionists. His brushwork remained rather tighter and more graphic, suggesting forms and textures very delicately, and his colour more restrained, though nuances of blue and green are used here to suggest the forms in the distance. In this sense, Boudin remained faithful to the *peinture claire*, the luminous, blonde painting, of which he had been a pioneer in the 1850s.

By this refined touch and colour, Boudin managed to evoke the vast scale of the beach and sky, bearing witness to the skills which led Corot to christen him the 'king of skies'. However, the execution of the canvas was a more complex business than appears at first sight. Where the primed canvas is visible in the sky area, it shows a speckled worn surface, indicating that it was rubbed or scraped down in order to reduce an early paint layer, a blue which shares signs of this abrasion, and the process inevitably removed the upmost ridges of the canvas weave. The present state of the sky for all its apparent freshness, is thus a thorough revision of the painting's original effect and exploits the partial retention of the underlying blue layer.

PROVENANCE
Dr Delineau, Paris; Vente Dr Delineau, Hotel Drouot, Paris, 1 February 1901 (lot 36); Devilder, Roubaix, France; with Wildenstein, Paris, London & New York; Samuel Courtauld, July 1936. Courtauld Bequest 1948 (on loan to Lord (R.A.) Butler until 1983).

EXHIBITED
Tate Gallery, 1948 (4); Courtauld Centenary, 1976 (3); Japan and Canberra, 1984 (5).

LITERATURE
Cooper, 1954, no. 5 (where incorrectly dated 1883); Robert Schmit, *Eugène Boudin 1824–98*, III (Paris, 1973), p. 210, no. 3150 as 'Deauville. La Plage. Marée Basse', 1893.

TECHNICAL DETAILS
Canvas weave: plain.
Threads per sq.cm.: 26 × 29.
Ground: artist's application;
colour: cream.
Lined.
Unvarnished.

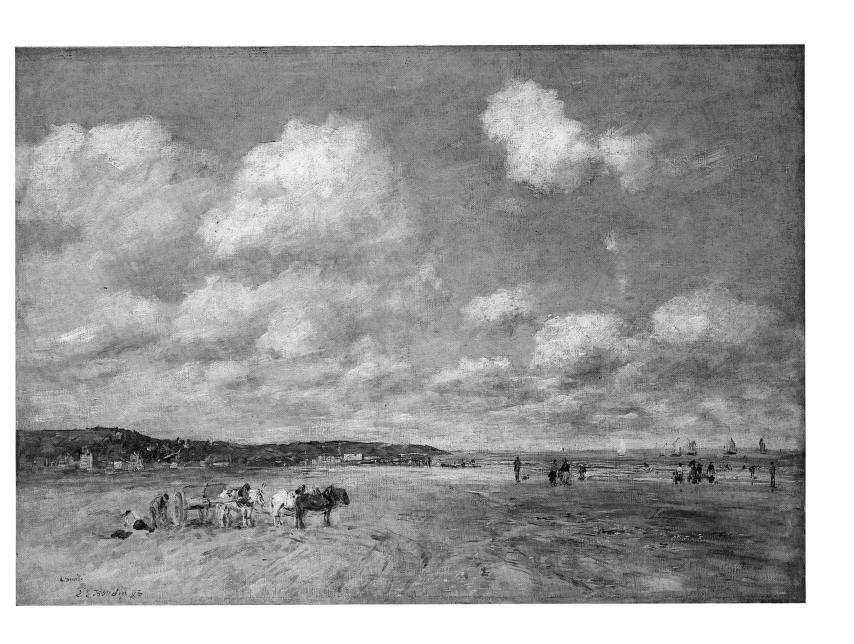

Cézanne, Paul 1839–1906
THE ETANG DES SOEURS, OSNY *c.*1875
Oil on canvas, 60 × 73.5 cm.
Unsigned

X-radiograph

Osny is a village near Pontoise, north of Paris, where Pissarro lived in the 1870s; Cézanne worked with him there on several occasions during the decade. This painting has normally been dated to 1877, but was very probably painted in 1875; there is no record of him visiting Pontoise that year, but he was in the north of France, and a visit to Pissarro might well have passed unrecorded. Cézanne had initially worked with Pissarro in 1872–4 in order to learn the discipline of working from closely observed natural effects (see no. 5), but by around 1874 both men began to work with denser, more tightly structured zones of paint, and in several paintings dated 1875 Pissarro made extensive use of the palette knife. *The Etang des Soeurs, Osny* is one of a group of paintings by Cézanne which are closely comparable to these; by 1877, Cézanne, like Pissarro, was again working only with the brush, and with a far more broken touch.

The knife is used here to build up the composition in bold swathes of paint, particularly in the foliage of the trees. In some places the paint is applied in denser blocks of colour, but the rhythm of the foliage is achieved by broad movements with the knife, creating a strong directional movement across the central area. Some sweeps of paint cover considerable areas of the picture with great simplicity, but others cover the underlying layers so thinly that they set up complex relationships with the colours seen through from below. The apparent breadth of this knifework belies the delicacy with which the knife is used. The brush is also employed on occasion, particularly in some of the narrower trunks and branches, but in the principal trunks the paint is largely built up from complex, superimposed knife strokes.

Green is the dominant colour of the picture; vivid yellow-greens appear in the sunlit foliage across the water, and strong clear greens are used in other areas, while the more shadowed zones are suggested in part by darker greens, in part by the mixture of blue with the colour, thus combining tonal and colouristic methods of modelling. Small warm-coloured accents enliven the composition, and at certain points, such as on the main tree trunks and along the far edge of the water, rich juxtapositions of blue with warm oranges, reds and browns create a more elaborate effect.

We have no clear evidence of how far Cézanne worked out of doors on paintings such as this, but it is likely that it was, in part, executed in front of the subject. However, the forms are simplified and rather stylised, with the arcs of trunks and branches framing the broad sweeps of the foliage. By using the knife, Cézanne gave the surface an overall coherence through the breadth and flatness of the paint layers, but the movements of the knife also give the areas of foliage a strong directional rhythm, running across and down from left to right; individual areas also acquire distinctive shapes of their own, rhyming with other similar shapes, most notably in the bands of dark leaves which lie over the sunlit foliage beyond. By the early 1880s, Cézanne was working with the brush, in delicate parallel strokes of colour, but in the trees in no. 23, for instance, these finer strokes are grouped so as to create rhythms and patterns whose overall effect is comparable to the foliage here. The X-radiograph underlines the similarity of handling; individual touches with the knife or brush can be clearly distinguished with characteristic accumulations of paint at the end of each stroke. In no. 23 Cézanne must have used the brush to place the paint on the canvas in a way rather like the manner in which he used the palette knife. The variations in the density of the ground around the cusped weave of the canvas edges indicate that the ground was applied when the painting was already stretched, and is therefore likely to be the artist's own application.

PROVENANCE
Camille Pissarro, Paris; Alphonse Kann, St. Germain-en-Laye; with Galerie Barbazanges, Paris; Reininghaus, Vienna; with Galerie Barbazanges, Paris; with Alex. Reid, Glasgow; with Agnew, London, from whom acquired by Courtauld in July 1923. Courtauld Gift 1932.

EXHIBITED
Französische Kunst des 19.u. 20. Jahrhunderts, Kunsthaus, Zürich, November 1917 (19); *Masterpieces of French Art of the 19th Century*, Agnew, London, July 1923 (3); *Cézanne*, Leicester Galleries, London, June 1925 (15); Tate Gallery, 1948 (5); *Cézanne*, Edinburgh and London, 1954 (16); Orangerie, Paris, 1955 (3); Courtauld Centenary, 1976 (4); Japan and Canberra, 1984 (7).

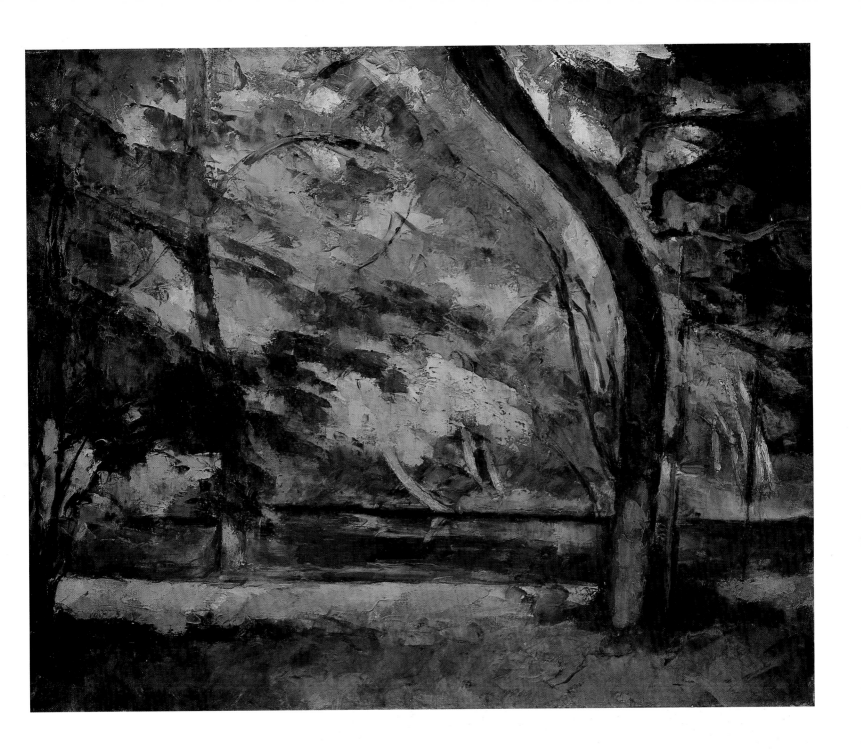

LITERATURE
Home House Catalogue, no. 74; Venturi, *Cézanne*,
no. 174; Cooper, 1954, no. 6; William Rubin (ed.),
Cézanne. The Late Work (London and New York
1977–8), pp. 5–6.

TECHNICAL DETAILS
Canvas weave: plain.
Threads per sq.cm.: 13 × 15.
Ground: artist's application;
colour: cream.
Lined.
Varnished.

22

Cézanne, Paul 1839–1906
FARM IN NORMANDY: THE ENCLOSURE 1882?
Oil on canvas, 49.5 × 65.7 cm.
Unsigned

In 1882, Cézanne's principal patron, Victor Chocquet, inherited a farm at Hattenville near Yvetot in Normandy, and Cézanne very probably visited him there that summer; this is one of a group of four closely related paintings of Normandy orchards, all of them originally in Chocquet's collection, which presumably show the place.

Though the picture is comparatively small and not elaborately finished, Cézanne built up a composition with a real monumentality, framed by the arching branches from the left trees, and structured by the rhythm of the background trunks. The canvas was left off at a point when some areas were more fully worked than others. At the top left the background is blocked in with simple muted patches of colour, thinly applied, and the grass is treated in broad sweeps of quite uniform colour; but at certain points in the foliage the brushwork is far more broken and rhythmic, in crisp parallel strokes which suggest the texture of the foliage at the same time as giving the painting a taut surface structure. This type of brushwork, Cézanne's so-called 'constructive stroke', appears again in no. 23. The greens which dominate the composition range from light and yellowish where the foliage is caught by the light, to duller hues with rich nuances of blue in the shadows; against this play of cool colours are set successions of warm touches — heightened red accents which appear seemingly without naturalistic justification, on tree trunks and branches, and on the roof edge on the left.

The sticks or saplings on the meadow to the right reveal most clearly Cézanne's process of revising his compositions. Though this area is not thickly painted, their placing was altered at least twice. Both verticals are overpainted, across the top of the area of open grass, with a stroke of green, as if both were to be erased, or perhaps their bases raised so that they seem to stem from the hedge; moreover, the left vertical was moved; its previous position can still be seen, not fully covered by reworking, at the same angle and about $\frac{3}{4}$ inch to the right of its present position. Since Cézanne did not have to sell his paintings in order to survive, he abandoned many of them when different areas of them were in different states of completion and certain parts were left unresolved. This blatant rejection of traditional notions of 'finish' in painting has fascinated twentieth-century viewers, who have come to see such visible evidence of the artist's working methods as the direct expression of creative genius.

PROVENANCE

Victor Chocquet, Paris; Vente Chocquet, Paris, 1, 3 and 4 July 1899 (lot 11, as L'Été); Ambroise Vollard, Paris; with Bignou, Paris; with Reid and Lefèvre, London; Samuel Courtauld, July 1937; Lady Aberconway, '1948; private collection, London.

EXHIBITED

Paintings from the Vollard Collection, Knoedler, New York and Detroit, November 1933 (7); Tate Gallery, 1948 (6); Landscape in French Art, Royal Academy, 1949 (316); Cézanne, Edinburgh and London, 1954 (30); Orangerie, Paris, 1955 (4); Impressionism, Royal Academy, 1974 (53); Courtauld Centenary, 1976 (5).

LITERATURE

Venturi, Cézanne, no. 443; Cooper, 1954, no. 7; John Rewald, 'Chocquet and Cézanne' in Studies in Impressionism (London, 1985), pp. 151–2, 165, and 184, n. 73.

23

Cézanne, Paul 1839–1906
THE TALL TREES AT THE JAS DE BOUFFAN *c.*1883
Oil on canvas, 65 × 81 cm.
Unsigned

The Jas de Bouffan was the house and estate owned since 1859 by the artist's father, Louis-Auguste Cézanne, a wealthy banker; it lies about a mile and a half west of the centre of Aix-en-Provence. Cézanne painted many views of the house and grounds from 1866 until he sold the estate in 1899, and found there the solitude that he needed in order to work, both in the garden and in his studio in the house.

The Tall Tress at the Jas de Bouffan is a particularly clear illustration of Cézanne's painting technique at the period. Working from a light creamy priming (still seen unpainted in places, for instance near the bottom right corner), he first laid on comparatively simple, flat layers of colour, such as those seen to bottom right, to lay out the essential planes of the composition. These were gradually refined by the addition of variegations of colour in crisper, more distinct brushstrokes; he did not work up the whole composition simultaneously, but focused on certain salient points, leaving other areas scantily painted. In its more highly worked parts, the resulting painting is covered with a network of rhythmic strokes, often running in sequences parallel to each other; their varied colour gives a shimmer and richness to the whole surface and a sense of light and atmosphere, but their ordered arrangement, and the simplified monumentality of the tree trunks, give the painting a structure which transcends the mobile effects of light on foliage which were Cézanne's starting point. This treatment of the surface in sequences of parallel brushstrokes has been described as Cézanne's 'constructive stroke';

it can be compared with the evenly weighted, rhythmic handling adopted by his friend Pissarro in the same years (see no. 6).

The colour in the picture is clear and rich, with strong reds and oranges set off against the dominant network of blues and greens; even the more subdued areas of the picture, such as the tree trunks amid the foliage, are enlivened by accents of stronger, warmer colour. This heightened range of colours, adopted to evoke the rich coloured light of southern France, is a contrast to the rather duller, denser greens of no. 22, painted in Normandy in the same period. In 1876 Cézanne wrote to Pissarro about his observations of the light of the Mediterranean: 'The sunlight is so dazzling that it seems to me as if the objects are silhouetted not only in white and black, but in blue, brown and violet. I may be mistaken, but this seems to me to be the opposite of modelling.' It was his experience of painting in the south that showed Cézanne how to make the final break with tonal, chiaroscuro modelling, in favour of translating effects of sunlight into colour (compare Monet no. 13). At the end of his life, Cézanne said: 'I was pleased when I made the discovery that sunlight cannot be reproduced, but that it must be represented by something else, by colour.'

PROVENANCE
Ambroise Vollard, Paris; with Paul Rosenberg, Paris; Samuel Courtauld, 1924. Courtauld Bequest 1948.

EXHIBITED
Grands maîtres du 19me siècle, Paul Rosenberg, Paris, April 1922 (11); *Cézanne*, Leicester Galleries, London, June 1925 (16); Tate Gallery, 1948 (11); *Cézanne*, Edinburgh and London, 1954 (33); Orangerie, Paris, 1955 (8); Courtauld Centenary, 1976 (7); Japan and Canberra, 1984 (8).

LITERATURE
Jamot–Turner, no. 20; Venturi, *Cézanne*, no. 475; Cooper, 1954, no. 11.

TECHNICAL DETAILS
Canvas weave: plain.
Threads per sq.cm.: 14 × 19.
Ground: commercial application;
colour: cream.
Lined.
Varnished.

X-radiograph

24

Cézanne, Paul 1839–1906
THE MONTAGNE SAINTE-VICTOIRE *c*.1887
Oil on canvas, 66.8 × 92.3 cm.
Signed, bottom right: 'P. Cezanne'

The Montagne Sainte-Victoire lies to the east of Cézanne's birthplace, Aix-en-Provence, and from many points of view its broken silhouette dominates the town. Cézanne painted it from many viewpoints throughout his career, and it was clearly a subject to which he attributed great significance. In this composition, it is seen from a vantage point to the west of Aix, near Cézanne's family home, the Jas de Bouffan (see no. 23), with the valley of the Arc in the foreground and an aqueduct to the far right; the mountain peak lies about eight miles from this viewpoint, but Cézanne, by focusing on a comparatively small part of the scene in front of him, gave the mountain its dominant role in the composition. A variant of this subject, including the trunk of another pine tree on the right, is in the Phillips Collection, Washington.

When this painting, along with a *Champ de blé*, was shown by invitation at the exhibition of the Société des Amis des Arts at Aix (a society of amateur artists) in 1895, it was received with incomprehension, but it attracted the admiration of the young poet Joachim Gasquet, son of a childhood friend of Cézanne; when Cézanne realised that the young man's praise was sincere, he signed the picture and presented it to him, initiating a friendship which lasted until around 1904. It is one of the very few paintings from after 1880 to which Cézanne added his signature. In 1908, two years after Cézanne's death, Gasquet sold it for the very high price of 12,000 francs to the dealers Bernheim-Jeune.

In comparison with *The Tall Trees at the Jas de Bouffan* (no. 23), the picture shows a simplification of Cézanne's painting technique. Traces of his system of parallel brushstrokes remain, particularly in some of the foliage, but elsewhere the paint areas are flatter and less variegated, with soft nuances of colour introduced to suggest surface texture and the play of light. In places the cream priming of the canvas is left bare, and its luminosity contributes to the overall tonality of the picture. Traces of the initial underdrawing, in Prussian blue paint, remain visible in the final state of the painting. Infra-red photography reveals how extensive this preparatory drawing was.

Recession into distance is suggested by the gradual transition from the clearer greens and orange-yellows of the foreground to the softer atmospheric blues and pinks on the mountain, but even the foreground foliage is repeatedly tinged with blues, and pinks and reds – notably on the branch silhouetted against the sky – knit the foreground forms to the far mountain. The placing of the branches, carefully framing the contour of the mountain, enhances this surface coherence. Small touches of red were added in several parts of the composition at a late stage in its execution in order to emphasise these interconnections, most conspicuously, the crisp red stroke on the roof of the tiny building about four inches above the bottom centre of the canvas. The treatment of the whole picture, with zones of cooler and warmer colour virtually alternating as the viewer's eye moves up its surface and into space, transforms its natural subject into a composition of great order and monumentality.

PROVENANCE
Given by the artist in 1896 to Joachim Gasquet, Aix-en-Provence; sold by Gasquet to Bernheim-Jeune, Paris, 1908; through Percy Moore Turner, London; acquired Samuel Courtauld, April 1925. Courtauld Gift 1934.

EXHIBITED
Société des Amis des Arts, Aix, 1895 (23); *Französische Kunst des 19.u. 20. Jahrhunderts*, Kunsthaus, Zürich, November 1917 (35); *Grands maîtres du 19me siècle*, Paul Rosenberg, Paris, April 1922 (10); Centenary Exhibition, Norwich, October 1925 (63); *Cézanne*, Galerie Pigalle, Paris, 1929 (6); *French Art*, Royal Academy of Arts, London, 1932 (457); Tate Gallery, 1948 (10); *Cézanne*, Art Institute, Chicago, and Metropolitan Museum, New York, 1952 (52); *Cézanne*, Edinburgh and London, 1954 (39); Orangerie, Paris, 1955 (9); Courtauld Centenary, 1976 (8); National Gallery, London, Feb.–March 1983 (no catalogue); Japan and Canberra, 1984 (9).

LITERATURE
Joachim Gasquet, *Cézanne* (Paris, 1921), pp. 54, 79; Home House Catalogue, no. 75; Venturi, *Cézanne*, no. 454; John Rewald, *The Ordeal of Paul Cézanne* (London, 1950), pls. 84–5; Cooper, 1954, no. 12; Henri Perruchot, *Cézanne*, 1961, pp. 263–4; John Rewald, *Cézanne, Geffroy et Gasquet, suivi de souvenirs sur Cézanne de Louis Aurenche et de lettres inédites* (Paris, 1960), pp. 20, 29, 39, 49, 50; Erle Loran, *Cézanne's Composition* (3rd ed., Berkeley, 1963), p. 60.

X-radiograph

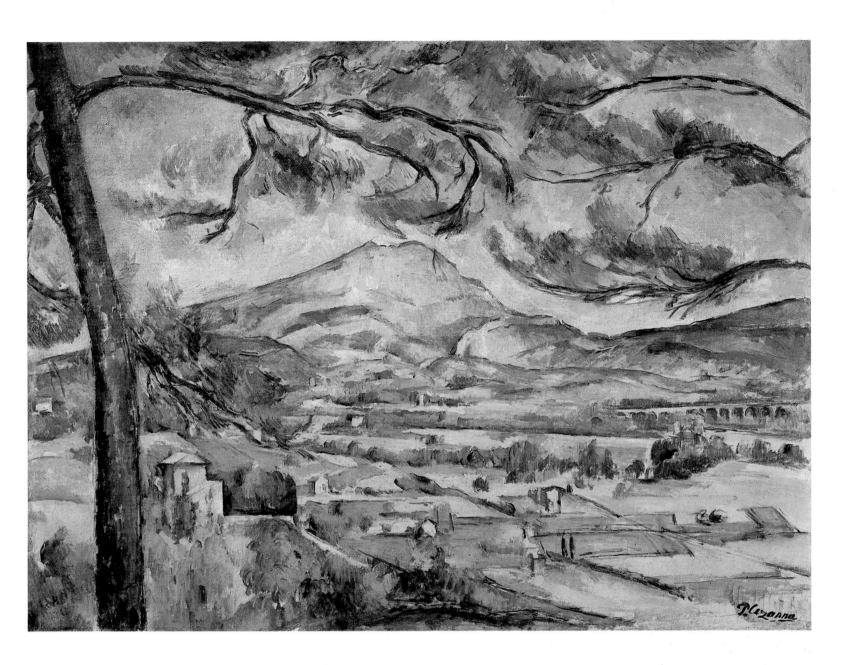

TECHNICAL DETAILS
Approximately 0.3 cm. wide area of 'made-up' paint
on all four sides to edge of modern wood slip.
Canvas weave: plain.
Threads per sq.cm.: 13 × 13.
Ground: artist's application;
colour: cream.
Lined.
Varnished.

25

Cézanne, Paul 1839–1906
POT OF FLOWERS AND FRUIT *c.*1888–90
Oil on canvas, 46 × 56.2 cm.
Unsigned

The apparent simplicity of this image of a plant in a pot, with three fruit and a plate, is deceptive. The primary subject and its surroundings are treated in a way which knits the whole image into a complex interplay of forms and colours; and, as the eye explores the picture, the configuration of shapes in the background becomes increasingly hard to read: is the form on the right the chassis of a canvas seen from the back, leaning against the wall, or rather a painter's easel, as its shape might suggest, were it not for the beige canvas tone between its bars, and what is represented by the three strips of colour on the background wall, the one in the centre a clear red? The X-ray reveals that Cézanne lowered the line of the table edge to the right of the pears so that it is no longer on a continuous level across the picture plane and more of the easel is seen.

These uncertainties prevent us from reading the image simply as the depiction of an actual space, and force us rather to concentrate on the roles that the colours and shapes play in the overall composition. At the core of the composition the lavish curves of the green plant are framed by the crisp bars beyond them, and their colour is set against the red bar seen through their leaves. Around the plant, the colouring is predominantly yellows and oranges alongside soft blues, variegated with great delicacy throughout. In places the boundaries between forms are simply expressed by changes of colour, but elsewhere Cézanne added fine contour lines late in the execution of the picture, presumably feeling that a more emphatic demarcation was needed. These contours are carefully varied according to their position, with a mainly green outline separating the nearer fruit on the plate from the one beyond it, while a crisp deep blue line pulls the right side of the pear on the table forward from the flowerpot.

Though most of the canvas is quite fully covered, it is not particularly thickly painted; its brushwork is unemphatic, and Cézanne has given it no strong overall rhythm. This handling would seem to fit a date in the late 1880s, not long after no. 24.

PROVENANCE
C. Hoogendijk, Amsterdam; with Paul Rosenberg, Paris; Marquis de Rochecouste, Paris; with Galerie Barbazanges, Paris; with Bignou, Paris; with Alex. Reid and Lefèvre, London; acquired by Samuel Courtauld, January 1928. Courtauld Bequest 1948.

EXHIBITED
Cézanne, Bernheim-Jeune, Paris, June 1926; *19th Century French Painters*, Knoedler, London, 1926 (21); de Hauke Gallery, New York, April 1927; Tate Gallery, 1948 (12); *Cézanne*, Edinburgh and London, 1954 (40); Orangerie, Paris, 1955 (10); Courtauld Centenary, 1976 (9); Japan and Canberra, 1984 (10).

LITERATURE
Jamot–Turner, no. 25; Venturi, *Cézanne*, no. 623; Cooper, 1954, no. 13.

TECHNICAL DETAILS
Canvas weave: plain.
Threads per sq.cm.: 17 × 14.
Ground colour: near white.
Lined.
Varnished.

X-radiograph

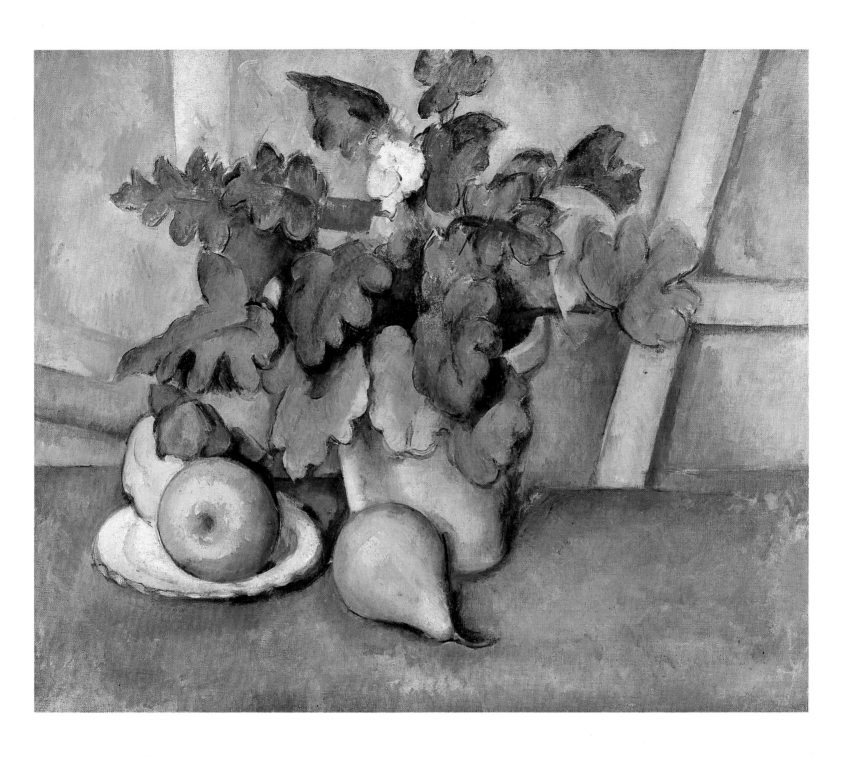

Cézanne, Paul 1839–1906
THE CARD PLAYERS *c*.1892–5
Oil on canvas, 60 × 73 cm.
Unsigned

During the 1890s Cézanne painted a long sequence of canvases of peasants from his home town of Aix-en-Provence. The most ambitious of these show groups of men playing cards. Two show three cardplayers, with spectators (Metropolitan Museum of Art, New York, and Barnes Foundation, Merion, Pa.), and were probably painted first; in the other three, which differ in size but are very similar in detail, the subject is distilled into a simpler form, with two figures facing each other, seen in profile (one other version in Musée d'Orsay, Paris). The existence of a number of preparatory studies shows the importance Cézanne attached to the theme.

The overall tonality of the present picture is quite subdued, but a wide range of subtly gradated colours is used to model the figures and their surroundings. A succession of warm accents revolve around the table top, with a sharp red placed above the left figure at the top of the picture (it is hard to tell whether this suggests something on a background wall, or in a wider space beyond the figures). Against the warm hues are set the soft blues which suggest the atmosphere of the room, but these cool hues are also very varied, with a few sharper accents of clear green. The colour is simply and broadly brushed on to the canvas for the most part, but at certain points, particularly in the men's faces, crisper and very delicate accents are introduced in order to suggest their modelling more closely; elsewhere, for instance in the hands, small zones of unpainted cream-primed canvas suggest the play of light. Numerous adjustments, for example to the contours of the hats, cards and knees, are visible in a good light. Infra-red photography revealed extensive drawing in Prussian blue.

In the painting's final state, there are certain clear discrepancies with 'normal' natural vision: the verticals of the table lean to the left, and the knees of the left figure extend unduly far to the right. Such oddities were not, it seems, wilful and deliberate distortions, but rather emerged during the execution of the painting, as Cézanne concentrated on relationships of colour and tone at the expense of the literal representation of the depicted subject. When friends pointed out the oddities in his canvases, he used to laugh them off; 'I am a primitive, I've got a lazy eye,' he told Rivière and Schnerb in 1905, 'I presented myself to the Ecole [des Beaux-Arts], but I could never get the proportions right: a head interests me, and I make it too big.'

However, this preoccupation with the organisation of his canvases does not mean that Cézanne was unconcerned about his subject matter. In his later art, he sought a reconciliation between working from nature and old master traditions; in the Card Players paintings he harnessed himself to a long tradition of images of figures seated round tables, perhaps in particular to the art of the French seventeenth-century painters of peasant subjects, the Le Nain brothers, of whom he spoke with admiration in the 1890s, and at the same time he worked closely from the observed model: apparently his peasant sitters posed for him at the Jas de Bouffan, probably one at a time, for the preparatory studies show single figures. He felt that peasant life enshrined the basic values of his local region, which he saw as threatened by contemporary urban fashions; at the end of his life, he told Jules Borély: 'Today everything has changed in reality, but not for me, I live in the town of my childhood, and it is with the eyes of the people of my own age that I see again the past. I love above all else the appearance of people who have grown old without breaking with old customs.' In this sense, the image of peasants seated still, concentrating on their game of cards is the living counterpart to the landscapes of his home countryside, notably the Montagne Sainte-Victoire (see no. 24), which held such significance for him.

PROVENANCE
With Paul Cassirer, Berlin; Dr Julius Elias, Berlin; J.B. Stang, Oslo; with Alfred Gold, Berlin; acquired by Samuel Courtauld, April 1929. Courtauld Gift 1932.

EXHIBITED
Cézanne, Galerie Pigalle, Paris 1929 (8); *French Art*, Royal Academy, London, 1932 (392); Royal Scottish Academy, Edinburgh, March 1933 (142); *Chefs d'oeuvre de l'art français*, Paris 1937 (256); Tate Gallery, 1948 (13); *Cézanne*, Edinburgh and London, 1954 (52); Orangerie, Paris, 1955 (11); Courtauld Centenary, 1976 (10); Japan and Canberra, 1984 (11).

LITERATURE
Jamot–Turner, no. 23; Home House Catalogue, no. 1; Venturi, *Cézanne*, p. 59, no. 557; Cooper, 1954, no. 14; Bernard Dorival, *Cézanne* (Paris, 1948), pp. 62–5; Kurt Badt, *The Art of Cézanne* (London, 1965), pp. 87–130; Theodore Reff, 'Cézanne's "Cardplayers" and their Sources', *Arts Magazine*, November 1980, pp. 104–17.

TECHNICAL DETAILS
Canvas weave: plain.
Threads per sq.cm.: 14. × 23.
Ground: commercial application; colour: cream.
Loose lined.
Varnished.

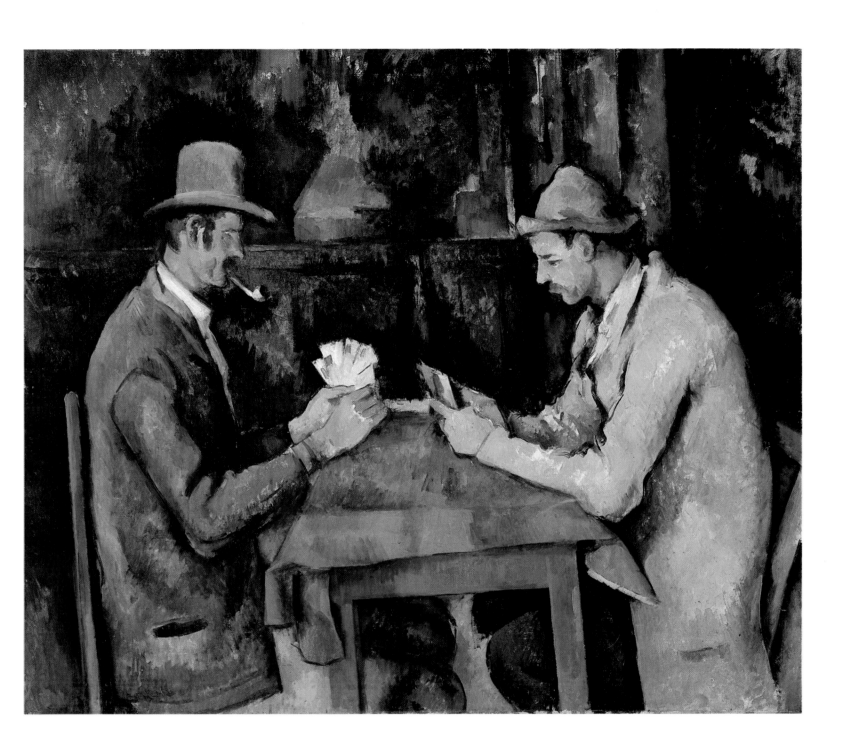

27

Cézanne, Paul 1839–1906
MAN WITH A PIPE *c.*1892–5
Oil on canvas, 73 × 60 cm.
Unsigned

The model is the same as that for the left-hand figure in *The Card Players* (no. 26); he was a peasant gardener, apparently named *le père* Alexandre. The two paintings were probably painted at much the same date, since they are very similar in colour and handling. Here the man's face, the prime focus of the composition, is more elaborated than any part of *The Card Players*: parts of the face are treated with successions of diagonal strokes (here running from upper left to lower right), reminiscent of the 'constructive stroke' which Cézanne had employed a decade earlier (see nos. 22–3). Pivotal to the treatment of the face is the contrast between the dull blues of the shadow of the nose and the rich warm hues of its lit side; this contrast is heightened by two particularly crisp, bold strokes of red added down the ridge of the nose very late in the execution of the painting. Prussian blue is used here together with a red lake pigment to underdraw and subsequently redefine the forms.

Again, as in *The Card Players*, the simple, monumental form of the peasant figure is used to suggest the timeless, traditional values which Cézanne attributed to the old country people of Aix (see no. 26).

PROVENANCE
Ambroise Vollard, Paris; Paul Gallimard, Paris; with Galerie Barbazanges, Paris; with Bignou, Paris; with Alex. Reid and Lefèvre, London, from whom acquired by Samuel Courtauld, 10 October 1927. Courtauld Gift 1932.

EXHIBITED
La Libre Esthétique, Brussels, 1904 (no number); *Cézanne*, Galerie Pigalle, Paris, 1929 (9); Tate Gallery, 1948 (14); *Cézanne*, Edinburgh and London, 1954 (51); Orangerie, Paris, 1955 (12); Courtauld Centenary, 1976 (11); National Gallery, London, February–March 1983 (no catalogue); Japan and Canberra, 1984 (12).

LITERATURE
Jamot–Turner, no. 22; Home House Catalogue, no. 9; Venturi, *Cézanne*, no. 564; Cooper, 1954, no. 15.

TECHNICAL DETAILS
Canvas weave: plain.
Threads per sq.cm.: 14 × 19.
Ground: artist's application;
colour: cream.
Lined.
Varnished.

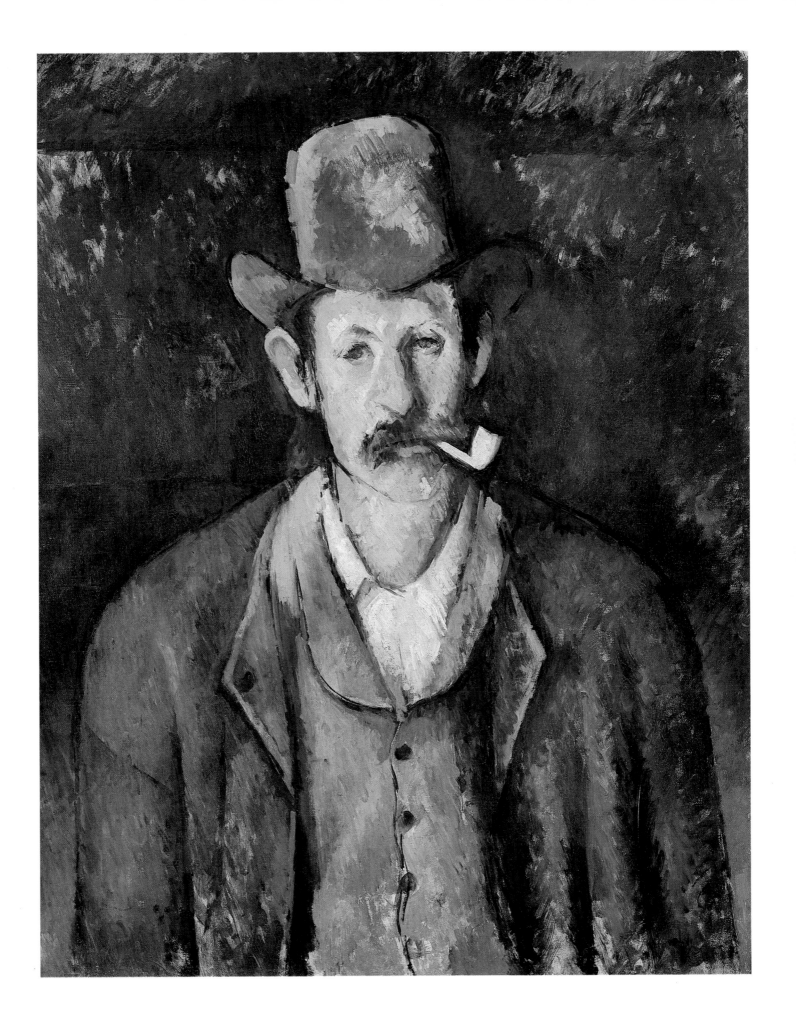

Cézanne, Paul 1839–1906
STILL LIFE WITH PLASTER CAST *c*.1894
Oil on paper, laid on board, 70.6 × 57.3 cm.
Unsigned

Cézanne's still lives perhaps reveal his changing pre-occupations most fully, since still life gave him the freedom to choose and arrange the combinations of objects he wanted to depict. A witness described the complex business of setting up one such still life subject:

> The cloth was arranged on the table, with innate taste. Then Cézanne arranged the fruits, contrasting the tones one against the other, making the complementaries vibrate, the greens against the reds, the yellows against the blues, tipping, turning, balancing the fruit as he wanted them to be, using coins of one or two sous for the purpose. He brought to this task the greatest care and many precautions; one guessed it was a feast for the eye to him.

Still Life with Plaster Cast is one of the most complex of his late still lives, both in its composition and through the inclusion of the cast and other works of art. The plaster cast of a Cupid (formerly attributed to Pierre Puget) still remains in Cézanne's studio at Aix, as does the cast of a flayed man which is seen in the painting at the top of the present picture. The Cupid cast is in reality eighteen inches high, and it appears larger than life in the painting; the same is true of the canvas which is shown leaning against the wall on the left, *Still Life with Peppermint Bottle* (National Gallery of Art, Washington) which was painted at much the same time as this picture; the area of it that we see, which uncludes the red stripe and blue area at top left, is shown here larger than it is in the original canvas, although implicitly it is standing on the floor well beyond the foreground table. The far apple, apparently placed on the distant floor, appears as large as the fruit on the table.

There are ambiguities, too, in the relationships between the objects. The 'real' blue drapery at the bottom left merges with the painted still life in the picture on the left; the foliage of the 'real' onion fuses with the table leg in the same still life; and the back edge of the table top virtually dissolves into the floor to the left of this onion. There is also real uncertainty about the arrangement of planes in the background, where the edges of the canvas depicting the flayed figure cannot be clearly determined.

The inconsistencies and paradoxes of the space are compounded by the paradoxes about the nature of the reality depicted which recur throughout the picture: between 'real' and painted fruit and drapery; between 'real' fruit on the table and the Cupid figure – a cast of a statue; and between this cast and the flayed man beyond – a painting of a cast of a statue. All of these devices seem to stress the artificiality of the picture itself – of its grouping and of its making; of all Cézanne's still lives, this one reveals most vividly the artificiality of the idea of *nature morte*, an assemblage of objects, arranged in order to be painted, and, beyond this, the artifice of the art of painting itself.

Some sketching, probably in pencil, is clearly seen in normal light as underdrawing for the apples and Infra-red photography revealed more underdrawing in the cupid's face. There are other areas where no underdrawing is visible and the image is started and finished in paint. In one area, the apple on the lower edge, there is pencil drawing on top of the paint.

PROVENANCE
With Bernheim-Jeune, Paris; Dr G. Jebsen, Oslo; with Paul Rosenberg, Paris; with Alex. Reid, Glasgow; with Agnew, London, from whom acquired by Samuel Courtauld in 1923. Courtauld Bequest 1948.

EXHIBITED
Fransk Malerkonst d.19 Jaarhonderts, Copenhagen, May 1914 (20); *Cézanne*, Montross Gallery, New York, January 1916 (16); *Masterpieces of French Art of the 19th Century*, Agnew, Manchester, October 1923 (5); Tate Gallery, 1948 (15); *Cézanne*, Edinburgh and London, 1954 (50); Orangerie, Paris, 1955 (13); Courtauld Centenary, 1976 (12); *Cézanne. The Late Work*, Museum of Modern Art, New York, 1977 (23) and toured to Houston, Tex., and Paris, 1977–8; National Gallery, London, February–March 1983 (no catalogue); Japan and Canberra, 1984 (13).

LITERATURE
Jamot–Turner, no. 24; Venturi, *Cézanne*, no. 706; Cooper, 1954, no. 16; William Rubin (ed.), *Cézanne. The Late Work* (New York and London, 1977–8), pp. 30–2.

TECHNICAL DETAILS
Paper: white wove.
The sheet unevenly trimmed, apparently to a ruled line in pencil, at the top, left and right sides. The bottom left corner of the sheet torn away (backing tinted, to make it up). Pin-holes visible bottom left, right and centre, evidence that the paper was not adhered to a panel at the time of painting.
Ground: artist's application;
colour: cream.
The paper is mounted on a wood panel accessory support and this had been cradled.
Varnished.

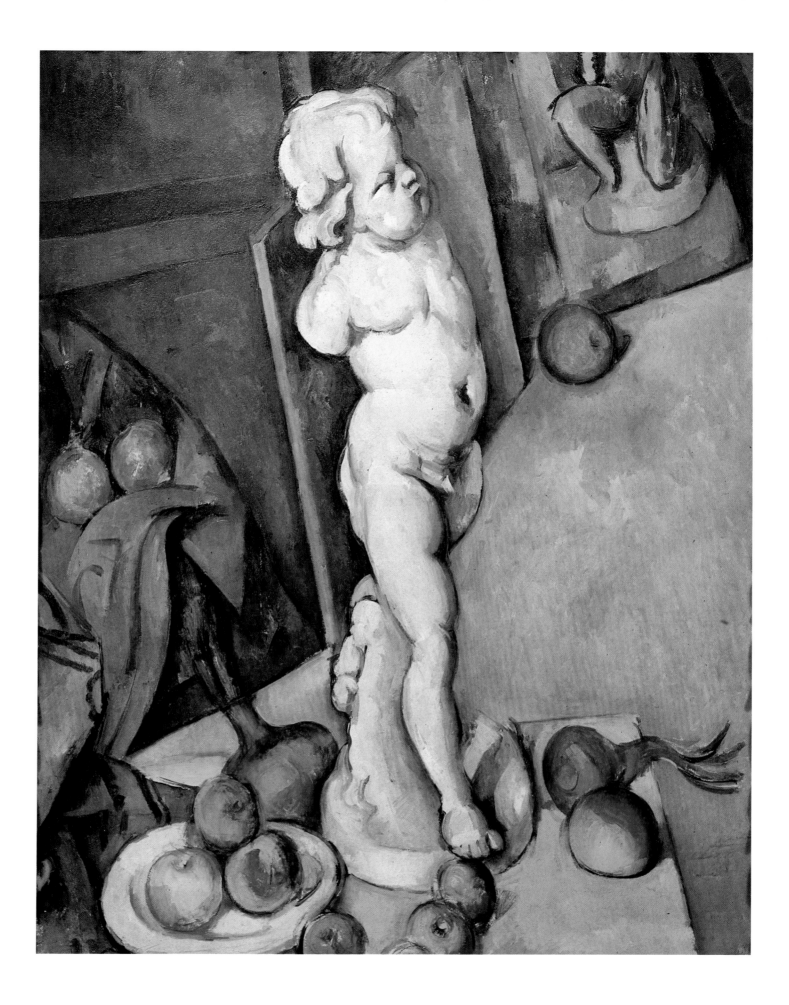

Cézanne, Paul 1839–1906
THE LAC D'ANNECY 1896
Oil on canvas, 65 × 81 cm.
Unsigned

The Lac d'Annecy was painted while Cézanne was on holiday at Talloires on the shores of this lake in Haute-Savoie in July 1896; the view is taken from the beach of Talloires, looking in a southerly direction towards the Château de Duingt, half hidden by trees on the far side of the lake. Cézanne wrote in a letter to Gasquet from Talloires: 'This is a temperate zone. The surrounding hills are quite lofty. The lake, which at this point narrows to a bottleneck, seems to lend itself to the line drawing exercises of young ladies. Certainly it is still a bit of nature, but a little like we've been taught to see it in the albums of young lady travellers.' In this canvas, with its vibrant colour and monumental structure, Cézanne was clearly determined to transcend this commonplace picturesque.

The large part of the canvas is dominated by a cool colour range of blues and greens, sometimes quite deep and sonorous in tone, but its principal focuses are the succession of warm accents which runs across it, where the early morning sunshine strikes the objects in the scene – the far hills, the left tree trunk, and the buildings across the water. This warm-cool contrast is brought into particularly sharp

focus on the left edge of the castle tower: a vertical stroke of orange is set against the deep blues beyond, but, between the two, there is an extremely narrow band of canvas, only very thinly painted with very pale hues so that the building is lifted forward from its surroundings both by the stroke of warm colouring and by this sharp thread of light. The decision not to overpaint this fine streak at the point that he added colour on either side of it shows how tightly he controlled the colour effects he achieved.

The whole picture is carefully structured, with the massive bulk of the tree as a *repoussoir* on the left and its branches enclosing the top (cf. *The Montagne Sainte-Victoire*, no. 24); the composition is anchored in the centre by the tighter, more rectilinear forms of the buildings and their elongated reflections. In reality, the castle is about one mile away across the water from Cézanne's viewpoint, but, by narrowing his visual field and focusing closely on it, he made it seem considerably closer (compare the mountain in no. 24). The reflections are slightly distorted – like the table legs in *The Card Players* (no. 26) they are not exactly vertical; Cézanne often ignored discrepancies of this sort as he concentrated on the relationships of colour and form in his canvases.

The brushwork across the background builds up a sequence of planes of colour, which unite the nearby foliage to the far hillsides. This means of giving a unified structure to the whole surface became even more prominent in Cézanne's last works, but it was not a means of rejecting nature; rather he sought, he

said, a 'harmony parallel to nature' and to 'revivify Poussin in front of nature'; it was thus that he hoped to make out of his experiences of the visible world a lasting, coherent art.

PROVENANCE
Purchased from the artist by Ambroise Vollard, Paris (1897); C. Hoogendijk, Amsterdam; with Paul Rosenberg, Paris; Marcel Kapferer, Paris; with Bernheim-Jeune, Paris; acquired through Percy Moore Turner by Samuel Courtauld, January 1926. Courtauld Gift 1932.

EXHIBITED
Grand maîtres du 19me siècle, Paul Rosenberg, Paris, April 1922 (14); *Les Grandes Influences*, Paul Rosenberg, Paris, January 1925 (14); *Cézanne*, Galerie Pigalle, Paris, 1929 (7); *French Art*, Royal Academy, London, 1932 (505); Tate Gallery, 1948 (16); *Cézanne*, Edinburgh and London, 1954 (55); Orangerie, Paris, 1955 (14); Courtauld Centenary, 1976 (13); Japan and Canberra, 1984 (14).

LITERATURE
Jamot–Turner, no. 27; Home House Catalogue, no. 8; Venturi, *Cézanne*, no. 762; Cooper, 1954, no. 17; J. Rewald, *Cézanne, Geffroy et Gasquet* . . . (Paris, 1960), pp. 27, 28; William Rubin (ed.), *Cézanne. The Late Work* (New York and London, 1977–8), pp. 26, 64; Paul Cézanne, *Correspondance*, ed. J. Rewald (Paris, 1978), p. 252.

TECHNICAL DETAILS
Canvas weave: plain.
Threads per sq.cm.: 16 × 13.
Ground: commercial application;
colour: grey.
Unlined.
Unvarnished.

X-radiograph

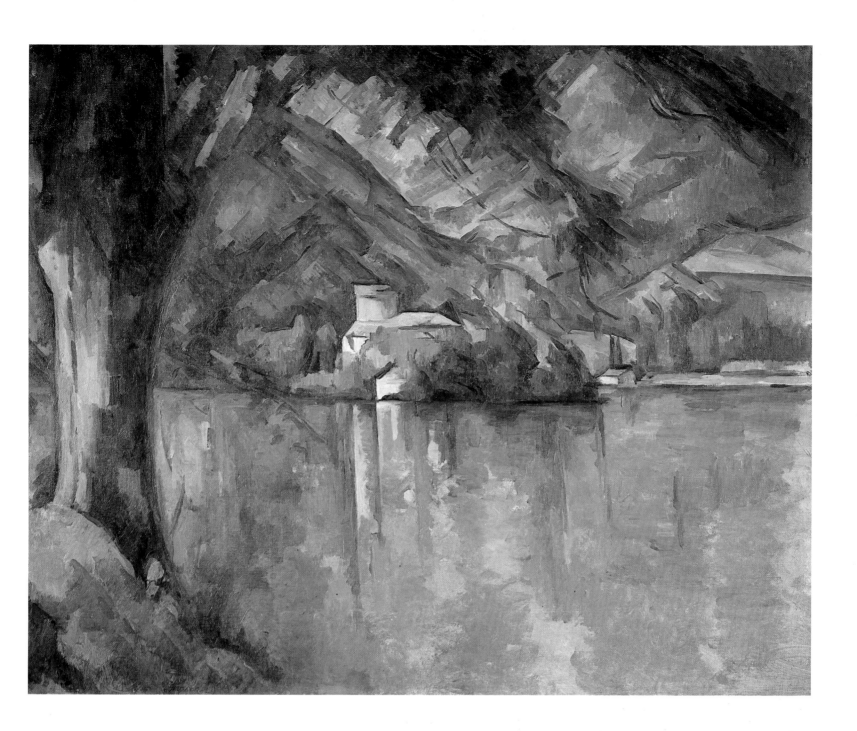

30

Seurat, Georges 1859–91
FISHERMAN IN A MOORED BOAT *c*.1882
Oil on panel, 16.5 × 24.8 cm.
Unsigned

Virtually all Seurat's early oil paintings are small studies on wood panels, broadly and seemingly rapidly executed, very probably in front of their outdoor subjects. His favoured subjects, of the suburban riverside around Paris, were those which the Impressionists had favoured (see nos. 3, 11, 18), but by the early 1880s such open-air sketching was a common practice, even among artists who, like Seurat, had gone through a thorough academic training at the Ecole des Beaux-Arts.

Fisherman in a Moored Boat is dominated by the crisp, dark forms of the fisherman, the boats and the railing, set off against the luminous background – a sharp tonal contrast quite unlike the interplay of clear light colour which the Impressionists used to suggest atmospheric effects. However, deep blues are used to model the dark forms, and soft blues recur in the foliage, which suggests that Seurat was also exploring methods of conveying the atmosphere. These blues are set against the warm orange-brown tones which recur throughout the picture; these (again in a way quite unlike Impressionist practice) are primarily obtained, not by coloured paint, but by the rich colour of the underlying wood panel, which is wholly unpainted in places, and elsewhere shows through thinly applied paint layers. In other small sketches (e.g. no. 31) Seurat did adopt the Impressionist practice of painting on a white or very light-toned priming.

Unlike no. 32, this panel does not relate directly to any larger project, but Seurat's many outdoor studies of the early 1880s must all have contributed to his first monumental figure painting, *Une Baignade, Asnières* (National Gallery, London). The theme of the riverside fisherman was to appear again in the preparatory studies for *A Sunday Afternoon on the Ile de la Grande Jatte* (see no. 33).

PROVENANCE
Emile Seurat, Paris; Félix Fénéon, Paris; with Galerie Barbazanges, Paris; with Georges Bernheim, Paris; with Joseph Hessel, Paris; Gaston Lévy, Paris; with Paul Rosenberg, Paris; Samuel Courtauld, 1937; Lady Aberconway, 1948; private collection, London.

EXHIBITED
Seurat, Bernheim-Jeune, Paris, 1908–9 (15); *Seurat*, Bernheim-Jeune, Paris, 1920 (7); *Seurat*, Joseph Brummer, New York, 1924 (12); *Seurat et ses amis*, Galerie des Beaux-Arts, Paris, 1933–4 (70); *Georges Seurat*, Galerie Paul Rosenberg, Paris, 1936 (16); *Ingres to Picasso*, Rosenberg and Helft, London, 1937 (30); Tate Gallery, 1948 (66a); *Landscape in French Art*, Royal Academy, 1949 (296); Orangerie, Paris, 1955 (47); Courtauld Centenary, 1976 (43).

LITERATURE
Inventaire Posthume Seurat, Panneaux, no. 49; Cooper, 1954, no. 61; H. Dorra and J. Rewald, *Seurat, l'oeuvre peint, biographie et catalogue critique* (Paris, 1959), p. 76, no. 79; C.M. de Hauke, *Seurat et son oeuvre* (Paris, 1961), no. 64.

31

Seurat, Georges 1859–91
MAN PAINTING A BOAT *c.*1883
Oil on panel, 15.9 × 25 cm.
Unsigned

In contrast to no. 30, this is a richly coloured painting, whose varied palette and strong blue shadows clearly testify to the influence of Impressionism. Its luminosity is enhanced by the fact that (again unlike no. 30) it was painted on a white priming, not directly on the wood panel; though this priming is largely covered, it appears just below the feet of the figure.

Its brushwork, though, owes little to Impressionism. In no. 32, probably painted in the same year, Seurat conveyed the diverse natural textures in the scene with a flexible, broken touch, but here the brushwork is far more even, built up of crisp little strokes, mainly applied with quite a wide brush and running in various directions; the result is an opaque paint surface of an even rhythm and density. Only the vertical fence posts, which give the panel a clear-cut central axis, are treated with longer, more separated strokes; the man and his boat are absorbed into the play of deft criss-crossing touches which fills the rest of the picture.

Like no. 30, *Man Painting a Boat* does not relate to any larger painting, though it, too, treats a theme of outdoor recreation by the river. The forms it depicts are treated broadly, without any precise detail, but in its brushwork, carefully harmonised throughout the picture, it is one of the more highly finished of Seurat's small oils. There is no evidence that he ever exhibited it during his lifetime, but on occasion he did show such small pictures, alongside fully finished, larger canvases like no. 34.

PROVENANCE
Mme Seurat, the artist's mother, Paris; Félix Fénéon, Paris; through Percy Moore Turner, London; Lord Ivor Spencer-Churchill, London; Lord Berners, London; through Percy Moore Turner, London; Samuel Courtauld, 1928. Courtauld Bequest 1948 (on loan to Lord (R.A.) Butler until 1983).

EXHIBITED
Seurat, Bernheim-Jeune, Paris, 1909 (14); *Seurat*, Bernheim-Jeune, Paris, January 1920 (9); *Ingres to Cézanne*, Independent Gallery, London, May 1925 (20); *19th and 20th Century French Masters*, Independent Gallery, London, June 1928 (31); Tate Gallery, 1948 (64); Orangerie, Paris, 1955 (48); Courtauld Centenary, 1976 (44); Japan and Canberra, 1984 (81).

LITERATURE
Inventaire Posthume Seurat, Panneaux, no. 44; Jamot–Turner, no. 43; Cooper, 1954, no. 62; H. Dorra and J. Rewald, *Seurat, l'oeuvre peint, biographie et catalogue critique* (Paris, 1959), p. 80, no. 82; C.M. de Hauke, *Seurat et son oeuvre* (Paris, 1961), no. 66; Roger Fry, *Seurat*, with Foreword and Notes by Anthony Blunt (1965), p. 78.

TECHNICAL DETAILS
Hardwood.
Ground: artist's application;
colour: white.
The thin original panel is mounted on an oak accessory support and this has been cradled.
Varnished.

32

Seurat, Georges 1859–91
WHITE HORSE AND BLACK HORSE IN THE WATER
c.1883
Oil on panel, 15.2 × 24.8 cm.
Unsigned

Seurat made many studies for his first major canvas, *Une Baignade, Asnières*, rejected at the 1884 Salon and first shown at the Salon des Indépendants in May 1884. These take two forms – small oil sketches on panel, like the present one, of the river banks at Asnières variously peopled, and conté crayon drawings in which Seurat worked out the poses of the figures in more detail. This is one of a small group of studies in which Seurat introduced horses, an idea he discarded in the final picture.

Seurat's methods in working up *Une Baignade, Asnières* bear the stamp of his academic training. The quick oil sketches like *White Horse and Black Horse in the Water* play the role of *esquisses*, as notations of possible compositional formats and colour relationships for the big painting, while the black-and-white drawings, studies of separate elements for the final picture, are *études* in the traditional sense. In oil sketches like this one, though, Seurat revealed another source of inspiration, which may have led to the rejection of the large picture at the 1884 Salon: this is the influence of Impressionism, seen in the luminous atmospheric colour and bold brushwork. In the final painting, the crisp, broken brushwork is rather more tautly ordered than in most Impressionist paintings, but oil sketches like the present one, with their free and varied handling, are the closest of all Seurat's works to the informality of surface of the typical Impressionist landscapes of the 1870s (compare in particular Sisley no. 18).

In *Une Baignade, Asnières* and its studies, figures relaxing by the river are set against the backdrop of the factories of Clichy, seen across the river, with the tip of the Ile de la Grande Jatte seen on the extreme right. These scenes of informal relaxation make a marked contrast with the subject of *A Sunday Afternoon on the Ile de la Grande Jatte*, in which the weekend promenaders on the river bank opposite are presented in stiff, hieratic poses (see no. 33). It was by this formal contrast that Seurat suggested the difference between two types of recreation, which belonged to two different classes: the informality of the working-class types on the Asnières bank, with the factories beyond, set against the self-conscious artifice of the bourgeoisie and the demi-mondaines over on the wooded island.

PROVENANCE
Mme Seurat, the artist's mother, Paris; with Bernheim-Jeune, Paris; with Galerie Barbazanges, Paris; through Percy Moore Turner, London; Samuel Courtauld, 1925; Lady Aberconway, 1948; private collection, London.

EXHIBITED
Georges Seurat (organised by *La Revue blanche*) Paris, 1900 (6); *Ingres to Cézanne*, Independent Gallery, London, 1925 (21); Centenary Exhibition, Norwich, 1925 (56); *French Modern Art*, Bristol Museum, 1930 (79); *Masters of French 19th Century Painting*, New Burlington Galleries, London, 1936 (115); Tate Gallery, 1948 (65); *Landscape in French Art*, Royal Academy, 1949 (316a); Orangerie, Paris, 1955 (46); Courtauld Centenary, 1976 (42); *Seurat: Paintings and Drawings*, Artemis (David Carritt), London, 1978 (15); *Post-Impressionism*, Royal Academy, 1979–80 (197).

LITERATURE
Jamot–Turner, no. 41; Cooper, 1954, no. 60; Dorra and Rewald, 1959, p. 87, no. 88; C.M. de Hauke, 1961, no. 86.

33

Seurat, Georges 1859–91
THE ANGLER *c.*1884
Oil on panel, 24.1 × 15.2 cm.
Unsigned

Fisherman is one of the many small oil studies which Seurat made for *A Sunday Afternoon on the Ile de la Grande Jatte* (Art Institute of Chicago) as he had for *Une Baignade, Asnières* (see no. 32). However, unlike no. 32, *The Angler* relates only to a small part of the final composition: a similar male figure, though without a fishing rod, appears by the water in the left background of the large painting. The arrangement of this study, with the figure's dark silhouette framed by a little sailing-boat in the top left and the reflection of a white building in the top right, shows that Seurat was already studying possible relationships between forms, but in the event these elements were subsequently rearranged, though similar forms were included in the final picture.

In no. 32, the study for *Une Baignade*, Seurat had adopted a loose, Impressionistic handling, whereas here the grass is treated in longer, crisper strokes which are closer to the appearance of the grass in the final version of *Une Baignade* and in the initial state of the *Grande Jatte* in 1884–5; this 'chopped straw' or *balayé* technique is characteristic of Seurat's finished pictures of 1883–5, before he began to evolve the pointilliste execution, in small dots of colour, which is seen in no. 34 and which was added in 1885–6 to the *Grande Jatte*. Various nuances of green and yellow are used in the sunlit grass, and clear blues in the water, but these light hues revolve around the crisp dark focus of the figure. Though it is treated in dull blues and browns, rather than in neutral dark tones, it stands out crisply against the lightness and colour around it, in contrast to the figure in *Man Painting His Boat* (no. 31), which is absorbed into the colour scheme of the whole picture.

In the final picture of the *Grande Jatte*, virtually all of the figures are treated as static, stylised silhouettes like *The Angler*; the effect of this is to emphasise the artificiality of the parade of the fashionable bourgeoisie and demi-monde, in contrast to the more easy-going attitudes of the lower-class figures shown on the opposite bank of the same stretch of the river Seine in *Une Baignade, Asnières* and its studies (such as no. 32).

PROVENANCE
Mme Seurat, the artist's mother, Paris; Félix Fénéon, Paris; with Galerie Barbazanges, Paris; with Knoedler, London; Samuel Courtauld, 1926; Lady Aberconway, 1948; private collection, London.

EXHIBITED
Modern French Painters, Knoedler, London, 1926 (18); Tate Gallery, 1948 (68); *Landscape in French Art*, Royal Academy, 1949 (295); Orangerie, Paris, 1955 (51); Courtauld Centenary, 1976 (47); *Seurat: Paintings and Drawings*, Artemis (David Carritt), London, 1978 (20).

LITERATURE
Jamot–Turner, no. 39; D.C. Rich, *Seurat and the Evolution of the Grande Jatte* (Chicago, 1935), no. 32; Cooper, 1954, no. 66; Dorra and Rewald, 1959, p. 142, no. 115; C.M. de Hauke, 1961, no. 115.

34

Seurat, Georges 1859–91
THE BRIDGE AT COURBEVOIE 1886–7
Oil on canvas, 46.4 × 55.3 cm.
Signed, bottom left: 'Seurat'

The Bridge at Courbevoie is one of the clearest pictorial manifestos for the divisionist painting technique evolved by Seurat and his colleagues in 1885–6. The technique was intended as a means of translating into paint the effects of natural light and colour, lending a scientific precision to the more empirical solutions that had been adopted by Monet and Pissarro (see no. 6). The dot, or point, of colour was the means which seemed best able to control precisely the relative quantities of each colour used in any area of the picture. However, the effect of these points has caused confusion. Although Seurat, like many of his contemporaries, stated that they were intended to produce an 'optical mixture' of colour, this is not exactly what takes place, for the dots are not small enough to fuse in the viewer's eye and produce a single resultant colour, when the picture is viewed from a normal viewing distance. Camille Pissarro, at the time that he was closely associated with Seurat, stated that the optimum viewing distance for a picture was three times its diagonal measurement, which in this case would mean seven feet. The effect of the canvas from this distance is that the dots are still clearly visible as dots, and the varied colours included can still be identified separately; far from fusing, they seem to shimmer and vibrate – in a sense to recreate in the eye of the viewer something of the sense of vibration produced by actual outdoor sunlight, but recreated by the complex artifice of painting technique. Ogden Rood's *Modern Chromatics*, one of the manuals of colour theory which Seurat studied most carefully, noted this phenomenon, quoting the findings of the German physicist Dove, and it seems certain that Seurat, with his close analytical concern for the optical properties of colour, was deliberately seeking such effects. The absence of varnish, the use of very lean paint and possibly the lack of a ground also combine to produce an intentionally matt surface that enhances the sensation of shimmering.

In *The Bridge at Courbevoie*, Seurat's analysis of the different elements present in a light effect is most evident in the treatment of the river bank. The dominant colour is green – the 'local' colour of grass – rather lighter and yellower in the sunlight, duller and bluer in shadow; warm, pinker touches further enliven the sunlit grass, and clear blues the shadowed areas. In addition there is a scatter of mauve touches across most of the shadowed grass, and they reappear in the topmost band of sunlit grass, along the edge of the river. The exact scientific justification for these is unclear: they may be meant to suggest a complementary colour induced by the dominant green of the grass, or simply to evoke the warmth of the light of the sun; their effect is to enhance the play of warm and cool colours, whose elaborately interwoven relationships give the surface its richness and mobility. The background is treated with softer, paler hues, the same colour repeating in many parts of the picture, in a way very comparable to the background of Pissarro's *The Quays at Rouen* (no. 6).

The scene represents the Ile de la Grande Jatte, looking south westwards, upstream along the Seine towards the Courbevoie bridge; the same stretch of river bank is seen in the opposite direction in *Sunday Afternoon on the Ile de la Grande Jatte* (see no. 33). In contrast to the elaborate parade of modern society in the *Grande Jatte*, *The Bridge at Courbevoie* is still and silent, with three small figures standing immobile by the river. Its mood seems elusive and difficult to interpret; though it has recently been described as a 'plangent evocation of melancholy and alienation', the picture employs none of the devices then favoured by French painters to invoke these feelings – indeed, Seurat seems to have studiously avoided any clear-cut hint of its mood. However, the picture retains an intriguing strangeness through its very stillness, and through the curious juxtaposition of the foliated trees on the left, and the stark bare branches on the right (traces of overpainted foliage can still be seen to the left of this tree). All the elements in it are presented in an ordered, harmonious coexistence; the vertical of the central factory chimney is closely paralleled by the boats' masts and the fence-posts, establishing with the figures a taut series of pictorial intervals.

There is a further oddity about the picture. The verticals of the chimney, the masts and the house on the far right are all inclined at a slight but perceptible angle to the left. Seurat organised his compositions with such care that this cannot have been accidental, but the reasons for it are unclear; its effect, it seems, is to emphasise the parallel lines within the picture, for the viewer's eye does not immediately relate them to the grid of the picture frame around them. A number of adjustments and alterations are visible; their presence tends to underline the care that Seurat took over the very precise placing of the compositional elements. For example, the foliage on the tree on the left of the painting has been reduced and the tall mast immediately adjacent partially painted out; a number of illegible brushmarks between the sails of the barge and the mast of the dinghy indicate changes here too. The most interesting alteration from the point of view of working methods is to the tree on the right. The X-radiograph illustrates the clarity of original composition, showing, for example, that Seurat left a 'space' for the tree trunk in the sky to cover underpainting; and between gaps in the paint it is possible to distinguish the Prussian blue and crimson lake drawing with which the composition was initially laid in. Seurat subsequently moved the tree just 1 cm. to the right so that that edge is now painted over the river, whilst the left-hand contour of the tree has been painted out in blue. Over and above the changes made to the tree on the right, the canvas was clearly the result of an elaborate process of reworking, with the small dots of colour added over broader paint layers; it may have been begun out of doors, but its final effect can only have been achieved in the studio. A detailed preparatory drawing exists for the whole composition. Moreover, the play of shadow in the foreground is so specific, and (if it records an actual effect) must have changed so rapidly, that Seurat would have had little opportunity to work on the canvas in front of its subject while the lighting

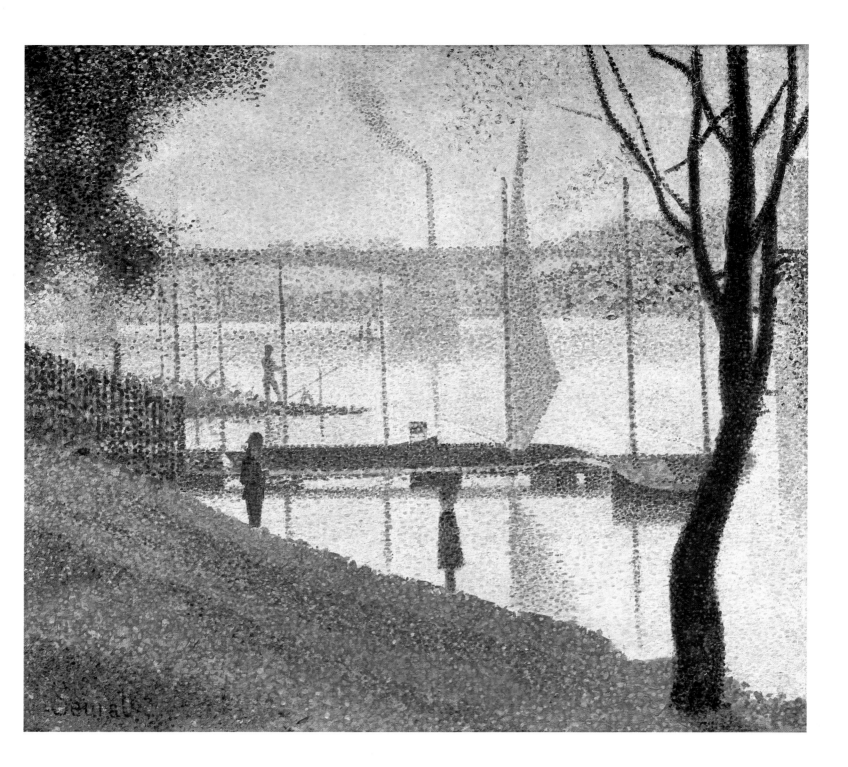

remained unchanged. Later in his career, he came to use his pointillist technique to achieve far more overtly artificial effects (see no. 36).

PROVENANCE

Arsène Alexandre, Paris (1887); Alexandre Sale, Paris, 18 May 1903 (lot 57; 630 Frs.); with Georges Petit, Paris; with L.W. Gutbier, Dresden; with Bignou, Paris; through Reid and Lefèvre, London; Samuel Courtauld, 1926. Courtauld Bequest 1948.

EXHIBITED

3me Exposition de la Société des Artistes Indépendants, Paris, 1887 (442); *Exposition commémorative Seurat*, Salon des Artistes Indépendants, Paris, March 1892 (1090); *Georges Seurat* (organised by *La Revue blanche*), Paris, 1900 (25); *Seurat*, Bernheim-Jeune, Paris, 1909 (64); *Georges Seurat*, Lefèvre Gallery, London, May 1926 (4); *French Art*, Royal Academy, London, 1932 (541); Tate Gallery, 1948 (69); Orangerie, Paris, 1955 (52); Courtauld Centenary, 1976 (48); Japan and Canberra, 1984 (82).

LITERATURE

Jamot–Turner, no. 47; Cooper, 1954, no. 67; Dorra and Rewald, pp. 204–6, no. 172; de Hauke, no. 178; Fry and Blunt (1965), p. 82; R. Thomson, *Seurat* (Oxford, 1985), pp. 134–5.

TECHNICAL DETAILS

Canvas weave: plain.
Threads per sq.cm.: 28 × 24.
No ground layer.
Unlined.
Unvarnished.

X-radiograph (detail)

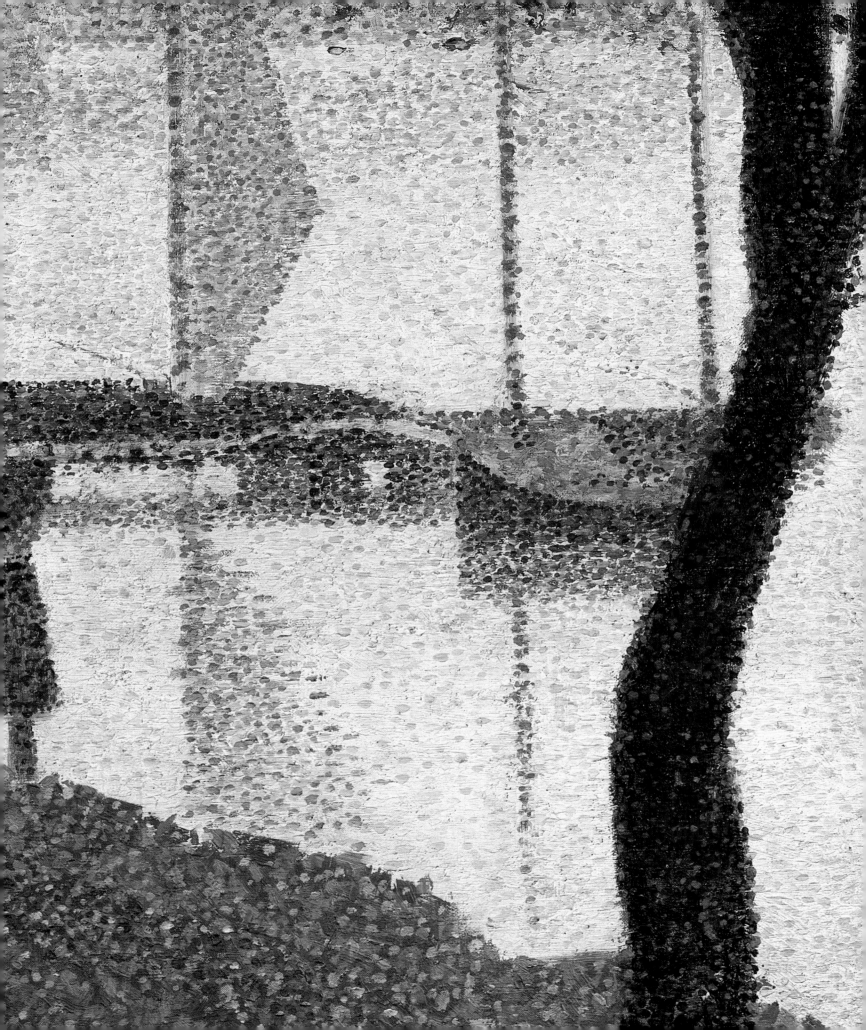

35

Seurat, Georges 1859–91
STUDY FOR THE CHAHUT c.1889
Oil on panel, 21.8 × 15.8 cm.
Unsigned

Raking-light

This is the first and smaller of two oil studies for *The Chahut*, which Seurat exhibited at the Indépendants in Paris in Spring 1890 (Rijksmuseum Kröller-Müller, Otterlo). The principal composition remained as it appears here, but further details were added, which further emphasise the upward moving lines which dominate the composition.

In a letter of 1890 Seurat described the devices he used in his paintings in order to evoke a mood of happiness and gaiety: lines moving upwards from a point and a dominantly light and warm-coloured tonality. He seems to have emphasised these qualities in most parts of *The Chahut* (the final version is warmer and lighter than the present study), but it remains uncertain just what effect he intended these devices to have on the viewer; according to the theories of his associate Charles Henry, they had an immediate physical impact, but Seurat seems to treat them rather more allusively, more as signs or emblems for happiness (see also no. 36).

The chosen subject of *The Chahut* compounds the uncertainties; of all his subjects, it refers most explicitly to the seamier side of Parisian entertainments. The dance, also known as the *quadrille naturaliste*, with its characteristic high-kick, was popularised in the later 1880s, particularly by La Goulue, whom Toulouse-Lautrec often painted; the high-kick was deliberately suggestive or overtly indecent, designed to show stockings, flesh and underwear (or lack of it). Seurat plays down this suggestiveness in *The Chahut*, by viewing the high-kick from the side, and by transforming it into a complex stylised pattern, but a contemporary audience would readily have picked up the associations of the subject.

Seurat left no statement of his intentions in treating this subject, but his friends had no doubt that he wanted to reveal the ambivalence of the subject – between its surface gaiety and its underlying implications. Gustave Kahn noted the contrast between 'the hieratic structure of the canvas and its subject, a contemporary ignominy'. It was by the formal device of placing the viewer's angle of vision to the side of the dancers, with the stark silhouette of the bassist, mainly cool in colour, at the front, that Seurat distanced the spectator from the central action; we are able to look in on it from outside, but are clearly not a part of it.

In the present sketch, the white primed panel shows through at many points, the forms were initially notated very simply in rather broader strokes of colour, before the surface was enriched with its skin of multicoloured points. On the figure of the nearest dancer, there are traces of pencil drawing on top of the paint layers of the face and dress, which may suggest that he planned to elaborate it further. The border which surrounds it on three sides was added by the artist; that on the fourth was probably removed after his death. He began to add painted borders to his canvases in the later 1880s, using them to focus the viewer's attention on the picture itself (see no. 36).

PROVENANCE
Mme Seurat, the artist's mother, Paris; Félix Fénéon, Paris; through Percy Moore Turner, London; Samuel Courtauld, by 1931. Courtauld Bequest 1948

EXHIBITED
Seurat, Bernheim-Jeune, Paris, January 1920 (29); Tate Gallery, 1948 (70); Orangerie, Paris, 1955 (53); Courtauld Centenary, 1976 (49); Japan and Canberra, 1984 (83).

LITERATURE
Jamot–Turner, no. 46; Cooper, 1954, no. 68; Dorra and Rewald, p. 253, no. 197; de Hauke, no. 197; Fry and Blunt (1965), p. 84; R. Thomson, *Seurat* (Oxford, 1985), pp. 201–2.

TECHNICAL DETAILS
The painted border on the right of the panel cutaway by a (?) later hand.
Mahogany panel. Cut on right vertical edge, traces of a painted frame remain, so presumably only 0.5 cm. is missing.
Ground: artist's application;
colour: white.
Unvarnished.

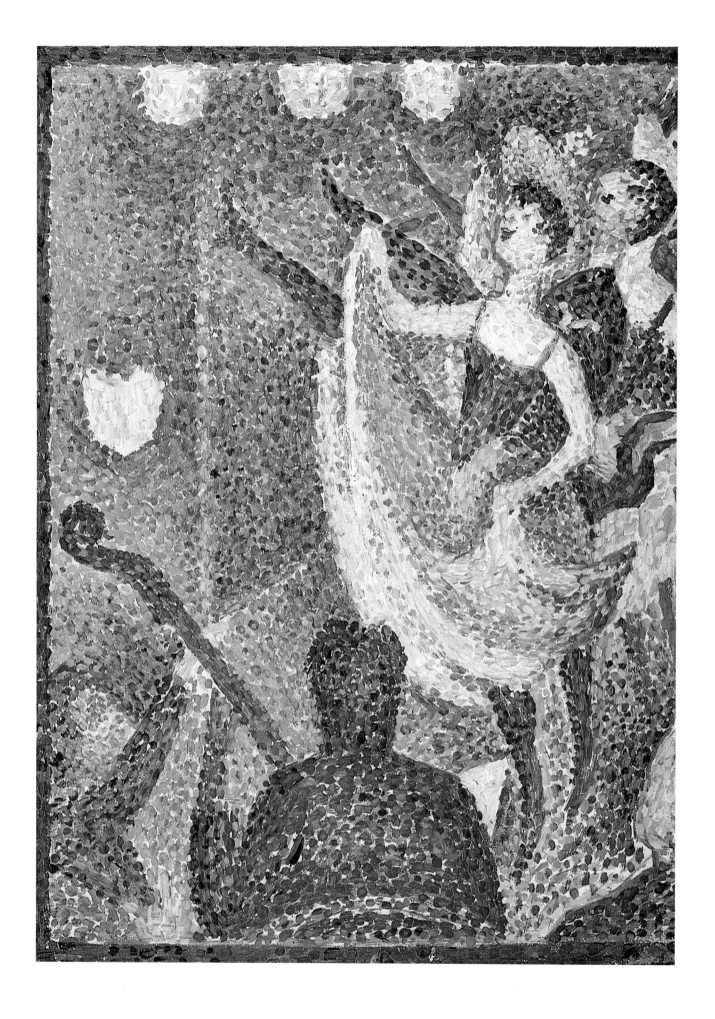

Seurat, Georges 1859–91
YOUNG WOMAN POWDERING HERSELF c.1888–90
Oil on canvas, 95.5 × 79.5 cm.
Signed, on painted border, bottom right: 'Seurat'

This is the only one of Seurat's paintings which reflects anything about his private existence; it shows his mistress, Madeleine Knobloch, at her toilette. Apparently Seurat's own face originally appeared in the frame on the wall, but a friend warned him that this might appear laughable and he replaced it with the vase of flowers. Examination of the painting under the microscope and of the X-ray clearly show that the artist did obliterate a previous reflection in the mirror. Vague outlines which do not correspond with any part of the present image can be discerned but an interpretation of these as the face of Seurat himself is highly subjective.

The painting is composed of a sequence of contrasts between rounded and angular forms: the figure and table are set against the wall with its picture frame and arrow-shaped patterns; and it plays on a set of visual incongruities – between the massive figure and her impracticably small table (the *poudreuse* by which the picture has sometimes been incorrectly named), and between the curving lines and pseudo-dix-huitième ornament of this table and the imitation bamboo frame above it.

Seurat left no indication of the picture's meaning, but it, like *The Chahut* (see no. 35), contains many instances of his sign for happiness and gaiety: the motif of lines rising from a point, which is used here to decorate the wall. The motif on the wall is echoed by the bow on top of the mirror, the frame top, the plant form at lower left, and even the model's right arm and the curl of hair behind her neck. But Seurat does not seem to have been using these directional lines in a literal way to uplift the spirits of the viewer. They all belong to her personal décor, to her furniture and cosmetics; the weighty model and her impassive expression counteract them, and the spirit which emerges from the painting is ironic.

In this light, the picture is a return to the theme which had characterised the contrast between *Une Baignade, Asnières* and the *Grand Jatte* (see nos. 32–3) – the contrast between nature and artifice; it explores the art of cosmetics, which, like the model's corsetry, force nature into the mould of style; the spectator, viewing her in mid-toilette, catches her in the middle of the process making her natural self artificial. The satire is not, though, directed against the model herself, but rather against her trappings, which were so characteristic a part of modern urban life; in these terms, the theme belongs with *The Chahut* (no. 35), in exploring the anomalous relationships between public and private in modern Paris. After his death in 1891, some of Seurat's friends attributed radical political views to him, but he left no clear indication of his politics; what emerges from his paintings is a keen and critical sense of the anomalies and ironies of contemporary urban capitalism.

In contrast to *The Bridge at Courbevoie* (no. 34), the brushwork and colours here do not evoke the play of natural light and shade. Rather, they are used to augment the pictorial impact of the canvas. The background wall becomes darker and bluer where it approaches lit contours of the figure, and lighter where it meets its shadowed edges; throughout the picture there is an eddy of interwoven warm and cool touches (pinks and yellows against blues and greens) which create a shimmering effect over the whole surface, but without in any way suggesting closely observed lighting. This effect is augmented by the way in which the painted border changes in colour so as to achieve maximum contrast with the area of the picture next to it; the arched top of this border seems to make the picture itself into a sort of altarpiece or shrine – like the little table and mirror before which the model sits. The modelling of the figure is wilfully anti-naturalistic; it is impossible to sense the form of the model's hips and legs within the sweeping, stylised curves of her skirt. The dots of colour, though comparatively even in size, are often slightly elongated and follow the contours of the forms; it is evident that this final skin of colour was applied over more broadly applied, initial layers of paint, as Seurat worked up the picture to completion.

PROVENANCE
Mlle Madeleine Knobloch, Paris; Félix Fénéon, Paris; Dikran Khan Kélékian, Paris; Kélékian Sale, American Art Association, New York, 31 January 1923 (lot 154; $5,200); with Eugene O.M. Liston, New York; through Percy Moore Turner, London; John Quinn, New York; with Paul Rosenberg, Paris; through the French Gallery, London; Samuel Courtauld, 1926. Courtauld Gift 1932.

EXHIBITED
6me Exposition de la Société des Artistes Indépendants, Paris, 1890 (727); *Exposition Seurat*, Musée Moderne, Brussels (9me Exposition des XX), 1892 (14); *Exposition commémorative Seurat*, Société des Artistes Indépendants, Paris, March 1892 (1085); *Georges Seurat* (organised by *La Revue blanche*), Paris, 1900 (35); exhibitions at Munich, Frankfurt-am-Main, Dresden, Karlsruhe (1906) and at Stuttgart (1907); *Seurat*, Bernheim-Jeune, Paris, 1909 (73); Sezession, Berlin, 1913; Brooklyn Museum, USA, 1921 (not in catalogue); Brummer Gallery, New York, 1924 (18); French Gallery, London, February 1926 (41); *French Art*, Royal Academy, London, 1932 (503); Tate Gallery, 1948 (71); Orangerie, Paris, 1955 (54); Courtauld Centenary, 1976 (50); *Post-Impressionism*, Royal Academy, London, November 1979–March 1980 (204); National Gallery, London, February–March 1983 (no catalogue); Japan and Canberra, 1984 (84).

LITERATURE
Jamot–Turner, no. 45; Home House Catalogue, no. 11; Cooper, 1954, no. 69; Dorra and Rewald, pp. 247–9, no. 195; de Hauke, no. 200; Fry and Blunt (1965), pp. 16, 84; John House, 'Meaning in Seurat's Figure Paintings', *Art History*, III (September 1980), pp. 345–56; R. Thomson, *Seurat* (Oxford, 1985), pp. 193–7.

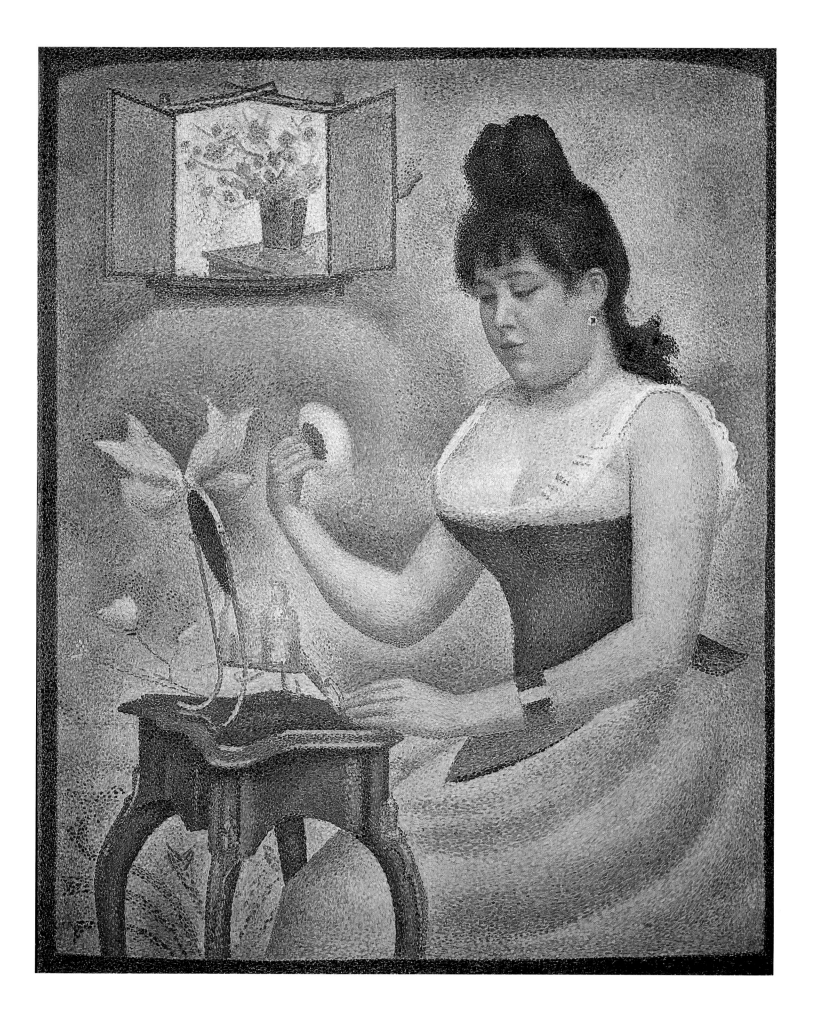

TECHNICAL DETAILS
Painted border of canvas in pointilliste technique on
all four sides, approximately 2.25 to 2.5 cm. wide.
Canvas weave: plain.
Threads per sq.cm.: 22 × 20.
Ground: 1. commercial application;
2. artist's application; colour: white.
Unlined.
Unvarnished.
Canvas stamp: V. CHABOD.

X-radiograph

X-radiograph (detail, cf. frame on the wall)

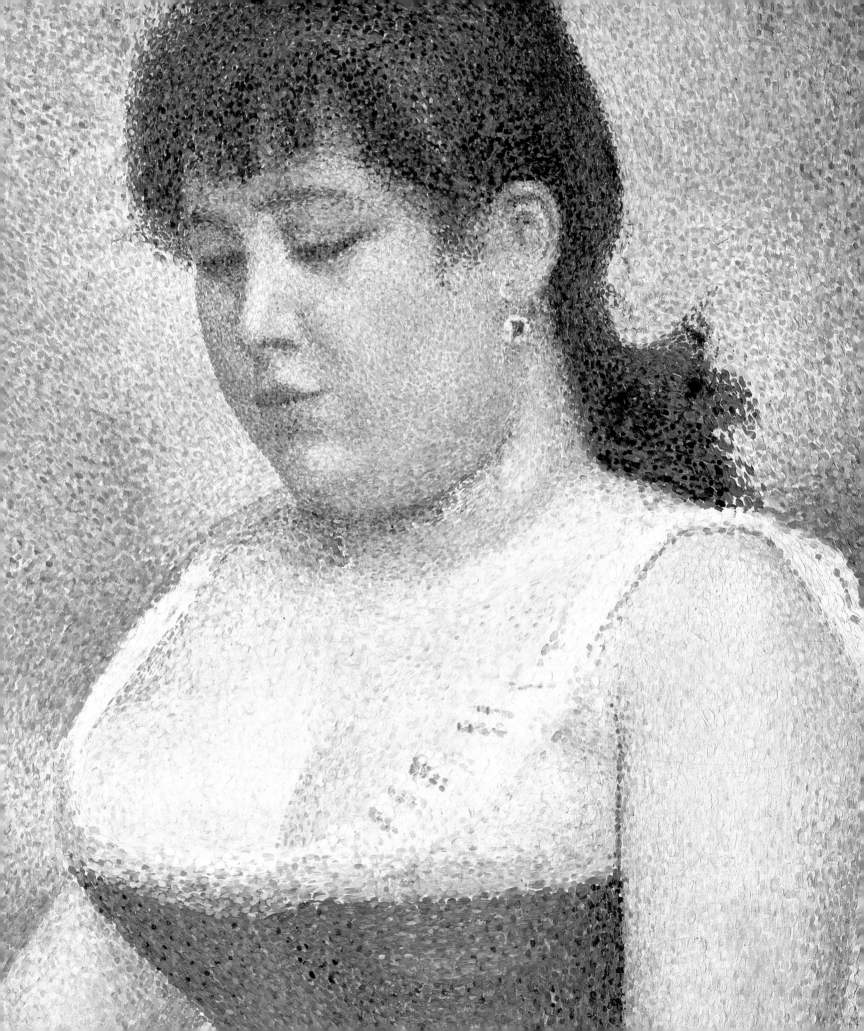

37

Seurat, Georges 1859–91
BEACH AT GRAVELINES 1890
Oil on panel, 16 × 24.5 cm.
Unsigned

Seurat spent the summer of 1890 (the last of his life) at Gravelines, on the Channel coast near Dunkerque and the Belgian border. He regularly visited the coast in summer, seeking, he told Emile Verhaeren, 'to cleanse his eyes of the days spent in the studio and to translate as exactly as possible the luminosity of the open air, with all its nuances'.

Several of his small sketches and drawings of Gravelines relate to the finished oils which resulted from the trip, but this is one which does not. These small paintings were very probably executed out of doors, at least in part; particles of sand have been found in the wet paint layers of the present painting. The larger oils may have been begun outside, but (like no. 34) were undoubtedly much elaborated in Seurat's studio when he was back in Paris. *Beach at Gravelines* is a deceptively simple image; though apparently informal in arrangement, the slightly greater weight of the shoreline on the left is carefully balanced by the placing of the boat just right of the centre.

The scene was painted on a white priming, which is left visible in small areas all over the picture, thus heightening the luminosity of this bright but overcast effect. The colour range is limited, almost all built up from contrasts of blues against yellows and oranges, ranging from the extremely pale hues in sky and sea, enlivened by certain rather brighter touches, to the quite strong contrasts in the foreground, where greens are introduced alongside the blues. The brushwork is more informal than in *Young Woman Powdering Herself*, but fairly evenly weighted across the whole picture; many of the touches are slightly elongated, creating a gentle horizontal movement which complements the expansiveness of the subject itself, looking out to sea across the wide sands of the northern French coast.

PROVENANCE
Mme Seurat, the artist's mother, Paris; Alfred Tobler, Paris; with Bernheim-Jeune, Paris; Alphonse Kann, St. Germain-en-Laye; with Bignou, Paris; through Reid and Lefèvre, London; Samuel Courtauld, 1928. Courtauld Bequest 1948.

EXHIBITED
Seurat, Bernheim-Jeune, Paris, 1909 (78); *Seurat*, Bernheim-Jeune, Paris, 1920 (31); 12th International Biennale, Venice, 1920 (56); Van Wisselingh et Cie, Amsterdam, April 1928 (59); Tate Gallery, 1948 (293); Orangerie, Paris, 1955 (55); Courtauld Centenary, 1976 (51); Japan and Canberra, 1984 (85).

LITERATURE
Jamot–Turner, no. 49; Cooper, 1954, no. 70; Dorra and Rewald, p. 261, no. 201; de Hauke, no. 204; Fry and Blunt (1965), pp. 84–5.

TECHNICAL DETAILS
Painted border of canvas in pointilliste technique on all four sides, irregular, approximately 2 to 4 mm. wide.
Mahogany panel.
Ground: artist's application, absorbent; colour: white.
Cradled.
Varnished.

Raking light

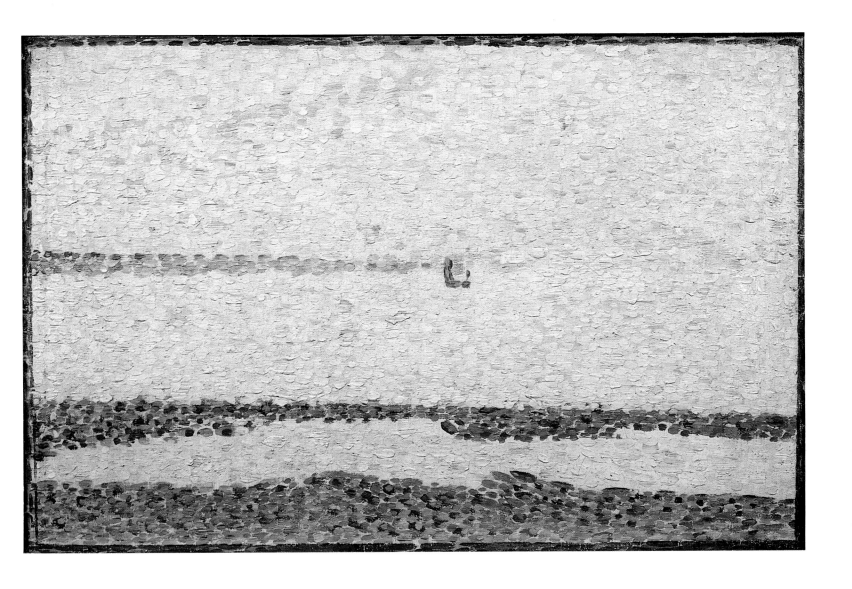

Van Gogh, Vincent 1853–90
PEACH BLOSSOM IN THE CRAU 1889
Oil on canvas, 65 × 81 cm.
Unsigned

X-radiograph (detail)

Painted in Arles in March–April 1889, this canvas shows a view of the Crau, the wide plain which lies to the north-east of Arles, between the river Rhône and the Alpilles – the range of hills that encloses the background of the picture. Van Gogh enclosed a rough pen sketch of the composition in a letter to Paul Signac, and described the picture:

> I have just come back with two studies of orchards. Here is a crude sketch of them – the big one is a poor landscape with little cottages, blue skyline of the Alpille foothills, sky white and blue. The foreground, patches of land surrounded by cane hedges, where small peach trees are in bloom – everything is small there, the gardens, the fields, the orchards and the trees, even the mountains, as in certain Japanese landscapes, which is the reason why the subject attracted me.

The idea of the south of France as a western equivalent of Japan had been one of van Gogh's main reasons for travelling to Arles the previous year; here, the seemingly snowcapped peak in the right background may be an echo of Mount Fuji-Yama.

Peach Blossom in the Crau was painted after Gauguin's visit to Arles, during which he had advised van Gogh to work from his imagination and not directly from the natural subject (see no. 39). But after Gauguin's departure, van Gogh reasserted his commitment to painting from nature, here returning to the approximate subject of one of his major works of the previous summer, *The Blue Cart* (Rijksmuseum Vincent van Gogh, Amsterdam); in contrast to Gauguin's schematic paint surfaces, van Gogh conveys the complex textures and patterns of the chosen scene with a great variety of brushmarks, some broad and incisive, but others of extreme finesse. The laden dabs of paint in the blossom reflect his study of Impressionist painting during his stay in Paris (cf. Monet nos. 12–13), but elsewhere the forms are far crisper and more clearly drawn, particularly in the web of very fine, dark red strokes added in many parts of the picture very late in its execution in order to emphasise the forms of the elements shown – in the houses, the trees and the foreground verge. Added very late, too, was the sequence of blue strokes on the road at the bottom, together with blue accents elsewhere in the landscape and sky, which serve to knit the main elements of the scene together into an atmospheric unity, whose keynote is the vivid blues of the far mountains and the lower band of the sky.

In its translation of this display of blossom into a rich coloured harmony, the picture is clearly indebted to Impressionism; yet its subject also reflects van Gogh's Dutch heritage. He often likened the wide spaces of the Crau with the panoramas of Dutch seventeenth-century landscape painting. When he began *The Blue Cart* in June 1888, showing a very similar scene, he wrote to his brother: 'I am working on a new subject, fields green and yellow as far as the eye can reach. . . . It is exactly like a Salomon Koninck, you know, the pupil of Rembrandt who painted vast level plains.' A month later he com-

mented: 'Here, except for an intenser colouring, it reminds one of Holland: everything is flat, only one thinks of the Holland of Ruysdael or Hobbema or Ostade than of Holland as it is.' In the inclusion of the working figure on the left of *Peach Blossom in the Crau*, along with the prominent small houses, van Gogh emphasised that this was a social, agricultural landscape, its forms the result of man's intervention. Of the Impressionists, Pissarro was always concerned to emphasise the human context of his chosen landscape subjects, whereas Monet (cf. no. 13) was by the later 1880s concentrating primarily on effects of light and atmosphere.

When van Gogh sent the picture to his brother Theo in Paris in summer 1889, its dense paint layers were not yet fully dry. He removed his canvases from their stretchers before despatching them, and packed them with one canvas directly on top of another; the imprint of the texture of the canvas of the back of the picture placed on top of this painting can be seen in the thickest paint, most visibly on the hat of the working figure.

PROVENANCE
With Bernheim-Jeune, Paris; through Percy Moore Turner, London; Samuel Courtauld, 1927. Courtauld Gift 1932.

EXHIBITED
Van Gogh, Marcel Bernheim, Paris, January 1925 (32); *Ingres to Cézanne*, Independent Gallery, London, May 1925 (26); *Dutch Art, A.D. 1450–1900*, Royal Academy, London, 1929 (454); Tate Gallery, 1948 (32); Orangerie, Paris, 1955 (66); Courtauld Centenary, 1976 (60); National Gallery, London, February–March 1983 (no catalogue); Japan and Canberra, 1984 (98).

LITERATURE
Jamot–Turner, no. 28; Home House Catalogue, no. 12; J.-B. de la Faille, *L'Oeuvre de Vincent Van Gogh* (Paris and Brussels, 1928), no. 514; J.-B. de la Faille (revised ed., London, Paris and Toronto, 1939), no. 531; Cooper, 1954, no. 86; J.-B. de la Faille (rev. ed. by A.M. Hammacher and others), *The Works of Vincent Van Gogh: His Paintings and Drawings* (Amsterdam, 1970), no. F.514 (H.531).

TECHNICAL DETAILS
Canvas weave: plain.
Threads per sq.cm.: 18 × 12.
Ground: commercial application;
colour: near white, possibly darkened by wax.
Lined and subsequently impregnated with wax (H. Ruhemann, Studies in Conservation, I, 1953, p. 77–81).
Varnished.

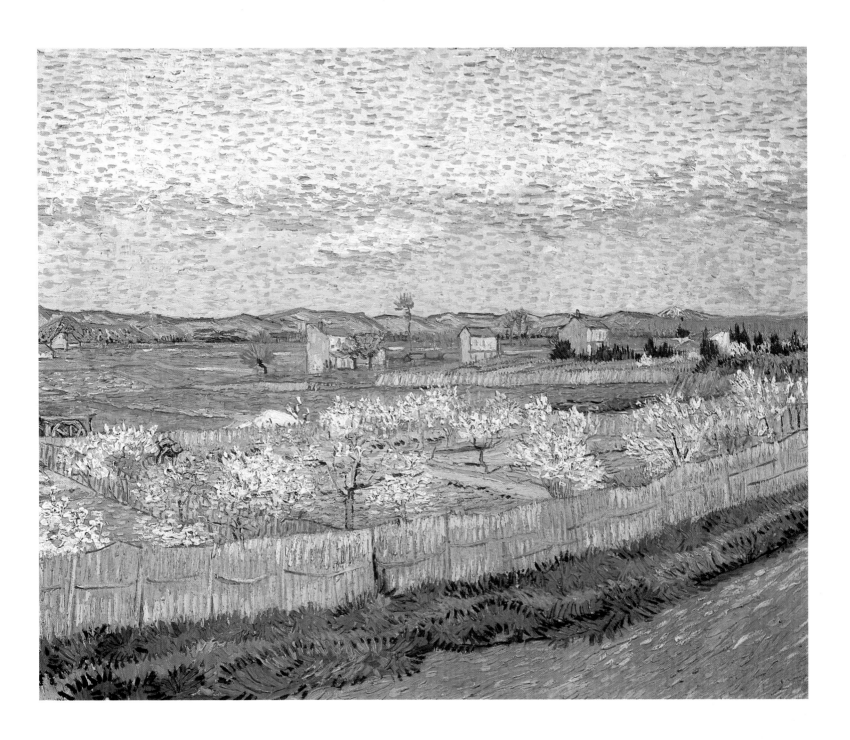

39

Gauguin, Paul 1848–1903
HAYMAKING 1889
Oil on canvas, 92 × 73.3 cm.
Signed, bottom right: 'P. Gauguin '89'

This is one of two haymaking scenes which Gauguin painted at Pont-Aven in Brittany in July 1889. Gauguin had first visited Pont-Aven in 1886, partly to get away from Paris, and partly to find a cheaper place to live (the Pension Gloanec where he stayed was noted for giving credit to artists). Brittany was by then becoming an attractive tourist centre, and was gaining in agricultural prosperity, but it retained an image as a place where primitive peasant types and folkloric customs could still readily be found. Paintings of picturesque Breton costumes and customs were common at the annual Salon exhibitions in Paris. Pont-Aven was one of the main artists' colonies in Brittany; Gauguin avoided the main groups of painters there, but a group of younger artists formed around him, including Emile Bernard, Paul Sérusier and Meyer de Haan, all of whom, like Gauguin, were committed to rejecting naturalistic depiction in favour of an art which expressed their idea of the essential qualities of Breton life.

Gauguin had worked with Pissarro in the late 1870s and early 1880s, and painted at times in a style very close to his (similar to no. 6); in the mid-1880s, though, he began to simplify his forms, and to subordinate naturalistic representation to a clearer, more stylised surface pattern. This was an explicit rejection of the variegated textures and rich surface effects of Impressionism. He described his aims in letters to Emile Schuffenecker in 1888: 'A word of advice, do not copy nature too closely. Art is an abstraction; derive it from nature while dreaming in front of it and think more of the creation which will result.' 'This year I have sacrificed everything – execution and colour – in favour of style.'

Haymaking bears witness to these experiments. Its brushwork is quite thin and crisp, lacking the density of paint and flexibility of Pissarro's, and its colour is simplified, with a clear dominant colour in each area, rather than complex harmonies of related hues. Gauguin had painted with Cézanne in 1881 and owned several of his works, and in some ways his handling here still reflects Cézanne's example – in the sequences of parallel strokes and in the way in which certain zones in the picture (like the trees and the bush) have a clear, distinct shape (compare the foliage in Cézanne no. 23). However, Gauguin's brushwork is thinner and streakier than Cézanne's, his drawing far more schematic, and there is little hint of the nuances of atmospheric colour so prominent in Cézanne's canvas. Moreover, Gauguin presented the space in his picture in a way that cannot readily be understood; the forms seem to be stacked one on the other up the canvas, and the position of the bush on the left is particularly ambiguous.

In his chosen subject, Gauguin avoided any possible narrative reading or any direct appeal to the viewer. The simplified forms of the oxen at the front, and the rhyming, rhythmic poses of the women in their Breton costumes, evoke a sense of timeless rural labour, while the handling of the picture further distances it from immediately perceived reality, presenting the activities as if they were a sort of secular ritual.

PROVENANCE
Ambroise Vollard; Dr. Frizeau, Bordeaux; through (?); Samuel Courtauld by 1923. Courtauld Gift 1932.

EXHIBITED
Gauguin Exhibition, Leicester Galleries, London, July 1924 (61); Tate Gallery, 1948 (27); Orangerie, Paris, 1955 (29); *Gauguin*, Edinburgh, 1955 (28); *Gauguin and the Pont-Aven Group*, Arts Council at Tate Gallery, 7 January–13 February 1966 (20); Japan and Canberra, 1984 (30).

LITERATURE
Jamot–Turner, no. 36; Home House Catalogue, no. 10; Cooper, 1954, no. 29 (as *Les Meules*); J. Rewald, *Post-Impressionism: From Van Gogh to Gauguin* (New York, 1956), p. 248 (as *Harvesting*); Georges Wildenstein, *Gauguin*, I (Paris, 1964), p. 135, no. 352.

TECHNICAL DETAILS
Canvas weave: plain.
Threads per sq.cm.: 17 × 18.
Ground: artist's application; absorbent; colour: white.
Unlined.
Varnished.

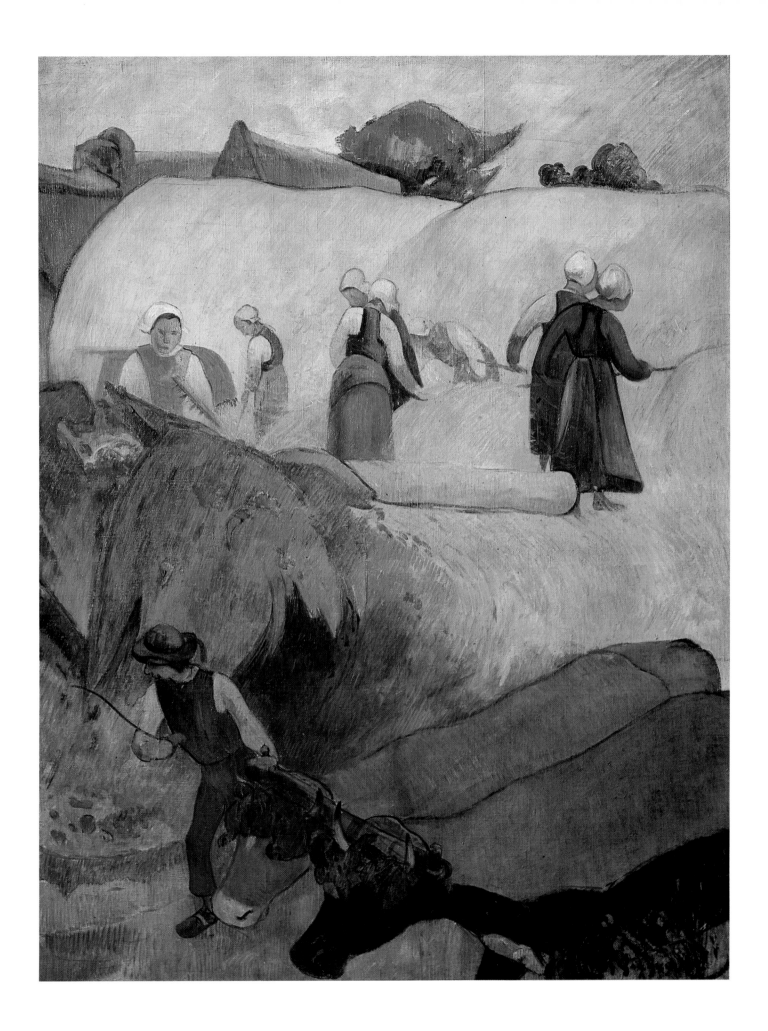

Gauguin, Paul 1848–1903
NEVERMORE 1897
Oil on canvas, 60.5 × 116 cm.
Signed, top left: 'NEVERMORE/P.Gauguin 97/O. TAÏTÍ'

Gauguin painted *Nevermore* in February 1897, during his second visit to Tahiti. He described the painting in a letter to Daniel de Monfreid, the fellow-painter who was acting as his agent in Paris:

> I wished to suggest by means of a simple nude a certain long-lost barbarian luxury. The whole is drowned in colours which are deliberately sombre and sad; it is neither silk, nor velvet, nor *batiste*, nor gold that creates luxury here but simply matter that has been enriched by the hand of the artist. No nonsense . . . Man's imagination alone has enriched the dwelling with his fantasy. As a title, Nevermore; not the raven of Edgar Poe, but the bird of the devil that is keeping watch. It is badly painted (I'm so nervy and can only work in bouts) but no matter, I think it's a good canvas.

Nevermore belongs to a long tradition of reclining female nudes. The pose, with the exaggerated curve of the figure's hip, perhaps echoes the sensuous exoticism of Ingres's *Odalisque with a Slave*, but whereas the luxury in Ingres's picture is presented as tranquil and undisturbed, Gauguin reworked the tradition so as to produce an image as complex and challenging as that other pioneering avant-garde odalisque, Manet's *Olympia* (Musée d'Orsay, Paris). But, whereas Manet's picture (of which Gauguin had a photograph in his hut in Tahiti) confronts the subject of public sexuality and prostitution in the modern city, *Nevermore* explores in a more allusive way more private realms of sensual experience.

The painting sets up a triangular relationship between the nude figure, the bird, seemingly watching, and the clothed figures in the background, turned away and talking. The turn of the nude's eyes suggests that she is aware of the bird or the other figures, but beyond this nothing is clear. The contrast of unclothed with clothed, of reverie with conversation, may evoke the loss of innocence; indeed, in his vast canvas *Where do we come from? What are we? Where are we going to?* of 1898 (Museum of Fine Arts, Boston) two very similar clothed figures, who have eaten of the tree of knowledge and 'dare to talk of their own destiny', are contrasted with the simple people amid virgin nature in the foreground. His reference in the letter about *Nevermore* to 'a certain long-lost barbarian luxury' suggests that the image should be understood not just as the awakening of a particular woman, but rather in the context of the corruption of 'primitive' cultures – Oceanic Gardens of Eden – by the influx of western values. Gauguin's own experiences on Tahiti bore eloquent testimony to this corruption, since colonialism and Christian missionary activity had virtually erased the remnants of the Polynesian culture which he had gone there to explore.

The bird's role, too, is ambiguous. Though in his letter Gauguin played down its relationship to Poe's Raven, the bird, in conjunction with the title, would inevitably have evoked Poe's poem for the painting's original viewers; Poe's work was widely known in artistic circles in Paris in the late nineteenth century, and Mallarmé's translation of the *Raven*, illustrated by Manet, had appeared in 1875. Gauguin may well have sought to minimise this association in order to avoid too explicitly literary a reference, but the bird's presence here is as ominous as in the poem, in which it stands above the poet's door, croaking 'Nevermore'; in the picture, it contributes, with the conversing figures, to the sense of threat which invades the luxury of the nude's surroundings.

The elements in the interior, as Gauguin's letter insists, are imagined, their luxury the product of the painter's imagination. Amid the swinging curves of the plant forms, the stylised gourds on the bed-head and below the bird hint at sexual penetration, bringing the décor into a more active relationship with the figures, but without any explicit meaning. Allusive elements like these were integral to Gauguin's idea of Symbolism; he wrote in 1899, quoting Mallarmé, of one of his paintings as a 'musical poem without a libretto', insisting that it could not be read allegorically. It is in this way that *Nevermore* operates, enriched by its lavish pictorial surface and colour. The sharp yellow of the nude's pillow and the red by her feet heighten her strangeness and further separate her from her surroundings, but cannot be interpreted literally. The iconic quality of the whole picture is enhanced by its smooth, dense surface (in marked contrast to no. 41), but this arose for practical reasons: the present picture was painted over another quite different subject, which Gauguin largely obliterated with a further layer of white priming before starting work on *Nevermore*. X-rays suggest that this may have contained trees (see p. 33). However, the final effect makes positive use of the density of these underlying layers; clearly Gauguin found that their presence allowed him to give the picture a distinctive physical quality.

The English composer Frederick Delius was the first owner of the painting. Gauguin wrote to de Monfreid in 1899 to express his pleasure that Delius had bought it 'given that it is not a speculative purchase for re-sale, but for enjoyment'.

PROVENANCE
Bought from Daniel de Monfreid by Frederick Delius, 1898 (500 Frs.); Alfred Wolff, Munich; with Alex. Reid, Glasgow; with Agnew, London and Manchester; Herbert Coleman, Manchester; Samuel Courtauld by 1926. Courtauld Gift 1932.

EXHIBITED
Salon d'Automne, Paris, 1906 (216); Sonderbund Ausstellung, Cologne, 1912 (168); *Masterpieces of French Art of the 19th Century*, Agnew, Manchester, September 1923 (17); *Gauguin Exhibition*, Leicester Galleries, London, July 1924 (52); Tate Gallery, 1948 (28); *Gauguin, Exposition du centenaire*, Orangerie, Paris, July 1949 (48); Orangerie, Paris, 1955 (25); *Gauguin*, Edinburgh, 1955 (55); Courtauld Centenary, 1976 (21); National Gallery, London, February–March 1983 (no catalogue); Japan and Canberra, 1984 (31).

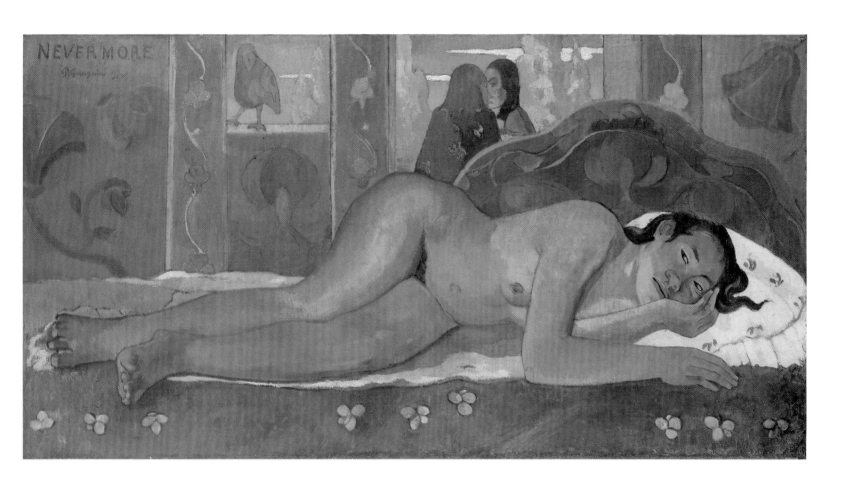

LITERATURE
Jamot–Turner, no. 37; Home House Catalogue, no. 4;
Lettres de Paul Gauguin à Daniel de Monfreid, ed. Mme
Joly-Ségalen (Paris, 1950), pp. 101, 135, 190, 210–11;
Cooper, 1954, no. 30; G. Wildenstein, *Gauguin*, I
(Paris, 1964), pp. 230–31, no. 558.

TECHNICAL DETAILS
Canvas weave: plain.
Threads per sq.cm.: 8 × 10, very coarse.
Ground: artist's application;
1. white, absorbent; 2. white, oil ground.
Lined.
Varnished.

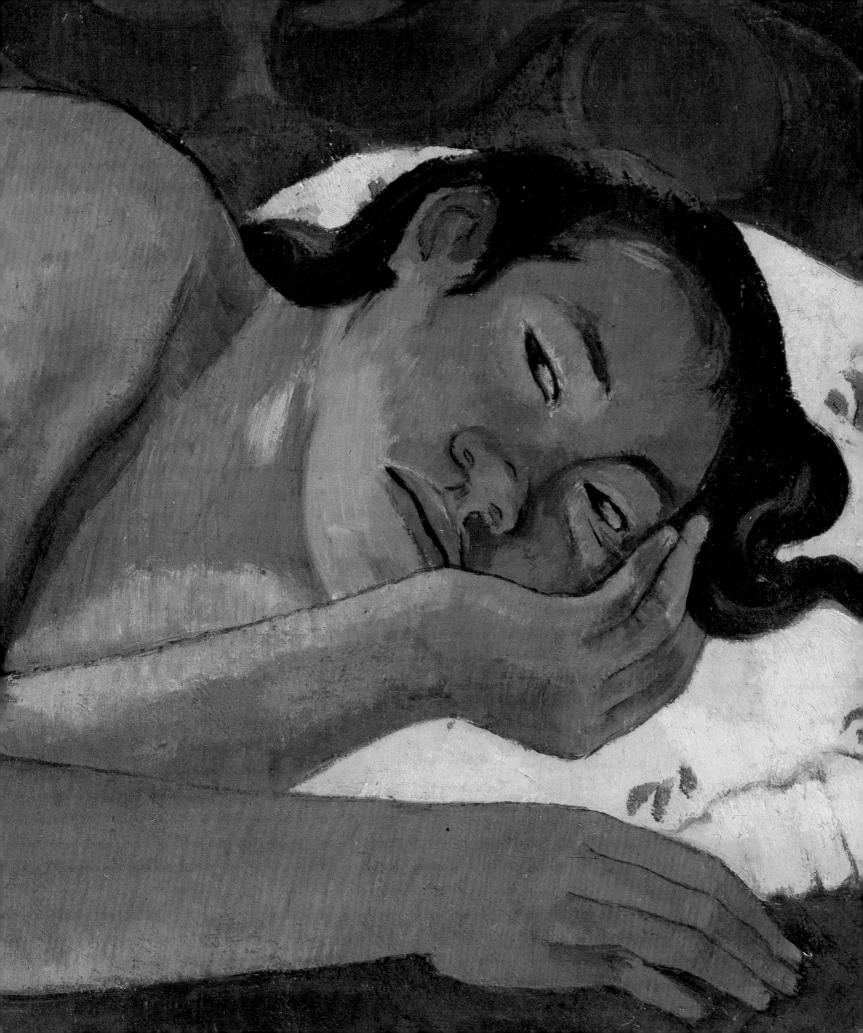

41

Gauguin, Paul 1848–1903
TE RERIOA 1897
Oil on canvas, 95.1 × 130.2 cm.
Signed, bottom left centre:
'TE RERIOA/P. Gauguin 97/TAÏTÍ'

Te Rerioa was painted in Tahiti in March 1897, about three weeks after *Nevermore*. Some of the forms shown on the walls of the room bear some relationship to Gauguin's surviving wood carvings, but it is probable that the decorations were largely imaginary, created as appropriate décor for the picture (compare *Nevermore*, no. 40, and Gauguin's letter about the decoration there).

Gauguin described the painting in a letter when he despatched it to Daniel de Monfreid in France: 'Te Rereioa (the Dream), that is the title. Everything is dream in this canvas; is it the child? is it the mother? is it the horseman on the path? or even is it the dream of the painter!!! All that is incidental to painting, some will say. Who knows. Maybe it isn't.' The spelling of the Tahitian title in this letter is correct; it is wrongly spelt on the canvas. The word in fact means nightmare, but, as he wrote, Gauguin was using it more generally to mean dream.

The uncertainties which Gauguin here spelt out in this playful fashion are integral to the painting, since no figures communicate with each other, and none has a clearly legible expression. The image is made up from a set of contrasts: sleeping child and daydreaming women; sleeping child and the seemingly active, carved figure on the cradle; the women seated still and the figures making love in the wall decoration; these figures seated passively and the active man, riding on the path and placed precisely between the heads of the two women; live animal on the floor beside carved animal on the wall decoration (the leftmost animal in the decoration may well be the only kangaroo in Post-Impressionist painting).

But Gauguin's letter reminds us that none of these elements is 'real', for all are the creation, the dream of the painter who has conjured up this series of puzzles and possibilities; this is emphasised by the physical appearance of the painting itself – thinly and broadly painted over coarse sacking, so that its flatness and the physical presence of the paint and the sacking are constantly apparent.

In its ambiguities, and also in the qualities of its surface, this canvas, perhaps more than any other by Gauguin, answers the requirements of the poet Stéphane Mallarmé for a true 'symbol'. In an interview in 1891, Mallarmé stated:

> I think that there should only be allusion. The contemplation of objects, the image emanating from the dreams they excite, this is poetry. . . . To *name* an object is to suppress three-quarters of the enjoyment of the poem, which is created by the pleasure of gradually apprehending it. To *suggest*, that is the dream. That is the perfect use of mystery that constitutes symbol.

Mallarmé also saw literature as absolutely self-conscious about its means – about the words that make it up – as opposed to *reportage* which was primarily concerned to give a sense of reality; this too parallels Gauguin's emphasis of the physical quality of the painting itself, as an artefact, rather than as a window on another actual world beyond the frame.

A painting such as *Te Rerioa* was intended for a European audience, presenting an archetype of 'primitive' reverie in unspoilt surroundings, and a fusion of eroticism and innocence. As we know from historical evidence, this vision bore no relation to the state of society in Tahiti in the 1890s (see no. 40), but the picture was a contribution to a long European tradition of images of the 'noble savage'; particularly relevant to *Te Rerioa* was perhaps Delacroix's *Women of Algiers* (1834; Musée du Louvre, Paris), in which sensuous reverie was sited in a North African Orientalist context. These visions owe their origins not to the 'primitive' worlds they show, but to the reactions of European artists against the complexities of modern urban society; the idylls they create from the 'otherness' of their material belong firmly in the west, as projections of dissatisfaction with the values of western society.

PROVENANCE
Bought from Daniel de Monfreid by Gustave Fayet, Igny (1,100 Frs.); with Paul Rosenberg, Paris (November 1928); with Wildenstein, New York; Samuel Courtauld, July 1929. Courtauld Gift 1932.

EXHIBITED
Musée de Bezier, 1901; Salon d'Automne, Paris, October 1906 (4) as 'Intérieur de case à Tahiti' and lent by Fayet; *French Art*, Royal Academy, London, 1932 (520); Tate Gallery, 1948 (29); *Gauguin, Exposition du centenaire*, Orangerie, Paris, July 1949 (49); *Gauguin*, Edinburgh, 1955 (56); Orangerie, Paris, 1955 (26); Courtauld Centenary, 1976 (22); Japan and Canberra, 1984 (32).

LITERATURE
Jamot–Turner, no. 35; Home House Catalogue, no. 5; *Lettres de Paul Gauguin à Daniel de Monfreid*, pp. 102, 237, 239–40; Cooper, 1954, no. 31; Christopher Gray, *The Sculptures and Ceramics of Paul Gauguin* (Baltimore, 1963), pp. 75, 266–7, 276; G. Wildenstein, *Gauguin*, I (Paris, 1964), pp. 229–30, no. 557; B. Daniellson, 'Gauguin's Tahitian Titles', *Burlington Magazine*, April 1967, p. 233.

TECHNICAL DETAILS
Canvas weave: plain.
Threads per sq.cm.: 7 × 6, very coarse.
Ground: artist's application;
colour: white.
Lined.
Varnished.

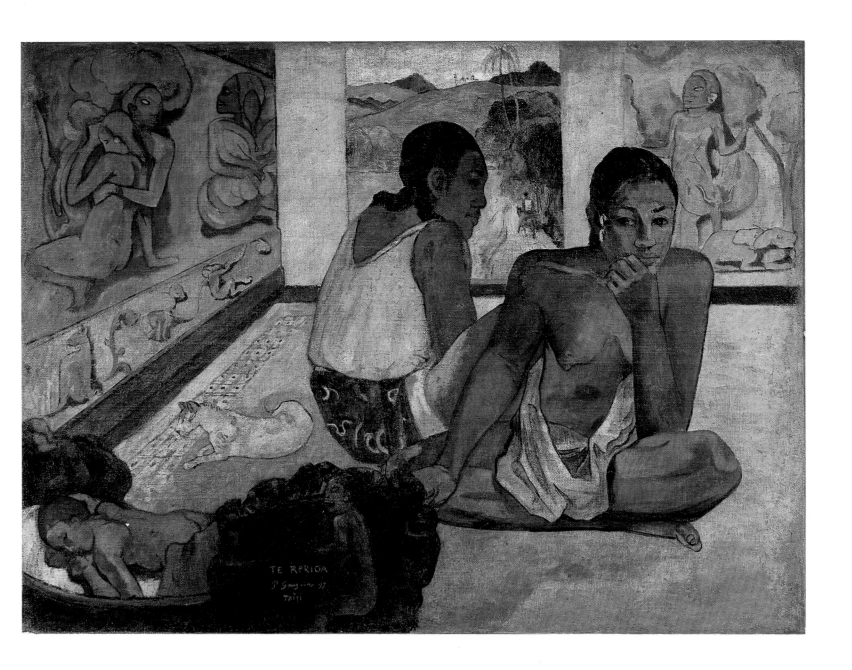

Rousseau, Henri ('Le Donanier') 1844–1910
THE CUSTOMS POST *c*.1890?
Oil on canvas, 40.6 × 32.75 cm.
Signed, bottom right: 'H. Rousseau'

Rousseau served in the army from 1863–8, then as a low-ranking customs official from 1871–93, manning toll-gates on the outskirts of Paris. He began painting, untaught, around 1880; rejected by the Salon in 1885, he began exhibiting with the jury-free *Société des Artistes Indépendants* from 1886. He gradually became known in avant-garde circles, meeting Gauguin and the playwright Alfred Jarry in the 1890s, and Picasso and his friends in the last years of his life. Only after the institution of a jury-less exhibition such as the Indépendants could an artist like Rousseau, from wholly outside any of the contemporary institutional frameworks of the art world, find an outlet and an audience for his work.

Rousseau's art has generally been viewed in the context of the avant-garde, but there is clear evidence that Rousseau's initial models when he decided to become a painter were the academic neo-classicists, Jean-Léon Gérôme and Charles Clément; apparently he sought their advice, and he used to claim that they had encouraged him to follow his own temperament. The precise definition of forms and smooth finish of his paintings corresponds to the expectations of masters such as Gérôme and Clément. The few small outdoor studies of his that survive belong to an already well-established tradition of open-air sketching, and have no significant relationship to Impressionism, while the finished paintings he made from these studies, and his other completed works, are essentially academic in finish.

The subjects of his large pictures – exotic jungles (which he never visited in reality) and large-scale allegories – are also comparable to favoured themes in academic art. But he also painted many smaller landscapes like *The Customs Post*, which show the every-day surroundings of the Parisian suburbs, and often focus particularly on the intrusion of distinctively modern elements into the scene – like the chimneys here, and balloons, and (later) even aeroplanes. These subjects can be closely compared to the suburban landscapes painted by the Neo-Impressionists and other young independent artists in the 1880s and 1890s, such as Seurat's *The Bridge at Courbevoie* (no. 34). The scenes that he painted around Paris were mainly the regions where he worked, near the toll-gates that ringed the city; it is one of these gates that is depicted here.

Rousseau knew little or nothing about linear or atmospheric perspective, but rather laid the elements in his scenes across the picture surface, and suggested space by successions of planes stacked one on top of the other up the canvas, so that forms on the horizon may be as crisply defined as those nearby. Forms are treated as silhouettes, like the figures here, or, like the tree trunks, as simple cylindrical tubes. Out of these subjects, though, he created paintings very tautly organised in two-dimensional terms: verticals and horizontals, from clouds to footpaths, mesh into patterns of great coherence and real grandeur. Such picture-making would of course have seemed absurd to the academic masters of the nineteenth century, but Rousseau's simplifications and stylisations at once struck a chord with vanguard painters of the generations which rejected naturalistic depiction, first with Gauguin and his circle, then with Picasso and his friends.

PROVENANCE
Wilhelm Uhde, Paris; Dr Hartwich, Berlin; with Alfred Flechtheim, Berlin; Samuel Courtauld, 1926. Courtauld Bequest 1948.

EXHIBITED
Wiedereröffnung der Galerie Flechtheim, Düsseldorf, December 1919; *Henri Rousseau*, Galerie Flechtheim, Berlin, March 1926 (12); Tate Gallery, 1948 (62); *Rousseau Exhibition*, Venice Biennale, 1950 (4); Orangerie, Paris, 1955 (45); Courtauld Centenary, 1976 (41); Japan and Canberra, 1984 (80).

LITERATURE
W. Uhde, *Henri Rousseau* (Paris, 1911), pl. 20; Uhde, *Rousseau* (Berlin, 1914), pl. 19; Jamot–Turner, no. 51; Cooper, 1954, no. 58; D. Vallier, *Tout l'oeuvre peint de Henri Rousseau* (Paris, 1970), p. 93, no. 39.

TECHNICAL DETAILS
Canvas weave: plain.
Threads per sq.cm.: 13 × 19, very open.
Ground: commercial application;
colour: white.
Unlined.
Varnished.

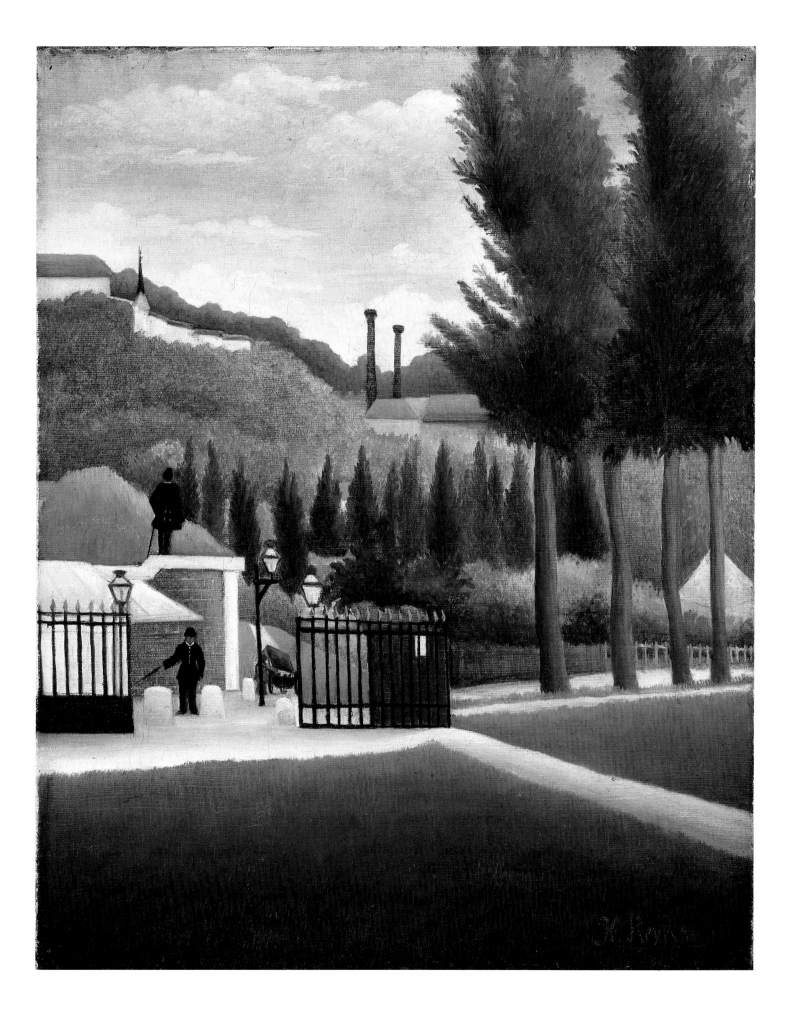

43

Toulouse-Lautrec, Henri de 1864–1901
JANE AVRIL IN THE ENTRANCE OF THE
MOULIN ROUGE, DRAWING ON HER GLOVES 1892
Pastel and oil on millboard,
laid on panel, 102 × 55.1 cm.
Signed, bottom left, initials in monogram: 'T-Lautrec'

Jane Avril was a celebrated popular dancer, reportedly the illegitimate daughter of an Italian nobleman and a Parisian demi-mondaine, who first appeared at the Moulin Rouge in 1889, and became one of its star performers. She was nicknamed *La Mélinite* – name of a recently invented form of explosive. She was one of Lautrec's favourite models, and became his close friend and supporter. Often he depicted her dancing; the English poet Arthur Symons described his first experience of watching her dance in 1892: 'Young and girlish, the more provocative because she played as a prude, with an assumed modesty, *décolletée* nearly to the waist, in the Oriental fashion. She had about her an air of depraved virginity.' But here Lautrec showed her in street clothes, either arriving at or leaving a performance. The thinness of the figure is emphasised by the elongated format – created by the addition of a large extra piece of millboard at the bottom. The apparent immateriality of her figure is wittily set against the looming presence of the male hat and coat seen on the left, apparently hanging on the wall alongside Jane Avril.

The experimental combination of techniques here is comparable to methods pioneered by Degas (see nos. 7 and 10). Lautrec laid in broad areas of the picture in oil, while the pastel elaboration allowed him to combine colour and drawing – simultaneously to sharpen the indication of the forms and to enrich the play of colour; this is most conspicuous around the figure's face and hat, where finer strokes of reds, yellows and greens are set off against the bold slashes of blue paint in the right background. These sharp colour relationships, and the pallid yellow which lights the figure's face, heighten the sense of the artificiality of this world of urban entertainments.

PROVENANCE
Murat, Paris; Eugène Blot, Paris; Blot Sale, Paris, 9 and 10 May 1900 (lot 161; 1,250 Frs., bought in); Blot Sale, Paris 10 May 1906 (lot 74; 6,600 Frs.); Mancini, Paris; Prindonoff, Paris; with J. Seligmann, New York; through Percy Moore Turner, London; Samuel Courtauld, November 1929. Courtauld Gift 1932.

EXHIBITED
Galerie Goupil, Paris, 1893 (18); International Society, London, 1898 (5); *Exposition Toulouse-Lautrec*, Durand-Ruel, Paris, May 1902 (72); Salon d'Automne, Paris 1904 (19); *Toulouse-Lautrec*, Musée des Arts Décoratifs, Paris, 1931 (95); *French Art*, Royal Academy, London, 1932 (551); Tate Gallery, 1948 (79); *Toulouse-Lautrec*, Orangerie, Paris, 1951 (37; wrong provenance); Orangerie, Paris, 1955 (60); Courtauld Centenary, 1976 (56); Japan and Canberra, 1984 (91).

LITERATURE
Maurice Joyant, *Henri de Toulouse-Lautrec, peintre* (Paris, 1926), pp. 136–40, 274; Jamot–Turner, no. 38; Home House Catalogue, no. 3; Cooper, 1954, no. 79.

TECHNICAL DETAILS
Three pieces of beige toned paper on three pieces of millboard, subsequently adhered to wood panel accessory support.
No ground.
Cradled.
Unvarnished.

44

Toulouse-Lautrec, Henri de 1864–1899
TÊTE-À-TÊTE SUPPER 1899
Oil on canvas, 55.1 × 46 cm.
Signed, top right, the initials in monogram: 'T-Lautrec'

The picture shows a tête-à-tête supper at the famous *Rat Mort*, a café and restaurant on the rue Pigalle, at the foot of the hill of Montmartre. By the late 1890s it retained a popular café downstairs, with a restaurant upstairs which was noted as a meeting point for stylish *demi-mondaines*; it is this that Lautrec portrayed here; his sitter was Lucy Jourdain, a celebrated *cocotte* of the day.

In the placing of the figures, and particularly in the startling device of cutting off the man's face with the picture frame, Lautrec has deliberately denied the viewer the possibility of reading a straightforward narrative into their relationship. Degas, in *L'Absinthe* (Musée d'Orsay, Paris) had used a similar arrangement in order to suggest psychological distance and separation, but here the mood is less readily legible. The vivid red slash of the woman's smiling lips is echoed by the ebullient, flowing brushwork of her clothes and the bowl of fruit, creating a sense of vivacity – this is enhanced by the use of paint much thinned with diluent and applied fluidly and transparently exploiting the light tone of the ground; but the seeming lack of focus in the woman's eyes, with the man's averted gaze and the glass of champagne before her, may suggest that this gaiety is superficial. The artificiality of her position is emphasised by her costume – clearly a fancy stage costume, in contrast to her companion's formal evening dress. These signs would have made it quite clear to the painting's original viewers that this was a scene of *demi-mondaine* entertainment, but beyond that its mood and meaning are not closely fixed, leaving scope for the viewer's interpretation.

PROVENANCE
G. Séré de Rivières, Paris; with Georges Bernheim, Paris; Caressa, Paris; through Percy Moore Turner, London; Samuel Courtauld, 1928. Courtauld Bequest 1948.

EXHIBITED
Exposition Toulouse-Lautrec, Durand-Ruel, Paris, May 1902 (38); *Exposition rétrospective Toulouse-Lautrec*, Galerie Manzi-Joyant, Paris, June 1914 (34); *Toulouse-Lautrec*, Galeries Paul Rosenberg, Paris, 1914 (21); *30 Ans d'art indépendant*, Paris, February 1926 (3252); *French Art*, Royal Academy, London, 1932 (513); Tate Gallery, 1948 (80); Orangerie, Paris, 1955 (61); Courtauld Centenary, 1976 (57); National Gallery, London, February–March 1983 (no catalogue); Japan and Canberra, 1984 (92).

LITERATURE
Joyant, 1926, p. 298; Jamot–Turner, no. 40; Cooper, 1954, no. 80; R. Thomson, *Toulouse-Lautrec* (London, 1977), p. 103.

TECHNICAL DETAILS
Canvas weave: plain.
Threads per sq.cm.: 26 × 28.
Ground: commercial application;
colour: light cream.
Wax lined.
Varnished.

45

Bonnard, Pierre 1867–1947
A YOUNG WOMAN IN AN INTERIOR 1906
Oil on canvas, 48.9 × 44.5 cm.
Signed, bottom right: 'Bonnard'

The sitter was the artist's mistress, Marthe Boursin, whom he married in 1925; after he first painted her in 1894, she became by far his most frequent model. In its freely brushed paint surfaces, the picture reveals Bonnard's return to a handling more akin to Impressionism, in contrast to the tighter drawing and crisper treatment of his paintings of the 1890s; this marked a turn away from a Symbolist search to find an essential form of sorts for each subject he chose, in favour of a more straightforwardly naturalistic approach.

A painting such as this occupies the boundaries between portraiture and genre painting. The sitter is presented as a type, not as a highly characterised individual, amid the informal bits and pieces of a domestic interior – perhaps the artist's studio. Yet the pose of the figure, and her gestures and expression, tell no story and evoke no particular mood, as she holds something (grapes or flowers?) up in front of her, and looks out beyond it. The angle of vision, from above and beside the model, increases the air of informality, and the lighting is more sharply focused on the piece of furniture beyond than on the figure. By these calculated devices Bonnard created a seemingly casual image of everyday life – of insignificant gestures in an intimate domestic setting.

PROVENANCE
Bought by Bernheim-Jeune, Paris, from Jos Hessel in 1919; Dr Soubies; Roger Fry (after 1920). Fry Bequest 1934.

EXHIBITED
Artistes français des XIX^e et XX^e siècles, Goupil Gallery, London, July 1920; *Bonnard*, Lyon 1954 (22), *Bonnard*, Royal Academy, London, January–March 1966 (38); *Bonnard*, Haus der Kunst, Munich, October 1966– January 1967 (38); *Bonnard*, Orangerie, Paris, January–April 1967 (45); Japan and Canberra, 1984 (3).

LITERATURE
Bulletin de la vie artistique, 1^re année, no.15 (1 July 1920), p.437 and 6^e année, no.21 (1 November 1925); Home House Catalogue, no.95; J. et H. Dauberville, *Bonnard. Catalogue raisonné*, II (Paris, 1968), p.48, no.405.

TECHNICAL DETAILS
Canvas weave: plain.
Threads per sq.cm.: 22 × 22.
Ground: 1. commercial application;
2. artist's application; colour: white.
Unlined.
Varnished.

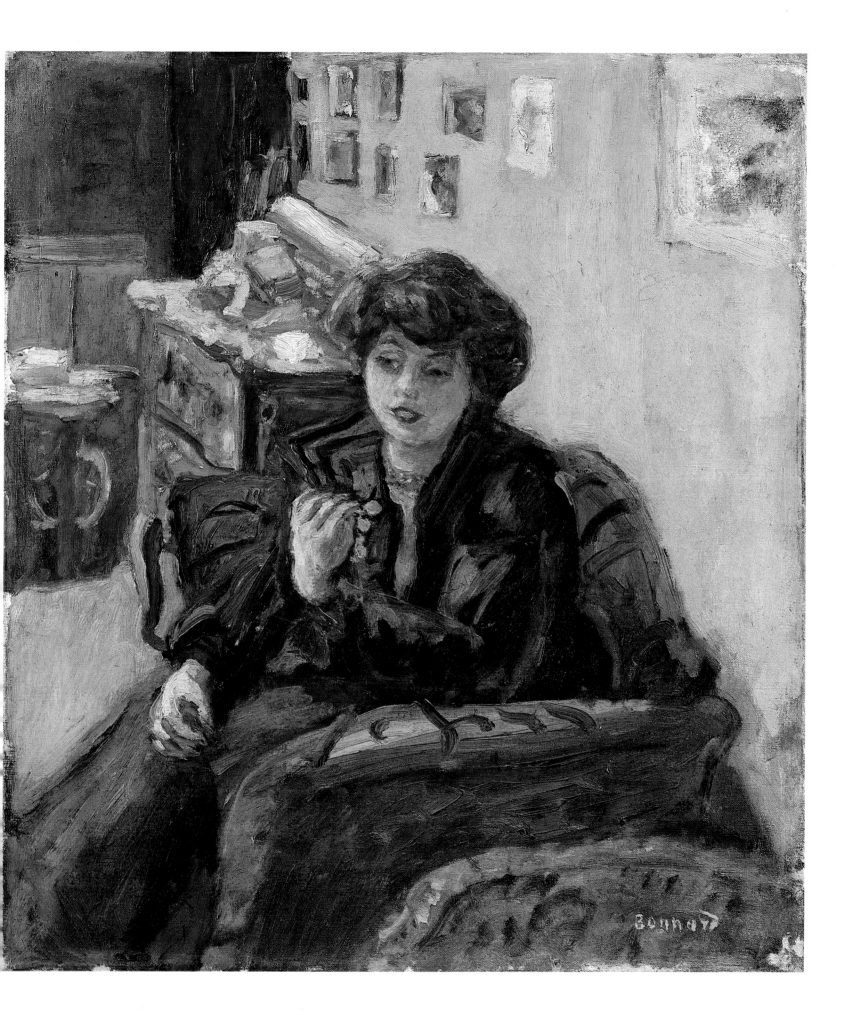

46

Bonnard, Pierre 1867–1947
THE BLUE BALCONY 1910
Oil on canvas, 52.5 × 76 cm.
Signed, bottom left: 'Bonnard'

The Blue Balcony shows the view from the artist's house, *Ma Roulotte*, at Vernonnet, in the Seine valley near Monet's home at Giverny. *Ma Roulotte*, literally my gypsy caravan, was the humorous name for this country villa; Bonnard's friend Thadée Natanson described the place:

> The upper floor of the 'Roulotte', with a wooden balcony, was on the same level as the road, and the small garden fell away steeply to the river bank where a boat was moored. The bedroom and bathroom were on the level of the road, with a garage which they had built on the other side of a little courtyard. They ate in the dining room, on the lower level, the ground floor, less often than they did in the local inn.

One of Bonnard's favourite themes in his middle and later years was the relationship between houses and gardens, which he presented in many unexpected forms, challenging the usual ways of depicting buildings in landscape; he created instead a far freer interplay between houses and their surroundings. Here, the most active part of the composition is relegated to the extreme left – the structure of the house and balcony, and the single small figure; the recession through the centre of the picture leads only to a very summarily treated bank of trees with a hint of a garden table and chairs at the end of the path. The different elements in the composition are all absorbed into an overall play of coloured touches which creates scattered points of focus all across the canvas; the figure and the tree trunks are no more crisply defined than the patches of light on the path and between the trees. Soft greens, blues and greys dominate the composition, enlivened by a few accents of sharper colour.

PROVENANCE
Bought from the artist by Bernheim-Jeune, Paris, 1910; Hugo Nattan; with Bernheim-Jeune 1912; Paul Vallotton, Lausanne; with Galerie Druet, Paris, 1928; Percy Moore Turner, London, from whom acquired by Samuel Courtauld c.1928. Courtauld Gift 1932.

EXHIBITED
Oeuvres récentes (1910 et 1911) de Bonnard, Bernheim-Jeune, Paris, May–June 1911 (14); Tate Gallery, 1948 (2); *Bonnard*, Kunsthaus, Zürich, June 1949 (90); Orangerie, Paris, 1955 (1); *Bonnard*, Royal Academy, London, January–March 1966 (92); Courtauld Centenary, 1976 (1); *Paintings from the Courtauld*, National Gallery, London, February–March 1983 (no catalogue); Japan and Canberra, 1984 (1).

LITERATURE
Home House Catalogue, no. 50; Cooper, 1954, no. 2; Jean et Henry Dauberville, *Bonnard. Catalogue raisonné de l'oeuvre peint*, II, 1906–19 (Paris, 1968), p. 209, no. 625.

TECHNICAL DETAILS
Canvas weave: plain.
Threads per sq.cm.: 14 × 14.
Ground: commercial application;
colour: grey.
Unlined.
Unvarnished.

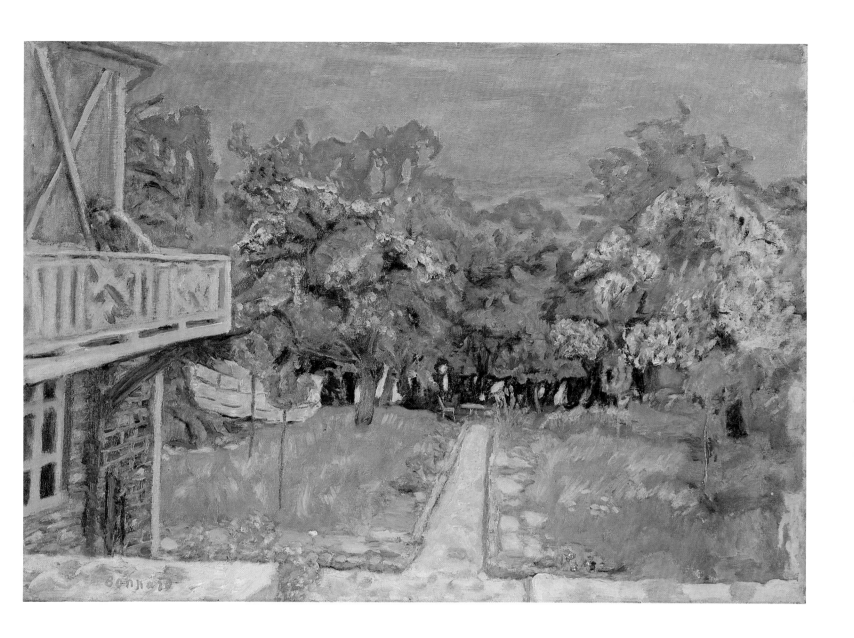

47

Vuillard, Edouard 1868–1940
INTERIOR WITH A SCREEN *c.*1909–10
Oil (peinture à l'essence) on paper,
laid down on panel, 35.8 × 23.8 cm.
Signed, bottom right: 'E. Vuillard'

This little sketch is treated in a particularly summary way; the toned paper is left unpainted in many places to serve as a mid-tone, particularly in the central figure; thus paradoxically the primary element in the composition is one of the least worked: the woman's body is almost evoked in negative. The richest colours occur in the screen, whose green, pink and blue panels set the figure off, while soft, muted, blue streaks suggest the modelling of her body, and a few crisp highlights, along her extended arm and her left thigh, locate her pose in relation to the studio window at top right. This window, with the wall and the screen, set up a grid-like structure across the whole picture, behind the curved shapes of figure and sofa. The colour is quite muted, with true black used for the cushion or drapery on the sofa and, in a tiny dab, to suggest the model's pubic hair. The surface of the painting is very matt, and has happily never been varnished, thus leaving it in the state which Vuillard would have wished. The subject of this picture, of a figure in an interior, placed in a situation and a pose which has no obvious narrative or psychological explanation, can be compared with Bonnard's *A Young Woman in an Interior* (no. 45).

Here Vuillard exploits peinture à l'essence in a technique that contrasts with that of Degas's 'Woman at the Window' (Cat. No. 7). The choice of an absorbent, fairly coarse, tinted paper, much of it left exposed, and the essentially opaque pigment mixtures, such as those in the thinned, flat marks of the screen behind the figure, suggest the appearance of gouache. Where the paint has not been so diluted, the surface retains the impasto of the brushstrokes, and, in the light of the window, a trace of the gloss of the reduced oil medium.

PROVENANCE
With Paul Gemetti, London; through the Leicester Galleries, London; Samuel Courtauld, July 1927. Courtauld Bequest 1948.

EXHIBITED
Tate Gallery, 1948 (83); Orangerie, Paris, 1955 (69); Courtauld Centenary, 1976 (61); Japan and Canberra, 1984 (100).

LITERATURE
Jamot–Turner, no. 55; Cooper, 1954, no. 89 (where dated '*c.*1912') as 'Intérieur: Le Paravent'.

TECHNICAL DETAILS
Coarse buff paper laid on card. No ground. The card is mounted on a wood panel, accessory support to this has been cradled.
Unvarnished.

48

Modigliani, Amedeo 1884–1920
FEMALE NUDE *c*.1916
Oil on canvas, 92.4 × 59.8 cm.
Signed, top left: 'Modigliani'

Modigliani's nudes are a combination of poses which often relate to the main traditions of western art (to Manet, Ingres and other earlier artists) with a type of drawing and execution which in its radical simplifications challenged the whole European figurative tradition. In *Female Nude*, the face is elongated, its features boldly simplified, in ways which testify to Modigliani's knowledge of Egyptian, African and Oceanic sculpture, though in a generalised way; yet the angle of the model's head recalls the very conventional imagery of the sleeping model, a favourite theme at the Salon exhibitions. Likewise the contours and modelling of the body are treated in simplified arabesques, but elements such as the breasts and especially the pubic hair are described more attentively. Modigliani's brushwork is highly individual, characteristic scallop shaped strokes can be seen in the X-radiograph, the paint being applied with a short stabbing action. The paint has been manipulated while still wet, ploughed through with a stiff brush in the background left and around the outline of the head, and scratched into with the end of the brush in the hair.

When a group of Modigliani's nudes were put on show at Berthe Weill's gallery in Paris in December 1917, the police first ordered the removal of the painting in the gallery window, and then the closure of the whole exhibition; apparently the prime cause of outrage was his explicit rendering of pubic hair, a taboo in the often very naturalistic depictions of the nude which hung every year at the Salon without any protests. It is noteworthy that this painting, with its combination of traditional and avant-garde elements, was the only painting in Samuel Courtauld's collection by a member of one of the avant-garde groups which emerged after 1900; Cubism and even Fauvism were outside the parameters of his taste.

PROVENANCE
With Léopold Zborowski, Paris; C. Zamaron, Paris; with Zborowski, Paris; Samuel Courtauld by 1931. Courtauld Gift 1932.

EXHIBITED
Modigliani, Palais des Beaux-Arts, Brussels, November 1933 (22); *Modigliani*, Kunsthalle, Basel, January 1934 (14); Tate Gallery, 1948 (42); Orangerie, Paris, 1955 (31); Courtauld Centenary, 1976 (27); *Modigliani*, Musée Saint-Georges, Liège, October–December 1980 (7), as 'Nu assis'; Japan and Canberra, 1984 (63).

LITERATURE
Jamot–Turner, no. 54; Home House Catalogue, no. 21; Cooper, 1954, no. 38; Ambrogio Ceroni, *Modigliani peintre, suivi des 'souvenirs' de Lunia Czechowska* (Milan, 1958), no. 29; Joseph Lanthemann, *Modigliani 1884–1920: catalogue raisonné, sa vie, son oeuvre peint son art* (Barcelona, 1970), no. 160; A. Ceroni and F. Cachin, *Tout l'oeuvre peint de Modigliani* (Paris, 1972), no. 127; Douglas Hall, *Modigliani* (Oxford, 1984), pl. 26.

TECHNICAL DETAILS
Canvas weave: plain.
Threads per sq.cm.: 12 × 14.
Ground: 1. commercial application;
2. artist's application; colour: grey.
Wax lined.
Varnished.

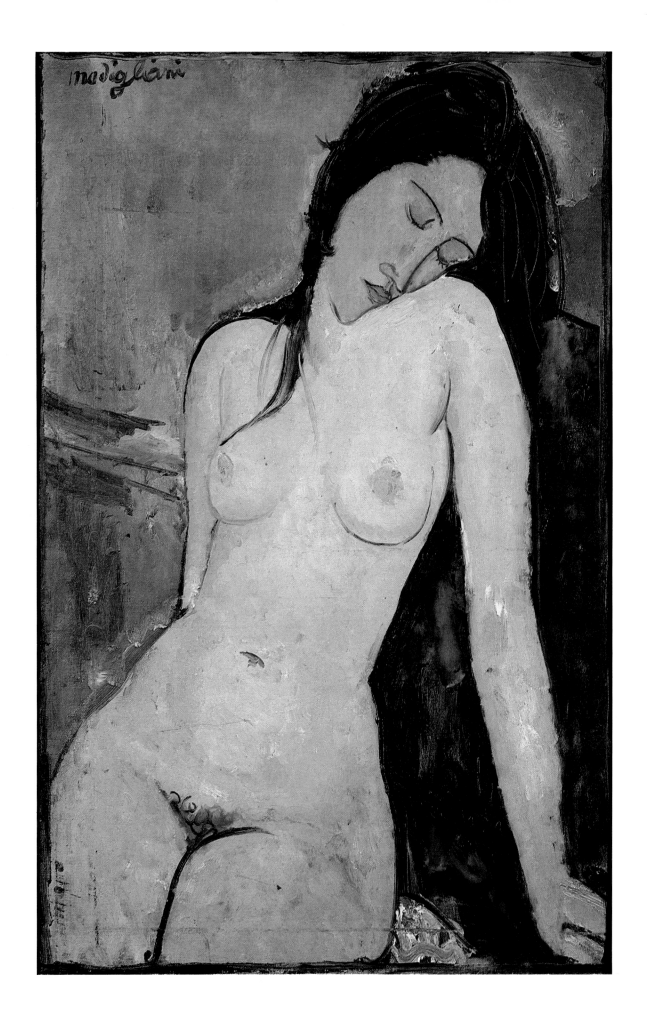

Index of Artists

Numbers refer to catalogue entries